the COMIC BOOK makers

the COMIC BOOK makers

by Joe Simon with Jim Simon

Vanguard Productions

The Comic Book Makers

by Joe Simon with Jim Simon

Revised Edition
Published by Vanguard Productions
J. David Spurlock, Editorial & Art Director
Jon B. Cooke, Book Design & Production
Roy Thomas, Consulting Editor

For Harriet

Acknowledgements

Thanks to William M. Gaines, Michael T. Groben, Esq., Carmine Infantino, Harry Mendryk, Will Murray, Lauren Newman, Alfred Harvey, Alan Harvey, Russ Harvey, Robert Wiener, and Russ Cochran

Vanguard Productions

59A Philower Road
Lebanon, New Jersey 08833

Table of Contents

The Butcher, The Baker, The Comic Book Maker...

The kid got there kind of late — and missed the comic book heydays of the late 1930s, the '40s and into the '50s. But while the kid wasn't there when it was happening, the kid was lucky enough to get the next best thing to it.

The kid got to hear many of the stories about those years.

The kid got to sit with and talk to and know many of the people who worked in the business.

They were entertaining just being themselves.

Butcher, baker, comic book maker....

The guy with the cigar could always be found working in the studio, a room filled with necessities of his trade: paper, pens and brushes, cement cans, India ink bottles, an ink-stained and razor-cut drawing table, taboret, illustrator's lamp, tape dispenser and the ever-present television with the incessant blue-glare of the flickering picture.

When not working at the drawing board the guy with the cigar could be found at the typewriter — an Underwood upright from the early days — pecking at the keys in the fashion of the old-time newspaper writers, one finger at a time.

Sometimes the kid thought the world revolved around the taboret holding ink bottles, gum-erasers, brushes, air brush, and Speedball pens.

It wasn't unusual, someone knocking on the front door late at night, the guy with the cigar standing in the hallway talking quietly: an artist or writer the kid recognized but didn't know by name asking for a loan. They had kids, too; a family to raise. And sometimes it was a writer or artist just down on his luck.

With five kids of his own in a house in the suburbs doing the kinds of things five kids in a house in the suburbs will do — running in and out of rooms, slamming doors, shouting, playing, fighting — the guy with the

cigar figured there was no way for him to get the work done. But he was ahead of the game: When the kids trudged up the stairs to go to bed at night, he'd be waking to go downstairs to work. The wife of the guy with the cigar had the coffee hot and ready, waiting for him to stagger down the stairs, pass the kids, pour a cup and head into the studio; a light flipped on, the television soon flickering.

In the morning, coming downstairs for school, the kids would often run into him again, now going up the stairs — his shift over, theirs just beginning.

Butcher, baker, comic book maker....

They moved.

The kid made new friends.

The kid explained to the new friends why they moved and that the family wasn't from another planet.

Then the inevitable.

"What does your father do?"

The kid gave them the stock answer.

"Yeah," said KC (it was one of those suburban towns where initials were popular as names). "Then how come we never see him go off to work?"

Robert rolled his eyes behind his glasses (it wasn't a deformity, it was Robert's special ability).

The kid should have asked them what planet they were from.

The kid simply shrugged. "That's because he's making books."

The kid answered as coolly as a kid could, and the subject was dropped. They had other things to do. There was a ball game that afternoon. They headed for the sandlot, arguing over more important topics, such as who was the better slugger — "Say Hey" Willie Mays or Mickey Mantle.

The next thing the kid knew, the friends' parents whispered when the kid went over to their houses.

The kid soon found out what the whispers were about.

INSET LEFT: *Joe Simon, working the phone, inking a page, and smoking a cigar in his Long Island studio, circa 1949.*

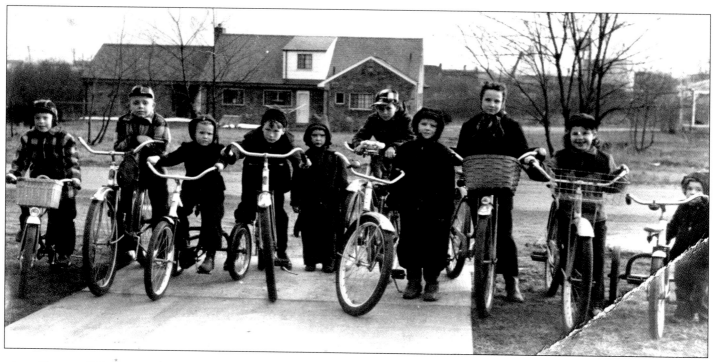

It happened on haircut day.

The Gang of Three, as they called themselves, piled into KC's mother's Ford for a ride into town.

The kid got the "regular" haircut, and Leo, the barber, was rubbing the greasy kids stuff into his scalp when the kid looked out the barbershop window and saw the family car pull up to the curb.

Leo glanced out the window as he dragged the comb across the kid's scalp, his form of child torture.

"Well it looks like pop's got the day off."

Leo wanted to do something else in life.

"He always has the day off," KC's mom said in that strange voice.

"That's nice," said Leo. He didn't seem interested. Then he looked up at KC's mom. "What does he do for a living that he gets the day off?"

That interested him.

Leo put the comb and scissors on the counter and stared, over the shoulder of KC's mom, out the window.

The guy with the cigar was dropping nickels into the town parking meter. The guy with the cigar looked happier than everyone else.

She made the *"Shhhhing"* sound again, and then in that whispering voice the kid couldn't fully hear, she leaned back and hissed into Leo's face, "He's a bookie."

And she looked at the kid, her eyes as sad and doleful as a dachshund's.

She thought this kid's got it rough.

"Bookie?" Leo moved closer to the window.

For some reason, the guy with the cigar was standing at the side of the car like he had nothing better to do.

"That's what Jimmy says."

And they both looked at the kid.

"What does your father do, son?"

"He makes books," the kid answered.

"I told you, Leo."

Leo, as if in a trance, untied the apron, shook free the cut hairs. The kid got out of the barber chair. At the mirror the kid rearranged his combed hair to the way he liked it.

This time Leo didn't yell at him for ruining his work.

Outside in the bright afternoon light the Gang of Three minus the kid

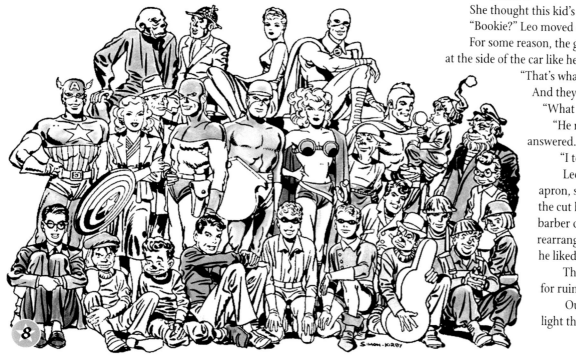

piled into KC's mom's car. They were going home. Without the kid.

The guy with the cigar and the kid wandered into Weintraub's where they first checked out the display racks for new magazines and comics. Then they sat down at the counter for ice cream sodas.

"What are you doing in town?"

"I finished the last issue last night. This afternoon I couldn't sleep," he said. "Cheers."

"Cheers."

Finally the kid asked him. "Dad, what's a bookie?"

"It's someone who takes money from people who don't want to keep it."

"Are you a bookie?" the kid asked.

"I'm an artist, writer, editor and sometimes a publisher: I'm a comic book maker — but that's between you and me."

"I've told someone you're a bookie."

"I've told people the same thing on occasion," the guy with the cigar confessed.

The kid guessed that being in the comic book line of work wasn't the normal thing for a grown man with a family to do.

At least that was the way it seemed back then.

His friends' dads had real jobs: carpenter, roofer, electrician, bricklayer, butcher, baker. One buddy's dad was the town Postmaster. It was a small town — the post office was in the friend's living room, and his dad also had to deliver the mail.

In school, the teacher asked the class what their dads did for a living. When it came his turn, the kid said, "Publishing."

That seemed to impress the teacher.

"Comic books," KC called out.

The teacher's eyebrows arched.

"His dad makes comic books. Superheroes, cowboys and Indians, even monsters."

The whisperings among the fellow classmates swelled to loud praises against the teacher's protest for calm and order.

The kid slouched.

At home there was a file cabinet. The kid wasn't sure what it contained, but the kid often scanned magazines for interesting photos — especially action shots — and he clipped and filed them in alphabetized folders like the guy with the cigar showed him. It was a steady source of reference material for drawing scenes. Far in the back of the cabinet the kid had found a file of clippings. The guy with the cigar had saved newspaper articles on the Senate investigation into comic books. The guys in the suits and the headlines running across the newspaper columns gave the impression that someone was really upset over these things called comic books but the kid had no idea why.

The teacher's voice echoed in the kid's head.

"Where does your father make these comic books?"

"Home."

"For whom?"

"For us —"

"I mean, who does he work for? What comic book company?"

"I'm not sure."

"I'd like to talk to you after class."

It turned out the teacher wanted to be a comic book artist.

The following week the guy with the cigar showed up at the school. The guy with the cigar told the class about comic books and what he did for a living. The guy with the cigar drew superheroes and funny animals and caricatures of the kids on the blackboard. Everyone had a great time though the kid was sure the guy with the cigar had the best time.

The teacher didn't quit.

The kid realized it wasn't easy, as some people thought it was, to make it as a comic book artist.

Now the kid's friends knew that the books the guy with the cigar made were comic books, and the kid was the kid with "the largest comic book collection in the world." Friends would come over to the house, bound up the staircase and rush for the booty the guy with the cigar brought back from the New York City publishing houses. At least a box for every trip. All kinds of comics. Later the kid and his friends would go downstairs and search the studio. There they'd always find something on the drawing table in various stages — a penciled comic page, half-inked, dialogue balloons sketched in with words rising over a character's head, almost always ending in an exclamation mark!

The kid's friends started making their own comic books.

The kid comic book makers didn't last long however. The guy with the cigar had made it look too easy. After a while the kid's friends started quitting, one by one.

Except Robert.

Robert held out the longest, having signed up for an expensive Famous Artists' mail order correspondence course — a birthday gift from his mom.

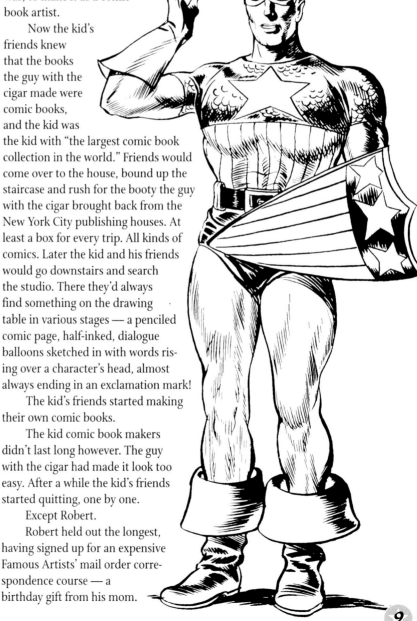

BELOW: *Joe Simon's most famous creation, Captain America, waves to the kids of the U.S.A., in this detail from the splash page of his debut story in* Captain America Comics #1 *(Mar. 1941). Art by Joe Simon & Jack Kirby.*

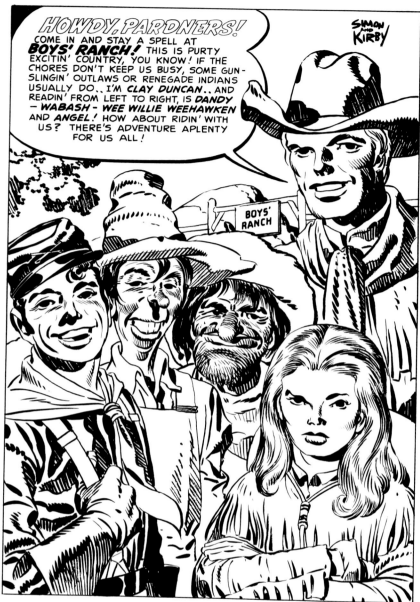

HOWDY, PARDNERS! COME IN AND STAY A SPELL AT **BOYS' RANCH!** THIS IS PURTY EXCITIN' COUNTRY, YOU KNOW! IF THE CHORES DON'T KEEP US BUSY, SOME GUN-SLINGIN' OUTLAWS OR RENEGADE INDIANS USUALLY DO.. I'M *CLAY DUNCAN..* AND READIN' FROM LEFT TO RIGHT, IS *DANDY* — *WABASH* — *WEE WILLIE WEEHAWKEN* AND *ANGEL!* HOW ABOUT RIDIN' WITH US? THERE'S ADVENTURE APLENTY FOR US ALL!

SIMON AND KIRBY

BOYS' RANCH

ABOVE: *Perhaps Simon and Kirby's most critically acclaimed title was* Boys' Ranch, *featuring the rambunctious, riotous, and sometimes poignant adventures of young American cowboys in the 19th century. This page served as frontispiece for* Boys' Ranch #2. ©2003 Joe Simon and the Estate of Jack Kirby.

Robert set up his studio in a corner of a garage riotous with lawn equipment, his dad's empty beer bottles and a '32 Ford that his dad planned to restore one day — leaning on two flat tires.

Robert would bring over his assignments for a critique. Those drawings were pretty bad, lines unsteady, though Robert insisted it was from the train that rattled past his house (his family lived literally within fifteen yards of the railroad tracks). The guy with the cigar would look over the drawings, look at Robert's hopeful face behind the thick glasses, and all too often announce as if on cue, "Yep, you've got the makings of a comic book artist!"

But eventually even Robert gave up.

Still, those stories of the comic book writers and artists were always there. The kids were amazed watching one artist create characters on the drawing board, but imagine how the kids felt with a team of these guys in their midst — Jack Kirby, Jack Davis, Al Williamson,

Leonard Starr, Bob Powell, George Tuska....

Get two or more of these guys together and listen to them talking over storylines, discussing who was most skillful with brush or pen. And then there were the personal problems of working or not working in this strange business called comic books. Was it true, as the kid had heard, that among these comic book makers there were intolerable mad artists, writers and publishers with whom it was necessary to coexist? And how improbable but true would it be for the kid to witness grown men debating the merits of a new comic book hero possessing superpowers enabling him to backflip 20 million times a second, jackhammer sense into a villainous mind, win the affection of the girl next door? And by the way, should his long-underwear costume be blue or red; did the new character look too much like that other character? And most of all, would the kids buy it?

Friday nights — no school the next day — the kid could stay up late. The TV blasting its ever-present blue-tint picture, the guy with the cigar at the drawing table, smoke wafting toward an open window and a suburban Long Island starry night. The kid would poke around the cluttered studio, a virtual treasure trove of art and scripts, see what had come in through the mail, read a sheet of freshly typed script held in the cylinder of the old Underwood. The guy with the cigar would chat between drags, eyebrows raising from the board, though the kid knew his mind was still somewhere in the story he was working on. The guy with the cigar would direct the kid over to a story he'd worked up the night before — several boards with penciled characters, dialogue ballooning from their heads. What were the other kids doing late at night? Friends' parents seldom talked to their kids about their work. In the studio, the kid often watched over the shoulder of the guy with the cigar. The guy with the cigar didn't mind.

The kid would like to think now, so many years later, that the guy with the cigar got and used ideas from him. The kid's head back then was reeling with ideas: Plots, characters, heroes, villains, titles. Growing up in that world the kid naturally thought like that. How many times driving into town did the kid and the guy with the cigar discuss new ideas and stories? The kid learned to see the world differently from his friends. Maybe it was a problem, the kid didn't know. Maybe it still is. Look at this book....

Anyway, the kid would ask about a writer or an artist, and the guy with the cigar would talk a while about the person. Then:

"What do you think about this?" The guy with the cigar would hold the board up from the drawing table.

The kid would take it all in with one long look.

"It needs a little more movement, don't you think?" the guy with the cigar would answer himself.

Although he didn't necessarily follow the kid's suggestions, the kid's opinion counted. The kid wasn't 12

years old yet: the kid could still be trusted.

The kid's favorite was *Bullseye*, a comic book about a cowboy marked for death by a vengeful Indian who burned a bullseye into the cowboy's chest with a branding iron when the character was only a child, the kid's age perhaps. Bullseye grew to be a man hunted by the fanatical Indian warrior, feared by menacing cowboys; a man-child with a secret and a secret identity. This character was not in some dark metropolis, but roamed the wide open spaces of America's imagination of the old Western frontier.

"You know why Bullseye's got that mask?" the guy with the cigar asked.

The five board pages were propped on the long work table so that the scenes reeled in the kid's head, panel by panel; the guy with the cigar put down the pencil, looked at the kid and asked again, "You know why he's wearing the mask, don't you?"

"Cause he's the good guy," the kid said.

"We had to make him look like a superhero. Yeah, he does look like all the other superheroes, doesn't he."

"He looks like Captain America on a horse," the kid said.

"That's the problem. He's a terrific character but I wish he didn't have to wear that mask."

"I like the mask, even if it makes him look like Captain America," assured the kid.

The other favorite was Fighting American. He too looked like Captain America.

In *Fighting American* the hero leapt off the page, fists slamming into the shattering jaw of some evildoer. And it was funny. The kid didn't understand everything at that age but just looking at it — the characters, the action — the kid could see the humor in it. The villains looked like dangerous clowns. Round Robin, bouncing all over, was an arch enemy — he didn't run away from Fighting American, he rolled away!

Robert was one of Fighting American's biggest fans. He started talking like a *Fighting American* script. He'd be at the house saying things like, "Hey, lookit that guy — it's Goitrous Goof!"

Then he would say that was one of his famous "patented lines"! What Robert meant was that his over-active imagination had come up with a new character, a villain with a goiter problem... but unfortunately the character was only in Robert's head, not in a comic book, and it was another one of Robert's rather unique or "patented" insights into the world of comic book making.

And, in his way, he was right. Goitrous Goof wasn't such a bad idea for a character... if only someone could draw him, a simple fact that eluded Robert — as it eluded all the kid comic book makers.

However, Goitrous Goof one day showed up on the drawing board as a new villain. The kid guessed the guy with the cigar had overheard. Attached to the sketch was a note: "For Robert."

"Hey," said Robert, waving the sketch in the kid's face, "it's Goitrous Goof! Holy cow, how'd he get in there? You didn't tell your father, did you?"

"No."

"Holy cow! Goitrous Goof! — You sure you didn't tell him?"

"I swear."

"This is great. This is patented!"

He was in ecstasy.

He ran out of the house with the sketch held in front of his face.

The kid didn't see him for the rest of the weekend. That Monday in school Robert told the kid he had spent Saturday and Sunday in his garage creating his own comic book. Robert's eyes were dark, he said he hadn't slept enough. Robert took out the sketch from his schoolbook and pointed his finger at the panel containing Goitrous Goof. "I'm patented, I tell you. Patented!"

The comic book was cancelled before Goitrous Goof ever saw print.

And although the kid wasn't always sure what Robert meant, the kid felt good knowing Robert was happy.

Butcher, baker, and comic book maker... everyone has their job to do, their work to make —

We hope this book makes *you* happy too.

—*Jim Simon*

BELOW: *Simon & Kirby's* Fighting American *began as a straight adventure title but soon became a hilarious satire featuring the Cold War Warrior's battles with the oddest group of nasty villains this side of Dick Tracy! This panel detail is from F.A. #1. ©2003 Joe Simon and the Estate of Jack Kirby.*

In the Beginning

p in the sky — able to leap over tall buildings in a single —

"Clown!"

It was ten minutes to five on a gray Tuesday afternoon in 1948. A crowd was gathered on Lexington Avenue between 45th and 46th streets in New York. The crowd had their eyes turned up to the roof of the Grand Central Palace Building across the street. Some of the observers glanced at their watches to check the time, then quickly refocused on the roof so as not to miss the attraction.

Suddenly a chauffeured limousine pulled up. A well-dressed, middle-aged man stepped out of the car. "Anything happen yet?" he asked the group.

Someone answered, "No sir. He hasn't shown up."

The faces of the crowd were tense, reflecting anxiety; they were waiting. The tailored man, comfortable in a Chesterfield coat, lit a cigarette and took his place in the group, eyes raised to the roof high above. "This isn't good for comics."

A younger man ventured, "Damn inconsiderate of him, pulling this stunt when it's time to go home."

"This is no time for sarcasm." The man from the limousine stamped out his cigarette on the pavement. "It's going to cost all of us."

A patrolman walked over to the chauffeur: "It's the rush hour, buddy. You're blocking traffic."

The chauffeur implored the officer for just a few more minutes. "I want to see him jump," he said.

"You want to see *who* jump?"

The chauffeur turned his eyes up to the roof—. "Superman. He's going to kill himself —

Below: Detail of Fred Ray's patriotic cover art to Superman #14 *(Jan.-Feb. 1942). ©2003 DC Comics.*

and the whole damn comic book industry!"

That stark afternoon causes every person involved in comic books to remember Jerry Siegel and Joe Shuster. Still in their teens, the two had come to New York from Cleveland in the mid-1930s to peddle an idea about a baby from the dying planet, Krypton. Sent to Earth in a space capsule by his parents, the baby grew to become a superhero with X-ray vision, the ability to leap over tall buildings, outrace speeding bullets, move mountains and be impervious to physical injury. Siegel and Shuster had developed their product with hopes of selling it as a newspaper comic strip.

The two teenagers submitted *Superman* along with other strip ideas to all the syndicates, but they were rejected across the board. They tried other outlets — book and magazine publishers, but the only person who "came to attention" was the Major.

The Father of Our Comics

If World War One contributed anything especially noteworthy to the history of comic books, it was Malcolm Wheeler-Nicholson, a former Army Major who in 1935 was publisher of the first comic book containing original material. His *New Fun Comics* showcased a collection of funny animal stories.

Siegel and Shuster offered the Major several strips they had developed for syndication in addition to their concept for a superhuman hero. The Major passed on "The Man of Steel," choosing instead such unmemorable strips as "Doctor Occult," "Henri Duval," and "The Federal Men."

Artist Creig Flessel, who at 26 years of age said that he felt like the old man of comic books, worked at Major Nicholson's National Periodicals (later known as DC, or Detective Comics) with editors Vince Sullivan and Whitney Ellsworth, and an associate of the Major, Harry Donenfeld. On the day Siegel and Shuster's *Superman* feature, still unpublished, arrived at the office, Flessel said that everyone thought it was crazy — the story about a guy with a cape, eyeglasses, that Superman costume... made everyone laugh, especially the Major.

Major Wheeler-Nicholson, a former calvary officer, was quite a character in his own right. He had been part of the army of occupation that went into northern Russia after the first World War to help clean up there, and he stayed only long enough for the Major to marry the

Lady-in-Waiting to the Queen of Sweden.

On June 5, 1922, at Fort Dix, N.J., the Major had been found guilty by a court-martial of violating the 96th Article of War for having written a letter to President Harding and for giving that letter out for publication. The letter charged that "Prussianism" existed in the Army. He was sentenced to a fine of "50 files," which meant his reduction in that number on the promotion list.

On the other two charges on which he was tried, that of being absent without leave and that he used deceit in procuring passes, Major Wheeler-Nicholson was found not guilty by the court-martial.

Back in civilian life, he became a fairly successful author of pulp stories and military novels, before and after his career as publisher.

The Major marched among his office cohorts sporting spats, an old Chesterfield coat, a beaver hat, a mouthful of rust-colored teeth — brandishing a walking cane in one hand, a briefcase in the other. At his door, a string of process servers seemed to regularly await him.

Harry Donenfeld, who held ownership in the printing and distribution end of the business, became increasingly annoyed with the Major's poor management, and offered to bury the printing bills under the condition that the Major resign. The Major refused. Donenfeld offered the Major buyout money and a token salary to leave the company, but the Major wanted to own it all. In the end, the Major's chaotic management and mounting bills drove him to retreat. Donenfeld and his accountant, Jack Liebowitz, took command.

The short, Scotch-drinking Donenfeld, who dabbled in publishing cheap romance and detective pulps, now was thrust into the business of comic books.

For Siegel and Shuster, the frustrating odyssey of *Superman* continued. They kept revising and resubmitting the strip to the same indifferent syndicates.

An editor from the *Ledger Syndicate* wrote the boys a letter professing that the public had become bored with superhuman characters. The Bell Syndicate failed to see any potential for mass appeal in the

character. Esquire Features, Inc., responded with the terse comment that the strip was lacking in professional illustration.

Yet the day of reckoning would come for Siegel and Shuster and their superhero.

The year was 1938. On the ninth floor of an office building at 480 Lexington Avenue in New York, the flamboyant Harry Donenfeld decided it was time to add a fourth title to his marginally profitable comic book line.

There was one problem. Donenfeld's inventory of cartoon art (mainly reprints of syndicate comic strips) was too low to fill out a fourth book. Donenfeld wasn't deterred. He put the word out to his contacts at the syndicates that he was willing to look at any strips that might be converted to comic books.

Over at the McClure Syndicate, Max C. (Charlie) Gaines was one of those who got the word. He gathered whatever strips the syndicate had abandoned and sent them over to Donenfeld. Among those unheralded offerings were the battered Siegel and Shuster *Superman* strips that McClure had turned down.

Donenfeld pored over Gaines' package of rejects. Without enthusiasm, he picked out the Superman strips and laid them aside. Several days later, Jerry Siegel and Joe Shuster got the news at their homes in Cleveland that their material might be published.

They were ecstatic. Donenfeld's one condition was that the strips be cut apart and pasted, in comic book format, into a single 13-page story so it would fit somewhere within the covers of his new comic book to be called *Action Comics.* Siegel and Shuster would be paid $130. Jack Liebowitz, Donenfeld's shrewd, no-nonsense accountant and general manager, concentrated on the business affairs of Donenfeld's

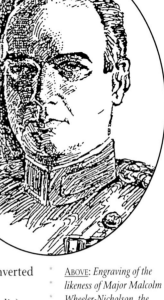

ABOVE: Engraving of the likeness of Major Malcolm Wheeler-Nicholson, the founder of DC Comics and a colorful character in his own right.

INSET LEFT: Writer Jerry Siegel (left) and artist Joe Shuster, the creators of Superman—and, in turn, the genre of costumed heroes in comics— in a caricature drawing by Shuster drawn for the 1942 book, Comics and Their Creators, *by Martin Sheridan. Superman ©2003 DC Comics.*

operation. Before making payment to the boys, he mailed them the company's standard release form. Back in Cleveland, the euphoria of *Superman*'s acceptance by a New York publisher after so many years of rejection was all that mattered to Siegel and Shuster, and without legal counsel the two young men consummated the deal with their signatures.

Action Comics rolled off the presses and onto the newsstands in June 1938.

Superman was alive, finally, but barely breathing. That first issue of *Action Comics* created no fanfare.

The second, third, fourth and fifth issues hit the streets. Again, only minor responses.

Then the sixth issue. And still the same response.

With flagging interest, Donenfeld released a seventh issue. *Action Comics* wasn't losing money, but it wasn't shaking the world, either.

In the publishing business, the sales of a new monthly or bi-monthly title cannot be accurately estimated before the fourth issue is shipped.

Action Comics, issue number seven, was a sell-out.

The rejuvenated Donenfeld initiated a survey by his distribution company, Independent News Corp., to determine what had suddenly ignited the public's demand for this particular issue. The distributor had no sure answer, but one constant kept coming up and that was the mention of Superman. Kids were besieging their local newsstands and mom-and-pop candy stores for more comic books with that Superman character in it.

Upon receiving this report, Superman was splashed across the covers of the next several issues.

On a late winter night that same year, not far from Donenfeld's office, thousands of teenagers were packed into New York City's Paramount Theater. A police squad arrived to maintain order. But when a skinny kid in glasses ascended the stage with his musicians, and began performing, the teenagers erupted, wildly dancing and screaming into the aisles and out onto the early morning streets. The young man was Benny Goodman, and the new music was swing.

In the summer of 1939 the economy continued its comeback. Parents shook their heads as their daughters in bobby socks and saddle shoes jitterbugged to the beat of

BELOW: Siegel & Shuster's seminal comic book character, Superman, was originally pitched as a syndicated newspaper strip. In fact, the first episodes in Action Comics *were reformatted strips from their presentation. Here are dailies from week two of the comic strip. ©2003 DC Comics.*

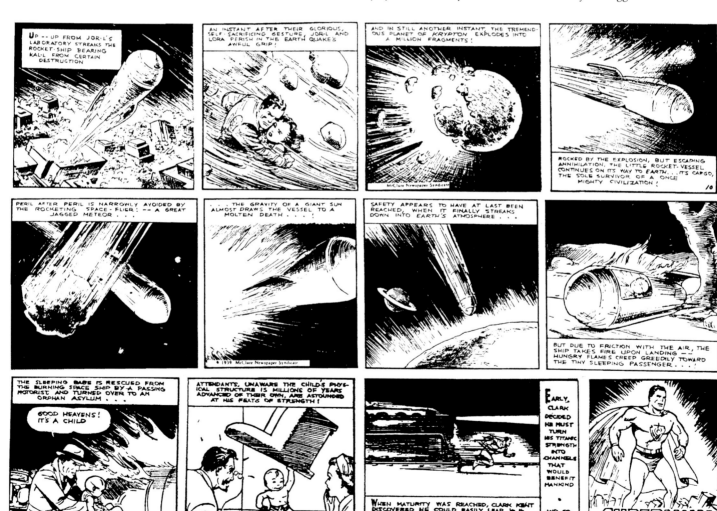

jukeboxes with boyfriends in ice cream parlors all over America.

Superman commandeered his own comic book, and exploded into a huge commercial success. Sales reached more than one million copies per bi-monthly issue — at the time an unheard of sales record for a comic book, and an event that gained the attention of publishers who heard the cash registers ringing in the promise of the lucrative new comic book industry.

The Super Rebellion

Superman was providing a comfortable living for Jerry Siegel and Joe Shuster, and their bylines made them celebrities as their brainchild grew in popularity. Through the years, however, Jerry and Joe were called on to do less actual work. As Donenfeld's publishing house flourished, he installed new editors, artists, and writers to work on Superman. Superman was now on radio, in newspaper comic strips, children's books, toys and games.

Jerry Siegel was in his early twenties when he entered the Army in World War Two. A stout, 5-foot, six-inch bespectacled man, his shrill voice and confident manner gave little hint to the frustrations that were building in him. Although he had done his job inventing the big moneymaker, Superman, he grew increasingly unhappy over giving away his creation for peanuts, with his future in the hands of Harry Donenfeld, a man of changing moods.

Joe Shuster, too, languished while Donenfeld's company — DC Comics — grew rich from the Superman phenomenon. The small, earnest artist, like Siegel, had little professional expertise, and it was rumored that his thick eyeglasses were strained to a hopeless cause. Capable artists were teaming up to turn out the many Superman comic books, with logical shading and respectable anatomy. Joe Shuster was becoming obsolete.

Together they decided to fight Donenfeld in court, filing a $5,000,000 damage suit against the Detective Comics Corporation, now publishers of over 30 comic book titles, of which *Superman* was the leader.

The publisher worried that exposure of the original contract and lopsided profit sharing would disclose unfair practices. Public sympathy would be on the side of the two creators, and Donenfeld's publishing business could collapse if the courts awarded Superman to Siegel and Shuster.

But despite their determination, the young men could not match the huge legal resources of their adversary. Besides, they had signed a release form stamped on the back of each check they had received, surrendering all rights forever. Consequently, they settled out of court with Donenfeld for a sum much smaller than they would have received if they had continued working for the company. And the fight, of course, cost them their jobs with Donenfeld's organization. Now they had nothing.

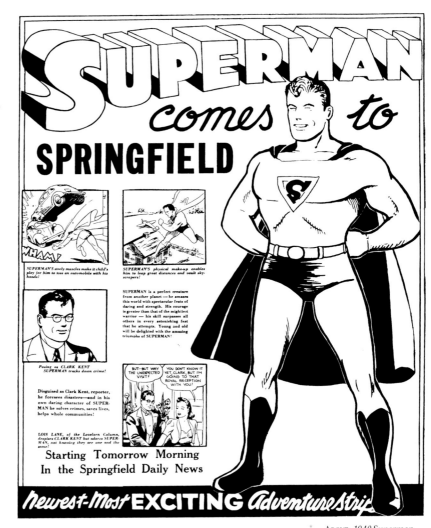

After the legal bout, Joe Shuster tried to earn a living elsewhere, but he was unable to compete with the more competent artists flooding the comic book industry.

Siegel, however, continued to harass his foe. He penned raging letters that were mailed to Donenfeld's competitors, announcing his intentions to bring down the wrath of public opinion on his former publisher's back.

One of these letters, allegedly written and signed by Siegel, proclaimed that at five o'clock on a stated day, he would dress in a Superman costume and leap to his death from the roof of the Grand Central Palace Building.

And it was on that day that the crowd of illustrators and comic book employees congregated on New York's busy East Side, waiting to see if the dramatic suicide would actually be carried out... but the heavy-set figure of Jerry Siegel never appeared.

Postscript: For almost 40 years, the bylines of Siegel and Shuster no longer appeared on the Superman publications, newspaper strips and other ventures. Generations of Superman enthusiasts grew up without knowing their hero had been invented by two struggling young men from the Midwest who spent the majority of their later years in poverty and poor health.

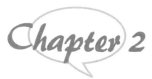

Growing Up Before Comic Books

On the late 1920s and early '30s, the funnies, as newspaper comic pages were known, were at the peak of their popularity. Radio was extremely primitive. There were no networks, and of course there were no such things as portable radios. Television existed only in science fiction pulps and novels, along with space ships and men landing on the moon. There was even a sizeable constituency who still believed the earth was flat.

In my hometown of Rochester, N.Y., I remember the first talking picture. It was Al Jolson and Ruby Keeler in glorious black and white in *The Jazz Singer*. Jolson played the role of a cantor's son who abandoned his Jewish tradition to perform the modern jazz, sometimes in blackface. Only part of the picture was in sound and the audience scanned the theater to guess where the phonographs were hidden. A huge crowd gathered around the theater entrance. When the audience filed out after the performance, the people outside asked if it was really true that the screen could talk and play music.

The media, in the main, consisted of print. The *Saturday Evening Post* came out every Thursday. It was large and colorful and it cost a nickel. Newspapers cost two cents and most were thriving. Every city had several daily newspapers. There were enough readers to support most of them very comfortably. For local advertisers, it was the only game in town. Nobody had thought of advertising on a Victrola record. The newspapers vied extravagantly for the more popular comic strips, which could do wonders for their circulation figures.

It was the highlight of the week when my sister and I finally had our turn at the Sunday funnies with their spectacular color cartoon pages. We sprawled on the carpet in the "front room," as the living room was called, devouring each cartoon strip. Sunday evenings we went back to the funnies again under the light fixtures on the side walls, which had recently been converted from gas to electricity. We lived in a first-floor flat, which doubled as my father's tailor shop. This made it a business necessity to invest in the modern electrical luxuries.

My favorite funnies were *Foxy Grandpa*, which I thought was very funny, about a small, sly grandpa who always wound up outsmarting the kids; and *Minute Movies* by Ed Wheelan, a strip that tried to approximate a movie serial.

When my father brought home one of those "new-fangled" crystal radios, we thought this was as far as mankind could go. The new marvel consisted of a small cardboard box, about four inches square, containing some quartz-like crystals with very thin wires coming out from under the crystals. If one scratched the crystal in the right place with the wire, it actually produced voices or music being broadcast from somewhere in the world. The sound might last for a few minutes and soon fade, at which time one would scratch other spots again and again until it happened once more.

The night of the heavyweight championship fight between Jack Dempsey and Luis Firpo, "The Wild Bull of the Pampas," a group of us kids joined a crowd of people outside the home of a man who had recently bought one of the new floor-model radios. We stood as close as we could get to the man's white picket fence, listening with intense excitement to the fight broadcast that was intermittently interrupted by loud static. When the sound faded, the obliging owner filled in the missing part with a mega-phone from his porch. The night resounded with the cheers of the crowd when Dempsey came back in the second round to knock out the Argentinean after being himself bullied through the ropes in the first.

Another big event was the baseball world series. A local newspaper, Gannett's *Democrat & Chronicle*, set up a huge billboard downtown on the flat roof of a one-story building. A baseball diamond was painted on the billboard along with an inning-by-inning scoreboard. Men stood on the roof below the billboard raising long poles to

BELOW: Another favorite of young Joe Simon was Chester Gould's detective strip Dick Tracy. *This detail is from the cover art of the comic book* Dick Tracy #125, *published by Harvey Comics. ©2003 Tribune Media Services, Inc.*

ABOVE: *The popular comic strip* Buck Rogers in the 25th Century *was the precursor of all the space operas to come. This beautiful Sunday page is from 1933.* ©1933 John F. Dille Co.

move different colored thin wooden circles around the bases. These circles represented players on the field.

There was a circle for each player representing his position on the field. If a batter slugged a two-bagger, a man with a pole would hang a circle on second base while the crowd below, overflowing the street and sidewalks, cheered or jeered depending where their loyalties lay.

I was impressed by the inventiveness of the newspaper people who dreamed up this progressive idea, and hoped to become a newspaperman myself some day.

As long as I can remember, drawing was my passion. At Benjamin Franklin High School, I was art director for the school newspaper and our graduating class yearbook. My best work was on the yearbook, where I did art deco full-page tempera illustrations, in multi-grays, for each chapter head; such as Sports, Seniors, Faculty, and so on. Two universities picked up this art for use in their yearbooks. They each paid ten dollars for publication rights. The entire faculty held a meeting to determine whether the school should keep the money or it should go to me. I won by a single vote. It was my first paid artwork and my professional career was born.

The growing development of "The Big Box," as radio was called then, had been making strong inroads on the American culture. Radio was fast becoming entertainment for the masses. People were skimping and saving to spend their hard earned money on the new sensation. Movie theaters

INSET RIGHT AND BELOW:
Young Joe Simon's "splash pages" for The Key, *the yearbook of Benjamin Franklin High School, Rochester New York (1933).*

started to feel the financial pinch as families stayed home to listen. For the young, the new medium offered new worlds of enticement.

Turn on the Big Box and you could hear young Jack Armstrong, the All-American boy, scoring touchdowns for his cherished Hudson High, outdoing bad guys, and reminding the kid listeners to gobble down their Wheaties. Jack also had his songs — "The Wheaties Song" and "The Hudson High Song" — the former a singing commercial for the breakfast of champions, the latter a wave-the-flag for Hudson High song. Kids could get a secret society whistle ring with Jack Armstrong's code (decipher the secret messages!), as well as an exotic-appearing map that charted Jack's adventures with the Dragon Talisman. Somehow the location of Tibet seemed mysterious and thus became a popular hangout for characters who could bestow a kid with impressive sudden powers.

Another favorite was Tom Mix, the "Old Straight Shooter." Tom implored his strip, radio and movie fans to

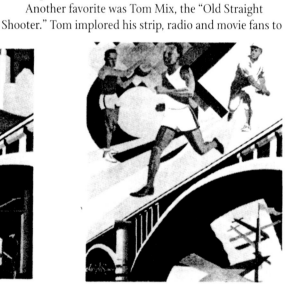

S E N I O R S S P O R T S

F E A T U R E S F A C U L T Y ORGANIZATIONS

send in Ralston Purina cereal box tops for prizes. Ralston offered so many Tom Mix premiums they could have been in the novelty business. The right number of box tops could get you a siren ring, an initial ring, the much cherished Tom Mix Decoder ring, a combination compass and magnifying glass, a whole slew of badges, a flashlight, pocket knife, and a toy replica of Tom's very own six-shooter. You could even win an autographed photo of Tom and his wonder horse, Tony. Of course, there were also the "Straight Shooters" theme song and Pledge of Allegiance (each with its own certificate, in case you had to prove it to someone!). Ralston's most sought-after premium was a full-page chart of the old Straight Shooter's outline marked in alphabetic code. This gizmo was titled "TOM MIX INJURIES" — and, from a-to-z, it illustrated every part of Tom's anatomy that had been injured fighting the good fights.

"Danger and difficulty have never daunted Tom Mix, nor broken bones stopped him. He has been blown up once, shot 12 times, and injured 47 times in movie stunting. The chart shows the locations of some of Tom's injuries. (X marks fractures; circles bullet wounds)."

And if that wasn't enough, the bottom of the chart stated:

"Note: Scars from twenty-two knife wounds are not indicated, nor is it possible to show on the diagram the hole four inches square and many inches deep that was blown into Tom's back by a dynamite explosion."

No wonder straight-shooting Tom was known also as the "Solemn Cowboy"!

Bullets and other objects that went bang in the strips might not have stopped Tom Mix, but Chester Gould's *Dick Tracy* exploded with the real thing in the Depression '30s as a no-nonsense cop who actually shot evil-doers dead. Right there in the strip. In front of your eyes! It was one of the earliest — if not the first — graphic illustration of a violent killing in the strips.

Gould's audience turned out to be of all ages — a young J. Edgar Hoover was a big fan — as a Depression-weary public fed up with gangsters cheered the jut-jawed detective right from the earliest strips when Dick Tracy avenged the murder of his fiancée's father, Jeremiah Trueheart.

In the movie serials the women were beautiful and

the audiences were awed by the daring-do of *Flash Gordon;* though they'd later giggle to discover that heroic Flash, portrayed by Olympic swimming champion Buster Crabbe, was forced by Hollywood producers to peroxide-bleach his hair for the role.

Flash's closest competitor was Buck Rogers, zooming among the planets with sexy co-pilot Wilma Deering and an array of futuristic gizmos that boggled the minds of his many fans. It may have been the drab 1930s — a time before television, stereo, or even ball-point pens — but anything seemed possible while reading the *Buck Rogers in the 25th Century* comic strip or turning on the Big Box to overhear the *ZAP* of Rocket Pistols and *KA-BOOMs* of bombs while Buck and his Solar Scouts bravely battled the villainous Kane.

In an attempt to lose some of our daily weariness during those years, Americans had discovered escapist entertainment. And if you were young, or at least young at heart, these characters, along with Tarzan, Popeye, Blondie, Terry and the Pirates, and so much more, brightened the world around us.

America was smiling again, thanks in part to movies, radio, comic strips, and towards the latter half of the '30s — if by then you could afford to spare a dime — something new called comic books.

INSET LEFT: *Flash Gordon and his arch-enemy, Ming the Merciless, have at it in this panel detail from Alex Raymond's extraordinary Sunday newspaper strip.* ©2003 King Features Syndicate, Inc.

BELOW: *Film star Tom Mix saddled on his trusty steed, Tony. The Western adventure hero remains the most popular cowboy screen idol of them all.*

Chapter 3

Working on the Newspapers

It was 1932 at the height of the Great Depression when I graduated from high school and started to read the help-wanted ads. I responded to an ad in the *Rochester Journal American* seeking an "assistant art editor." With samples of my high school work and some other art, which I had done *gratis* for the Rochester Chamber of Commerce publications, I bicycled downtown to the *Journal*, where a copy boy was assigned to take me to the art department down the hall. A single sign in a simple thin black frame hung on the wall. It was a message from Henry Ford congratulating the employees for working at William Randolph Hearst's newspapers, and extolling the All-American principles of Mr. Hearst.

A man who appeared to be in his mid-thirties was seated with his back to the wall at a drawing table, working feverishly on a photograph, his brush flying from an inkwell to a coffee can half filled with muddy water, to the drawing table. In front of him was an empty chair tucked under another drawing table. The wide window sill to the left of the drawing tables was littered with newspapers and photos faded by time and the sun. High iron radiators hugged the window sill. At the right of the drawing tables were two small taborets holding paint tubes, the coffee cans, an inkwell and brushes. The paint tubes were marked "Brush Grey" They were marked one to five. I learned later that "#1" was a very light grey, a shade darker than white. They ranged to #5, which was a shade lighter than black. Two large metal air tanks, approximately five feet high, stood like sentinels next to the taborets. At the top of each tank, brass fittings held a pressure gauge. A quarter inch rubber hose led from each gauge to an instrument the size of a large fountain pen, which hung from a small holder screwed into the drawing table. This pen-like object was a Paasche airbrush and it was to play a big role in my career.

The artist, stooped over his drawing table, was doing wondrous things to the news photo. His airbrush sprayed the brush grays, thinned to the proper consistency, over background shadows, bringing contrast to the picture that hadn't been there before. The man hurriedly placed a piece of cotton in his mouth, then rolled it onto the top of his brush handle, forming a Q-Tip of sorts. With this saliva-moistened "thingamajig," he skillfully wiped excess paint from the photo.

Another man in a sweat-soaked faded blue apron hustled in

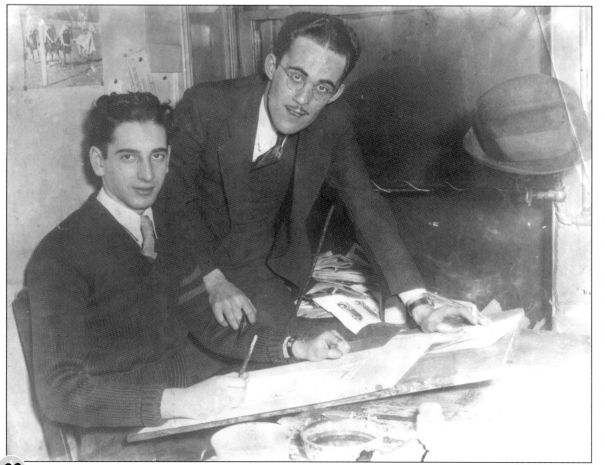

from a room across the hall that was marked "Engraving," took the photo and dashed back. He gave off a strong odor of acetic acid tempered with body odor.

Now the artist lifted his head for the first time and confronted me. It was a moment to remember. He had wild blue eyes, a square patch of a moustache and light brown hair that formed a cowlick falling over his forehead. The man was a dead ringer for Adolf Hitler. "I'm Adolph Edler," he said.

Adolph shut off the compressed air by turning a round valve on the tank. He rinsed his brush in the muddy jar, then wiped it on a rag that was tacked to the right side of his drawing table. After wiping his hand on the same rag, he shook my hand. "My assistant quit," he sighed. "The fool wanted more money. He had his name in the paper so much it went to his head." Adolph shook his head. "Maybe he's punch drunk," he said sadly.

"Are you talking about Al Liederman?" I asked. I had seen Liederman's cartoons and bylines many times. He was also a heavyweight boxer who was known as "The Fighting Cartoonist" and often "The Bleeding Cartoonist" in the semipro fight cards that were held weekly at the Elks Club. Al was famous in Rochester.

"Yeah, Liederman," Adolph said. "An artist today is lucky to have a job. He'll find out."

Adolph looked at my samples. "We've had several applicants for the job," he said. "If you don't hear from me in a couple of days, give me a call."

I left in despair. "No way Adolf Hitler is going to hire me," I moaned as I bicycled home.

It turned out I was wrong about Adolph. He did hire me... at the handsome salary of fifteen big ones a week, which was considered a substantial salary for the times.

My first week on the job I discovered why Adolph sat at the back of the room. To watch me. Every minute. He was a hard-driving taskmaster who drove me like a mule and considered it a personal affront if I paused at my work during the periods when we had to meet a deadline for one of the three daily editions. At these times he worked himself into a state of near-hysteria. The man was intense and at times almost hostile, yet he was a master at his trade who taught me all I would ever need to know about reproduction, scaling and cropping photos as well as making photo layouts. The layouts, in the fashion of the day, were extremely ornate with inked borders, round and oval with swirls and designs in the "holes," meaning any empty spaces.

Under Adolph's tutelage I mastered the art of retouching. Mr. Hearst had established certain rules we had to memorize. One rule was non-negotiable — the inside of a woman's thighs was never, never to appear in print. If we had such a picture, it was required that a skirt or dress be painted over the offending area.

In his mellower moments, Adolph told fascinating stories of the years only recently before my time when newspapers sent out sketch artists instead of photographers on assignments. The old engravers also remembered and said they were better times because the line engravings from the drawings were simpler to make than the damn halftones needed for the printing of photographs.

On weekends, Adolph would hop into his Model-T Ford and drive to the country to a "nudist camp." Some of the reporters confided that it was actually a German American Bund camp, one of the many Nazi-backed Fifth Column movements that were springing up abundantly in the upstate countryside. To my knowledge no one ever did confirm that our art director was actually involved in this nefarious movement. If he was, we chuckled,

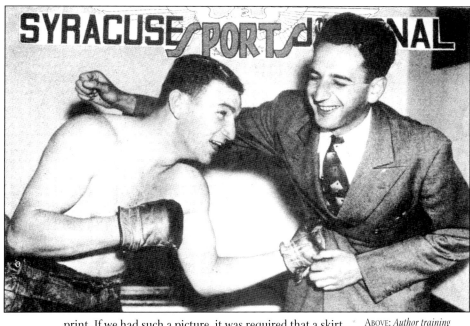

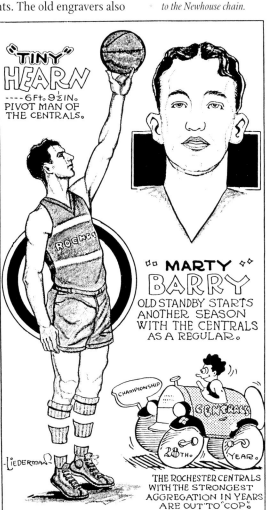

"TINY" HEARN
----6FT.9½IN.
PIVOT MAN OF THE CENTRALS.

ROCHES

°° MARTY °°
BARRY
OLD STANDBY STARTS ANOTHER SEASON WITH THE CENTRALS AS A REGULAR.

CHAMPIONSHIP

THE ROCHESTER CENTRALS WITH THE STRONGEST AGGREGATION IN YEARS ARE OUT TO "COP".

Adolph, with his name and resemblance to the other Adolf, would have been some kind of hero there.

Adolph frequently received mail from friends in Germany, which disturbed him. They related stories of atrocities and the persecution of Jews that were becoming a fact of daily life in the fatherland. Adolph was perplexed and saddened. This was not the glory he had perceived for the resurrection of his ancestral homeland.

Soon after, Adolph's appearance changed. His hair was slicked back and his moustache was allowed to expand until it no longer resembled Hitler's small patch beneath his nose. He was ours once again, an American Adolph.

During the slack moments between our daily production chores of retouching and pasting up photo spreads, I was permitted to do sports and editorial cartoons which the paper then published. It was a great thrill to see this art with my byline in publication and eventually, as I improved, the editor sent me on assignments to cover sporting events.

I sat ringside in the press section of the weekly boxing shows, where more than once my clothes were splattered with the blood of Al Liederman, the Fighting Cartoonist who had preceded me at the *Journal*. Al never did bother with the sweet science of self-defense. He always emerged victorious in spite of this deficiency. I did a cartoon feature on Al, which appeared in the

Sports section. Al said it was his blood and he should be paid for the space. I told him it just didn't work that way.

After two years at the *Rochester Journal,* I received an offer from the *Syracuse Herald.* Forty-five bucks a week plus moving expenses. It was goodbye to Adolph and off to Syracuse, 90 miles east, at the ripe age of twenty.

The first day at my job on the *Syracuse Herald* a young man about my age, in a neat, dark, well-pressed suit with pointed black shoes (adorned with white "spats") and a bow tie, appeared in the art department where I was working in my shirt-sleeves. He beckoned me to step into "his office." It was an impressive executive office. The young man leaned back on a leather chair, looked me up and down, picked up a pen from the glass ink holder and started scratching on a sheet of typing paper in a very managerial manner.

"I'm James Miller," he said. "Tell me something about yourself — your goals, your ambitions."

"Another interview," I was thinking. I had already been interrogated by the Managing Editor.

Abruptly, loud shouts from the City Room drifted into our conversation: "Boy!... *BOY!*"

James Miller dropped his pen, splashing ink on the desk, and scampered out the door. I stood in the doorway watching. A rewrite man handed James some typed pages of copy. "Where the hell you been, Jimmy," he growled. "We're going to press in half an hour!" On his way to the pressroom, Jimmy, the *Herald*'s copy boy, passed me, grinning sheepishly. I liked him and we were to become close friends.

Al Liederman, the Fighting Cartoonist from Rochester, was now working for Hearst's *Syracuse Journal American*. We were friendly rivals, competing to outdo one another with editorial and sports cartoons. While Al was still bloody but unbowed in the ring, I thought I could be a good match for him in print. The contest didn't last too long. Al soon received a telegram from Bruce Shanks, one of the nation's leading editorial cartoonists, who offered Al a job at the *Buffalo Evening News.*

Liederman felt that the move was a step up, both career and money-wise. It was like a game of musical chairs when Hearst's *Syracuse Journal American* offered me Al Liederman 's job as art editor at sixty-five dollars a week. I accepted without hesitation.

My jubilation at this rapid climb to fortune was to be short lived, however, as the all-consuming popularity of radio attracted more and more advertisers. Newspapers staggered from the loss of revenue while we learned a new word — attrition. Hearst was suffering financial reverses and his empire was crumbling. We were saddened to learn that the *Rochester Journal American* shut down and, soon after, we were devastated when the Newhouse chain came to Syracuse, bought out the three local dailies, and consolidated them into one afternoon and one morning paper. *The Journal* closed its plant. I was out of a job.

"I HAF CHOPPED WOOD ON GABE'S FARM IN SUMMER AND SKIED IN WINTER, UNTIL I AM IN PERFECT SHAPE!"

HANS GAVE US AN EXHIBITION ON THE ELUSIVE STICKS — HE COULD HOLD HIS OWN WITH THE BEST OF THEM!

"BEAT PASTOR? HE WILL BE EASIER THAN MY LAST TWO FIGHTS!" THE LIKEABLE AUSTRIAN, WHILE ANYTHING BUT BOASTFUL, IS COCKSURE OF HIS SUPERIOR FIGHTING ABILITY!

HANS HAVERLICK

SYRACUSE'S ADOPTED HEAVY AIRS HIS VIEWS ON MR. PASTOR BETWEEN SPARRING PARTNERS AT BRADY'S GYM... HANS WORKS HARDER IN TRAINING THAN MOST BOXERS WORK IN THE RING!!

"I WILL SET HIM UP FOR THE KILL WITH MY LEFT. IT WILL BE EASY!!"

"I SPARRED WITH PASTOR WHEN HE TRAIN FOR LOUIS — HE COULD NOT HIT ME!!"

BOB PASTOR

IF YOU LISTEN TO HANS, THE HIGH RANKING NEW YORKER IS LITTLE SHORT OF A BAT-BOY IN THE INTER-NATIONAL LEAGUE

JOE SIMON

"I WORK ONLY TO KNOCK THIS PASTOR OUT — IT WILL BE A SHORT CUT TO THE TOP"

DEMO CRACY

"A DOUGHTY SWORD FOR THE CAUSE OF RIGHTEOUSNESS!!"

DR. DAVID RHYS WILLIAMS "A MODERN KNIGHT!"

—SIMON—

JOE SIMON

THIS PAGE: More Simon cartoons for Rochester and Syracuse newspapers.

IMMEDIATE LEFT: Tap dancer Bill "Bojangles" Robinson.

New York, Here I Come

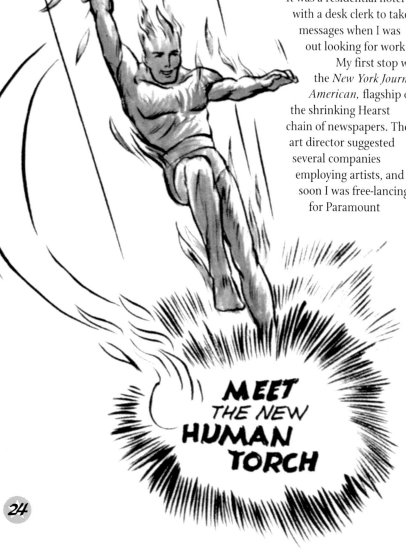

MEET THE NEW HUMAN TORCH

I was 23 years old when I decided to abandon Syracuse for the big time — New York City.

I started out in my Essex automobile, filled with the sense of excitement and adventure young people feel upon heading for Manhattan for the first time.

In Syracuse I had learned that college bulletin boards were a good place to find decent lodgings. At Columbia University, I found a list of rooming houses and soon decided on a place called Haddon Hall, in Morningside Heights just off the campus. It was a residential hotel with a desk clerk to take messages when I was out looking for work.

My first stop was the *New York Journal American*, flagship of the shrinking Hearst chain of newspapers. The art director suggested several companies employing artists, and soon I was free-lancing for Paramount

Pictures, working above the old Paramount Theater on Broadway, retouching studio publicity photos.

I worked with several other artists in a large room crowded with desks and drawing boards. Through the magic of the airbrush "gun," we erased wrinkles, shaved off pounds, and rounded bosoms (bosoms were big even then). I retouched some of the most notable bosoms in pictures — Gloria Swanson, Joan Crawford, Bette Davis. Good bosom men got lots of work and were considered experts. I could hold up a sagging bust line with the best of them. However, it was tedious, eye-straining work. I didn't want to make a career of retouching, so I kept on following leads for more creative work.

First, I bought a new, shiny leather portfolio to hold the cartoon and illustration samples. This small sign of affluence would, I believed, stamp me as a successful artist. So armed, I started out making the rounds of publishing houses. But finding permanent work was difficult. Even in those days, publishers sought specialists. They wanted an artist who could retouch photos, or lay out pages or sketch illustrations, not someone who claimed he could do all three. To them I was a country doctor — a jack-of-all-trades, master of none.

Art editors set aside one afternoon a week, customarily Wednesdays, to look at samples. A secretary or apprentice art editor would screen the samples first, dismissing the incompetent to avoid wasting the big chief's time, or in truth depriving him of the pleasure of insulting the poor peons who waited around for hours in a stuffy, windowless room which hadn't yet considered air conditioning.

On Wednesday afternoons, in publishing house waiting rooms all over New York City, artists would recognize familiar faces again and again. Many friendships sprouted in these waiting rooms.

One grizzled old practitioner sat staring at me, smiling as if he were seeing his own past.

"Just out of school?" he asked.
"No... I've been working a few years."
"New in town, right?" he persisted.
"More or less. Does it show?"
I was losing confidence.
The old artist extracted a thin, flat box from his breast pocket. He took out a Turkish cigarette and lit it. It

smelled like rope. He offered the box around the room. "Fag, anyone?"

Some accepted his offer.

"Half of these idiots don't know good art from bad," he puffed. "They're just kids or goddamn secretaries."

"So... ?"

"So these asses look at your spanking new patent leather portfolio and they got you pegged as a beginner. A rank amateur, buddy." He kept puffing at the rope. Other artists had now lit up their cigarettes and pipes. The stuffy room was a war zone. My burning eyes went to the large manila envelope the old man held between his legs. The comers were bent flat. It was splattered with paint stains. I could swear I recognized some mustard. Beneath all those stains, his name and address were lettered quite artistically, but that could have happened decades ago. He pointed at one streak that ran vertically down the edge. "Piss," he grinned through brown teeth. "I get plenty of work because of this piss, buddy." I thanked him. Another trick-of-the-trade mastered.

The following Wednesday afternoon I fitted my samples into a large manila envelope that I'd carefully smudged to give it a 'don't-give-a-damn' look. It must have convinced someone. At Macfadden Publications I hit a little pay dirt.

Macfadden published a quality line of slick magazines including *True Story,* true detective magazines, women's confession magazines and a wide assortment of specialized publications.

I was passed through the "screening idiots" to Harlan Crandall, their suave, personable art editor. He assigned me to do small illustrations and "spot" drawings of kitchen utensils, furniture, women's hairstyles, guns. The purpose of these little spots was to decorate raw type pages so they wouldn't be boring. The work was free-lance.

Occasionally Harlan presented me with a choice assignment — a half page illustration for one of the stories in the true detective magazines. Such illustrations were expected to be very slick and photographic.

Illustrators were required to hire professional photographers who would supply professional models to pose for the scene from sketches furnished by the illustrator. The illustrator would supervise the shooting,

not unlike a movie director. He would then copy the photo print faithfully for his final rendering. This procedure was adamant. Art directors were known to reject an illustration if an artist neglected to submit the photograph along with the finished rendering. Why they didn't just use the photo itself escaped me.

Artists were abundant but only a handful made it to the top. These few became rich and famous.

Artists such as James Montgomery Flagg and, before him, cartoonist John Held, Jr. were celebrities, but the glamour often vanished abruptly as different styles became popular. One day an artist might be in vogue — the next day a has-been.

But this was another world. I accepted the truth that my work wasn't remotely up to the standards of these lofty practitioners of the art, so I was content to churn out the little pen and ink "spots" for Harlan Crandall.

There was one thing in my favor. Speed. I always delivered the job a day or two after the assignment.

"You work pretty fast," Harlan observed.

I explained that speed was a necessity for newspaper work.

"There's a new art field opening up," Harlan said. "Comic books. It might be right up your alley."

He wrote an address on his memo pad.

"Why don't you go see the Colonel and find out what it's all about."

"The Colonel?"

"Don't worry,

kid, they won't draft you. You're too skinny."

Harlan patted my bony shoulder.

Funnies, Incorporated

Funnies, Inc., was in a tired, walk-up office building on West 45th Street, off Times Square. It had worn, concave marble steps and a dimly lit hall. The neighborhood was run down. I wondered how many more years the row of buildings would stand. The company offices consisted of two large rooms dotted with shirt-sleeved artists, bare wood floors, and a very large stained table on which ink bottles and paint jars fought for space with piles of cardboard drawings.

In a corner, huddled over an ancient typewriter, a husky, gruff-looking youth identified himself as a writer and editor. His name was Mickey Spillane. A smaller office was the domain of Lloyd Jacquet, a pleasant, reserved man in his early forties who was, so to speak, the proprietor. Jacquet, I learned, had a regular job with the McClure newspaper syndicate and operated Funnies, Inc., in his spare time. He had been the first editor for Major Malcolm Wheeler-Nicholson.

Dressed in conservative English tweeds, a gray, checkered vest, and wearing spit-and-polish black shoes, Jacquet blended with the battleship gray color of the walls and the straight-backed chair he offered me. A former Army officer, his appearance commanded respect.

"Call me Lloyd." He puffed hard on a straight ramrod of a pipe. "Harlan Crandall phoned about your work."

Sitting there, I thought of another bit of advice Harlan gave me as he handed the slip of paper with Funnies Incorporated's address on it: "When you go there, just remember one thing — don't try to be a Rembrandt. It's not that kind of business."

I expected Jacquet to criticize my samples. Instead he said, "I've seen your work. Crandall showed them to me.

"We put together comics for publishers," he continued. "They don't want to hire an editorial staff, so we do that for them. We have several different publishers that take our work. If they like yours — story and art work —

you'll be paid $7 a page. Since each feature runs about six pages, you'll get $42 for each accepted feature soon after publication."

Finally Jacquet caught his breath. I thought it over quickly. It sounded reasonable. Publication for my newspaper work had always meant the next day. I didn't realize that in comic books, publication usually averaged three or four months after the creative work.

I asked, "Who pays me?"

"We pay you. We are an agency. We package the art and editorial contents for the publisher. In other words," Jacquet explained patiently, "we act as a sort of free-lance editor."

"Then I don't understand why the publisher, instead of you, must approve my feature."

Mr. Jacquet continued unruffled. He spoke to me as one would speak to a child. I had the feeling that he thought of all comic book artists as children. And perhaps he wasn't far wrong.

"The publisher has a very large investment," he said. "The mortality rate of comic book titles is high. If this were a more stable business he would hire his own staff editors. But first, it's not easy to find people with the know-how, and second, the publisher would feel bad if he had to drop the comic book business and fire the editors."

I knew that he was avoiding my question, but it wasn't worth pursuing at the moment. For now, the deal he offered was worth a try. I went home to my room and worked for two days and nights on my first venture, a seven-page Western. It was not memorable, but the faceless publisher accepted it without changes.

This all had taken place in four days and when I dropped by to see Lloyd Jacquet, he was extremely cordial. "I've got another assignment for you. One of our biggest clients, Martin Goodman. He saw your stuff and liked it."

Even more than money, an artist likes to be loved. I was ripe for any assignment.

Jacquet explained: "Goodman's got a character called 'The Human Torch.' Roughly, it's about this guy who was set on fire and then learned the secret of turning himself into a flaming torch to fight evildoers. It's quite successful and Goodman wants you to do a character like it for another comic book."

Jacquet showed me a copy of *Marvel Comics*. The drawings were simple but the flaming color of the hero

ABOVE: Marvel Comics #1, the issue introducing Timely's mainstay characters, the Human Torch and the Sub-Mariner. ©2003 Marvel Characters, Inc.

INSET CENTER: Detail of a cover featuring the Human Torch, drawn by Alex Schomberg. ©2003 Marvel Characters, Inc.

made it effective.

"How much like it?" I asked.

"Well, basically," said Jacquet, "all you have to do is make up a character that can set himself on fire."

"And survive," I muttered.

"We live in a world of fantasy," Jacquet apologized.

"It doesn't sound too difficult."

"Oh yes, " Jacquet added, "and he must wear a mask. All the heroes should wear masks."

"How many pages?" I asked.

"This is going to be a lead feature," Jacquet explained. "It could go up to 15 pages. And I want it with lots of action and fire. Fire is easy to draw. You're getting a break."

"Still it's a lot of work," I speculated. "I'd like to present a story line first... at least penciled sketches."

Jacquet was beginning to show his impatience. "That's potatoes," he sighed. "Just give us the red meat. We don't have much time."

That evening I sat in my room at Haddon Hall, ready for work. A drawing board rested against an end table. I surveyed the scene: a pen, a pencil, a small pointed sable brush, a bottle of India ink, a jar of white tempera, a package of illustration board, and a stack of erasers. The character I created was called "The Fiery Mask." His eyes had the power of a flame-thrower. The feature went ten pages and again it was accepted without changes. I was amazed. It was so easy, this work. And although I hadn't yet received any money, I was satisfied that I could make out in this crazy business.

There seemed no end to it. The pattern was to first invent a hero. And after that, to write the story. Complicated plotting wasn't necessary. Few publishers read the copy. They were interested in exciting graphics and action.

The drawings evolved into a stock format. Simplifying the artwork was the most difficult. Slits for eyes, unless the character was to register astonishment or horror — and then the eyes became circles. Heavier lines for the eyebrows, raised for bewilderment, slanting down toward the nose for anger. One thin fine formed the upper lip. A heavier line, indicating a shadow, constituted the lower lip. It wasn't necessary to draw an open mouth when the character was speaking. Almost always, our comic people spoke through clenched lips.

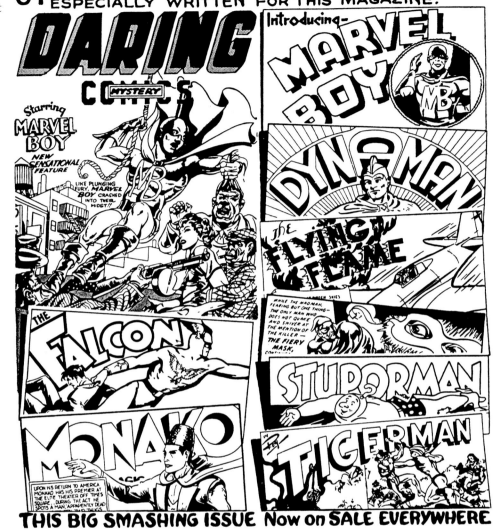

Sketchy lines, even for backgrounds, were out. There had to be an inked outline to hold the color. Action lines denoted movement. Objects in the foreground warranted a heavier outline than backgrounds, to show dimension and depth. One involved scene per page and several close-ups would save time and work. And explosions periodically. They were easy and colorful. As we progressed, we learned the value of extreme perspective. That and the non-stop super-action were to be the hallmarks of the comic book art form.

The stories were lettered in pencil on the drawing paper. Sometimes the drawing was done first and then the copy written to fit the movement.

Finally, the drawings were inked and the lettering penned to fit the speech balloon, a bubbly outline with a pointed end (the tail) which was supposed to end at the mouth of the speaker, but often ended somewhere at his head, eyes, nose, or even his armpits.

The first speaker was supposed to be at the left, but

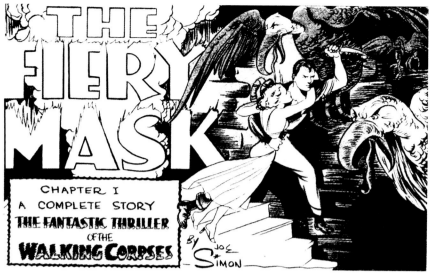

ABOVE: *One of Joe Simon's earliest comic-book assignments was to create the Fiery Mask (a sort-of Human Torch imitation) for Timely Comics when the young professional worked for Funnies, Incorporated. This panel is from the hero's debut adventure in the first issue of* Daring Mystery Comics. *©2003 Marvel Characters, Inc.*

INSET RIGHT: *Trio of typically busy Timely Comics covers, from the early 1940s, produced by the increasingly popular Simon and Kirby. ©2003 Marvel Characters, Inc.*

BELOW: *Before becoming renowned as Marvel Comics, Martin Goodman's comics publishing company was called Timely. ©2003 Marvel Characters, Inc.*

such incidentals were often overlooked, resulting in crossed "tails," a shoddy but common occurrence.

Timely Publications

There was a message for me waiting with the desk clerk when I came downstairs one afternoon. It read: "Please call Martin Goodman at Timely Publications."

How this publisher obtained my phone number was a mystery, although I suspect some employee or hanger-on at Funnies, Inc., was selling the firm's talent list.

Goodman's Timely Publications was located on West 42nd Street, in what was then the McGraw-Hill Building. The offices were business-like and unpretentious, consisting of five rooms: Goodman's living-room-like office, a small waiting room, business and bookkeeping room, and two editorial rooms, one with a barren corner reserved for a non-existent art director.

The business was growing. Established publishing companies were setting up comic departments with their own in-house editors. A major part of the editor's job was to seek out capable and experienced comic book artists and spirit them away from

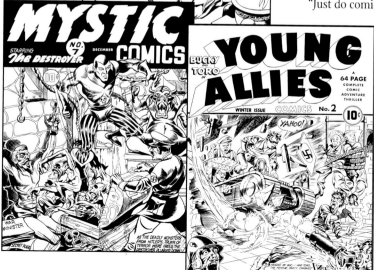

their current clients. There were several reasons for the shortage of comic book artists: first, the pay was too low for the amount of work involved; second, few artists were able or willing to create characters, write scripts, do the lettering and perform all the services involved.

Very few of us were concerned with ownership of the characters.

But as the scope of the industry expanded, creative people were being attracted from other fields, such as the adventure pulps which were losing ground to comic books. A few of these pulp illustrators stayed, but most buckled under the tedious workload and pressure of deadlines.

Martin Goodman was of medium size and spoke softly. A pleasant-looking man, he was in his early thirties, already sporting a head of prematurely white hair. The swivel chair in which he sat was padded with three cushions that served to make him appear taller, although that was not their function. On his desk were the remains of his plain crackers-and-milk lunch.

Martin Goodman, it was rumored, had not continued past the fourth grade in school yet he was an amazingly astute businessman with an uncanny sense of what the public would buy on the newsstands. Like so many of the publishers in his class, he had come up through the ranks of the circulation departments.

Although he gave the impression of being a shy and introverted man, Goodman wasted no time in making his point.

"How much are they paying you at Funnies?"

"Seven dollars a page." I paused, then added, "There's other work around for ten, though." (If there was, I hadn't seen it.)

"I'll pay you twelve."

I asked what he wanted me to do.

"Just do comic books. Come up with new ideas. This business is getting competitive and we can't keep putting out this crap for very long."

This was the one time I knew him to be wrong.

The King of Comics

Will Eisner was no more than twenty when he teamed up with cartoonist Jerry Iger to organize Universal Phoenix, a comic book factory.

As a student at De Witt Clinton High School in New York City, Will had at one time entertained the idea of becoming a stage designer.

After graduation, he was employed as a cartoonist in the advertising department of Hearst's *New York American.* Then he discovered the riches of comic books. Eisner and Iger reasoned that by setting up an assembly-line production they could turn a profit churning out comic book stories and art.

Eisner would write and create the characters. They hired eager novices to pencil and ink. Others would do backgrounds and lettering. Iger was the salesman and business manager. "Jerry kept the books," Eisner explained. "That's why he kept his hair while I was losing mine."

At a cost to the publisher of $5 to $7 for each complete page, the partners made a profit of about $1.50 a page and the shop work paid off.

Eisner was the talent scout. He was known to respond promptly to all hopefuls who submitted material. His most memorable and haunting experience was a letter of rejection to two young fellows in Cleveland. Eisner's "fatherly advice" (he was three years older than the boys from Cleveland) was for the youngsters to stay in high school and forget about comic books. He returned their comic strip: it was called *Superman.*

Victor Fox, a Wall Street hustler, had briefly been employed as an accountant in the office of Harry Donenfeld. The profits Fox was entering in the ledgers looked very attractive indeed, so, in 1938's, he folded up his attaché case and opened his own publishing office in the very same building.

There was one problem. He didn't have the slightest idea of how to put a comic book together.

Then Victor Fox heard about Universal Phoenix. He summoned Eisner and Iger and addressed himself to Will Eisner.

"I want a comic book, Sergeant," he said. Fox wasn't one to remember names. "Now I want you to make up a hero. Put him in a red suit, you know, like a union suit. And he should have lots of muscles, see. And make him so strong he could beat up anybody and anything."

As Eisner recalled the procedure, "We went back to the shop and started malting roughs. We would then send them to Victor Fox who would make changes in them and return the roughs to us.

We would refine his changes and, when Fox was finally satisfied, Jerry Iger brought the finished product in to me and commented, 'You know, this looks a lot like that Superman character.' Anyway, Victor Fox accepted it and we named it Wonder Man. We had the account and *Wonder Comics* #1 went to press."

After the issue was published, Eisner became worried. He heard that Fox was going to be sued by Donenfeld for plagiarism. Eisner consulted a lawyer who advised him to get out.

Eisner walked over to Fox's office and told him he wanted to quit. As Eisner tells it: "I wanted my money, and [Fox] said, 'All right, but if you want to get paid you'd better say the right things...'"

When the case came up for trial, Eisner and Iger told their story just as it happened, which of course conflicted with Fox's version of accidental coincidence. Fox lost the case. Universal Phoenix never collected their fee.

Audience with the King

I was as busy as I wanted to be, but it was a monastic existence working all hours in my small room, and I

LEFT INSET: *It's no wonder that the publishers of Superman took exception to Victor Fox's blatant rip-off of the Man of Steel, Wonder Man (created by comics legend Will Eisner in his early years), which led DC Comics to slap the self-professed "King of the Comics" with a plagiarism suit. This cover detail is from* Wonder Comics #1. *©2003 the respective copyright holder.*

itched to break out. I had made a ritual of reading the help-wanted ads in the Sunday *New York Times,* still hoping to get back into the newspaper business. One ad caught my attention: "Artists and editor wanted for major comic book company. Call Mr. Roberts at Fox Publications. It was worth a try. I phoned Mr. Roberts and arranged an appointment. Victor Fox's comic book company had grown into a force to be reckoned with. He had met Donenfeld's lawsuits with his own counter suits, while continuing to expand.

He added to his sizeable line of comic books a chintzy newspaper comic strip supplement that, to be charitable, never made the big time. Another publishing venture, even worse than the syndicated strips, was a group of astrology magazines.

He received me in the largest office I had ever seen. The domed ceiling was sky blue and at least 20 feet high. In dead center of the room, dwarfed behind a huge glass-covered desk, Fox guided the destinies of his comic book empire. On his right flank stood his aide, a stuttering one-time attorney named Robert Farrell, who later was to revive the *Brooklyn Eagle* and the *New York Daily Mirror.* Each of these ventures died a second death within a year.

Fox was a short, round, nattily dressed man in his late forties, with a rasping voice that would shrill to frightening crescendos when he was excited. And he was excited often. It was rumored that he was a former ballroom dancer and dandy, although he looked too small. Probably, he had spread the rumor himself.

His prime talent was that of a promoter. He had raised great sums of money for various business ventures that somehow never panned out for the investors, but always left him solvent. He was as outlandish as any of his comic book characters.

"I'm here to see Mr. Roberts," I said, trying not to be intimidated. He and Bob Farrell exchanged glances. He sighed, ignoring my statement, and went into his routine that would become familiar in our future relationship.

"I'm the king of the comics," he began, turning to Farrell once again. "This may be a kid's field, but we're not playing school here with chalk on a blackboard." His voice was growing louder and threatening. "I've got millions of dollars tied up in this industry." He paused, and

then for what seemed like the first time, addressed me: "Now what makes you think you can handle this job, protect my investments?"

Both Fox and Farrell stared, waiting. I thought this must be how a condemned man feels when he's asked if he has one last statement. I could only extract my samples from the battered manila envelope, suddenly wishing that I had brought along the shiny new portfolio instead.

I gently set the samples on the desk where Fox's stubby arms wouldn't have to strain reaching for them. The samples included, in addition to comic book work, my newspaper clippings — cartoons, illustrations and by-lined articles. Victor Fox looked them over carefully, rose politely, shook my hand and said he'd let me know. Bob Farrell ushered me out the door. A few days later, Farrell left a message. I phoned back. He wanted a reference. Was I steady? Did I finish assignments? I gave him the name James Miller and asked if an editor at the Syracuse Herald, one of several papers I had worked on, would be a good reference.

"Yes," he said and hung up.

A week later I was standing in that huge office in front of the same two inquisitive men. Victor Fox was beaming. "*The Herald* wrote that you're the greatest, most talented, most creative artist and writer ever to work in that city. They say you have the character of a saint."

He showed me the letter, written on *Herald* stationery and signed by James Miller. It was so complimentary that I was embarrassed and worried that Fox might think it was a fake.

"They exaggerate," I said, lowering my head to look humble.

"I once knew a whore in Syracuse," Fox continued. "People said she was the best whore in town. That didn't impress me. It's a small town."

My heart sank.

"Anyway, you're hired. You are now editor-in-chief of Fox Publications. Eighty-five dollars a week. I want you to sign an unbreakable contract." I hurriedly signed the papers placed in front of me. As I walked out of Fox's office, I silently thanked Jimmy Miller, the "copy boy" at the *Herald* — the best friend a cartoonist could ever have.

Enter the Script Writer

Chaos was the order of the day as I attempted to hold to the schedules with my stalwart band of rookies. I "batted out" many of the covers myself, doing my best to initiate the individual styles. In the parlance of the trade, "batting out" means to do a quick job of art work, omitting details and unnecessary shading. The in-house, salaried artists were a help, but turning out hundreds of pages of comic book art a month with mostly new people seemed an insurmountable task.

As the artists reported in with their assignments, a cloud of doom descended over my desk. The artwork was bad enough, but the best that one could say about the stories was they were illiterate.

Tuesday mornings were set aside by Victor Fox for his editor to interview new artists. I became a new Mister Roberts, as advertised. Eddie Herron, a gangling unkempt young man from West Virginia, was one of the worst art prospects. "You need more training," I advised him. I was being charitable.

He assumed from this that he had potential. "Please, Mr. Roberts. I'm flat broke. I've got no place to sleep. I'll do anything."

Tempted to give him an assignment, I looked at his portfolio again. My artistic soul rebelled. But his stories were interesting, more exciting than most in the house. "Look, Ed," I said, "we have enough lousy artists as it is. Would you like to try writing for some of them?"

His face lit up. "I'll start right at this moment. What do I have to know?"

"Just one thing: On the third panel of the first page of every story, you have an explosion."

"Of course," the bewildered young man agreed. "I'll work it out somehow. Anything for a buck, Mr. Roberts."

My thoughts went back to earlier that very morning. Victor Fox had summoned me to his inner sanctum. As soon as I opened the door, he thrust the open comic book straight up at my face. It was a copy of *The Flame*.

I was alarmed, thinking that I had committed some terrible mistake, such as the one a week before when an alcoholic letterer had made the "L" run into the "I" in the title "FLICK WILSON" (Newsreel Cameraman), and it had been printed that way. Understandably, then, I felt greatly relieved when Victor Fox's expensive dentures flashed in a wide, happy grin.

"This issue is walking off the stands, Sergeant," he announced, punching my arm in a fit of ecstasy. "It's selling like crazy. I mean, really selling. And I've figured out the reason." He tapped his forefinger in the direction of his slicked sideburns.

SUNDAY, NOVEMBER 24, 1940

"Oh yes, Victor Fox has the answer. It's this goddamn explosion on —"

He flipped open the comic book and pushed it up closer to my eyes....

"—see, here, this one on the third panel. The third panel of the first page!"

He threw the open comic book on his desk, pointing directly at the core of the blast. Then his voice suddenly went softer. I sensed a confiding tone. "This color... It's blue?"

"No, sir. That's red."

His finger moved to another area of the page. "And this color?"

"Yellow, Mr. Fox." I realized now that the little general was colorblind.

"Then that's it," he said before the irony of the fact could hit me. Fox slapped at his desk in another of his triumphant gestures. "I want a red

ABOVE: *November 24, 1940* Spirit *section by Will Eisner, artist-writer-businessman who continues to be innovative and influential in the comics field. ©2003 Will Eisner.*

LEFT INSET: *House ad for Fox Comics. ©2003 the respective copyright holder.*

and yellow explosion in the same spot — the third panel of the first page of every story."

"In every story? Of every comic book?"

"You heard me, Sergeant. That's an order." He dismissed me with an unmistakable air of finality. The discussion was at an end.

After several issues of explosions — which made no difference whatsoever in sales — the practice of including an explosion on the third panel of the first page of every feature simply faded away. There were no memos, no instructions.

As for Ed Herron, he was to receive five dollars for every script. As our first scriptwriter, he would no longer have to worry about his room rent at the YMCA.

I was not the only "Mister Roberts" at Fox Publications. All the editors were required to answer to that surname. I suspect it was because Victor Fox didn't want his employees' names to get around the comic field;

they could be lured away by competitors.

Fox continued in his attempt to pirate his competitors' staff, much the same as William Randolph Hearst had hired reporters and editors away from rival newspapers. Fox would place an ad in the *New York Times,* such as: "ARTIST WANTED: Bob Raymond, author of the *The Flame,* call Mister Roberts at Fox Publications." The Flame was a character in the Fox comic books, which had been handled by Eisner and Iger's Universal Phoenix.

Believing himself clever, Fox in turn advertised for each of the artists who had bylined his superheroes, although they were still working for Eisner and Iger. Among those who responded were several Bob Raymonds. Unknown to Fox, many of the bylines had been fictitious, since more than a few of the character drawings had actually been patterned by the prolific Will Eisner and his assembly line crew using fictitious bylines.

Fox's sure-fire theme had backfired and I was faced with the bleak prospect of turning out dozens of monthly comic books with a skeleton crew of novices.

"Mr. Roberts," I told myself, "you're not going to make it."

The Fox Staff

None of the executives had a key to the Fox Publication offices. Only Victor Fox himself and a slovenly young shipping clerk, Irving, were entrusted with keys. Irving was known for his laxness and his pants that bagged outrageously at the seat. Mornings, the staff would line up in the hallway like schoolchildren waiting for Irving to let them in. Irving was often late, but Victor Fox was usually later. So Irving invariably got away with his lateness. There was a lot of fooling around in the halls between the bullpen artists and the female workers, but waiting around like that was embarrassing for an editor. Many expensive man-hours were shot down while we waited. But since it was the unanimous opinion that Victor Fox deserved it nobody ever turned Irving in.

Yet Irving wasn't helping the schedules. Victor Fox hadn't the slightest suspicion that his staff would have the unmitigated gall to miss a schedule. That would be mutiny, and Captain Bligh knew how to deal with mutineers and scoundrels. One day he stormed into the editorial offices, took a wide legged stance center stage, and waved a copy of a comic book at the staff. "I want you to see this," he bellowed. "I want you all to see what my competitors are doing!"

The magazine waved frantically above us was an animated type of children's comic. The title: *Vic the Fox*. It was about a fox that was always getting into mischief, published by Martin Goodman.

Fox sneered in my direction. "What are they trying to do, kid me? They know I'm the king of the comics." Then, turning to his aide, Farrell: "Bob, can't we sue these bastards?"

"Forget it, Victor," Farrell chuckled. "They're trying to get your goat."

Fox shook his head. Then back to me: "How's it going, Sergeant?" He managed a smile that came out more like a sneer. It was his first editorial comment to me since I joined his company. This was my opportunity to "tell it like it is," to confess to the utter folly of the operation.

"It's going okay, Mr. Fox," I said, intimidated.

Fox might not have known, but at least Farrell understood what was going on. One afternoon he walked into my office with a personable young man in his early twenties. "This is Al Harvey. He'll tell you he's a cartoonist but he'll be exaggerating. Anyway, he's a bright boy and can take some of the load off your back."

I was thankful. Here was somebody to take the rap for the late schedules. Al Harvey did marvelous things with hand lettering and was constantly making up cover dummies — roughs — to present new ideas. Also, he did an uncanny impersonation of Victor Fox. "I'm the king of the comics," he would proclaim. "We're not playing school here, with chalk on a blackboard. I've got millions of dollars tied up in this business...!"

Al Harvey had the nasal, rasping voice down pat and every artist got the Fox monologue treatment. Eventually, Al began to sound like Victor Fox even when he wasn't trying. He never stopped sounding like Fox.

Victor Fox was a born huckster. He was the first comic book publisher to promote his own products. Kooba Cola was the most bizarre. In 1940, inspired by the popularity of Coca-Cola, the inside covers of his comics heralded the arrival of "the world's newest and best-tasting soft drink, delightfully refreshing and fortified with 35 USP units of vitamin B1 (for the sake of health and nutrition)." The slogan, "Each bottle has enough for two," was accompanied by a picture of a pretty girl or a couple of typical young Americans sipping contentedly on a bottle of giant sized Kooba Cola.

Later, the ads featured coupons offering a bottle of Kooba Cola free of charge. Coupon redemption as well as distribution of the soft drink was to be handled by newsstand and magazine distributors. In addition, there were the premium refund offers. The reader could save and redeem Kooba Cola bottle caps for toys such as baseball bats — and for 250 bottle caps, a Buck Rogers pop-pop pistol. A kid would have rotted every tooth in his head before he could ever earn enough points to win these prizes. Luckily, no evidence of any Kooba Cola has ever

come to light. Certainly, we who worked for the company never saw one single bottle.

Another of Fox's promotions was the Comicscope. This was Bob Farrell's product. It consisted of a printed cardboard box with paper film strips and a lens arrangement, available for coupons from any five Fox comics plus fifteen cents and a three cent stamp to cover the mailing. "Practically a Gift," proclaimed the ads. It had to be. The Comicscope was a noble experiment that never showed a profit.

ABOVE: *Beside comics, Victor Fox huckstered the apparently non-existent Kooba Cola. Here is one of the ads. ©2003 the respective copyright holder.*
BELOW: *An ad that ran in the Fox line. None of the staff knew what was discontinued or how it got there in the first place.*

'Thanks kids... FOR ALL YOUR SWELL LETTERS, AND I WISH I COULD TAKE EVERY ONE OF YOU WITH ME ON MY THRILLING ADVENTURES. EVEN THOUGH THE OFFER HAS BEEN DISCONTINUED... I KNOW YOU'LL STILL ENJOY READING MY EXCITING EPISODES IN THIS ISSUE AND OTHERS TO COME.'

Lou Fine

ouis K. Fine was regarded as the first of the fine illustrators in the comic book art factories, which were occupied in the 1930s mostly by crude, if imaginative, technicians or rank beginners from high school art classes. A slight, soft-spoken youth from New York City, Lou limped around the art department like Captain Marvel Jr.'s alter ego, Freddy Freeman, dragging a shortened right leg, a victim of childhood polio. Yet, like America's Mightiest Boy Hero, Lou was super-powered in his field. He pioneered a slick, fine-line technique which influenced an admiring school of comic book artists for many years.

Fresh out of art school, Lou began his career in the assembly line of Eisner and Iger's Universal Phoenix. When the partners split up, Lou joined Eisner to work on the newspaper comics supplement, *The Spirit*.

These pages of the Flame by Lou Fine appeared in Fox Publications' *Wonderworld Comics* in 1939. ©2003 the respective copyright holder.

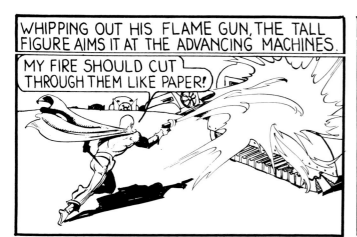

CLOSELY PURSUED, HE WADES THROUGH THE SLIMY SWAMPS —SUDDENLY, WITH A DEEP HISS, A HUGE ALLIGATOR ATTACKS HIM!..

SLIPPING ON THE SOFT MUD, THE FLAME FALLS HEAVILY, THE SNAPPING JAWS OF THE REPTILE INCHING NEARER AND NEARER HIS THROAT...

WITH A QUICK, AGILE TWIST, THE FLAME LEAPS ONTO THE UGLY CREATURE'S BACK.....

STRAINING HIS TREMENDOUS MUSCLES, HE BENDS BACK ITS HEAD UNTIL THE SPINE SNAPS.

HERE COME THOSE FIENDS! MAYBE I CAN USE THESE ALLIGATORS AGAINST THEM..

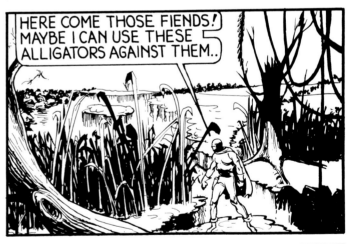

PULLING OUT HIS GUN, THE FLAME QUICKLY FIRES THE MATTED UNDERBRUSH. MADDENED BY THE BURNING REEDS, THE HIDEOUS CREATURES DASH FOR SAFETY, PLUNGING INTO THE MIDST OF THE ASBESTOS CLAD MEN, MIGHTY JAWS AND TERRIBLE TEETH RIPPING THEM APART.......

5

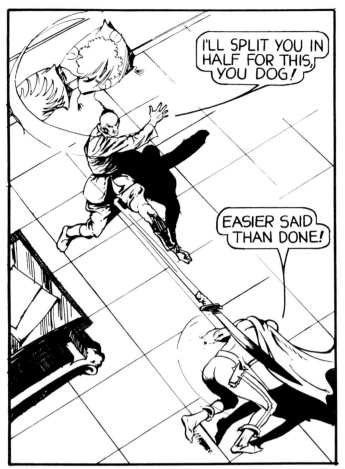

36

A New Breed of Publishers

As comic books became a national fad, more publishers turned to the cheap little newsprint magazines for an easy buck. National distributors were anxious to advance most of the capital to publishers who could turn out complete comics. And there were always printers willing to back a line of comic books in order to keep their presses busy. It was not unusual for a publisher unfamiliar with the comic book business to take a fling at the field, fail, and come out with a profit.

Artists, too, were reaping the harvest. With prosperous illustrators scorning the industry as a cheap art form, there was lively competition for the experienced, the promising, and the willing comic book artists. There was a market for just about anything they cared to produce. If a feature was rejected by established publishers, there was always an outlet with the new entrepreneurs: the cloak-and-suiters, investors from the garment industry, taking a fling at the media; the undercapitalized promoter and hustlers with desk space and an answering service. As a rule, though, these publishers were without talent, without savvy, and without a chance.

Then a new breed of publisher came upon the scene: printers who would take over the failing companies as they were being abandoned by the losers.

All the while, the mainstream publishing companies had been observing the field: checking sales figures, projecting the low overhead into profits under their superior distribution; and, in 1940, the first of the giants stepped in.

The rumors that Curtis Publications, publishers of the *Saturday Evening Post* was to become a comic book house gave us all a lift, although we were disappointed when they eventually published under an affiliate named Novelty Press. The Philadelphia-based firm arranged to have their comic line packaged by Funnies, Inc. All this had been relayed to me by artists and writers who did freelance work for both Funnies and Fox.

Lloyd Jacquet called me at the Fox office to tell me about his new client. I let him have his moment of triumph without suspecting that I knew. He was trying to be nonchalant. "We've been appointed to put out a line of comics for Curtis." He paused dramatically, waiting for my reaction. I accommodated him with a great amount of delight.

Some time before, I had submitted a lengthy feature to Funnies, Inc., called Blue Bolt. It was a fantasy about a long underwear character (all costumed characters in tights were known as long underwear characters). Blue Bolt lived in a futuristic subterranean civilization ruled by the sexy but ruthless Green Sorceress. Tirelessly, he hurled electric charges at her evil henchmen. When he had lived on the earth's surface, his body stored the electricity from the sun and, through a kindly scientist, he discovered a way to generate it at will.

I had wondered why the feature had not been used before, and now I understood. It was part of the package Jacquet had used to make his pitch to Curtis.

Jacquet pointed to the feature on his desk. "They want me to name their first book *Blue Bolt.* Of course you'll be paid for the title."

Blue Bolt was successful for several years and, although I was paid for all my work at Funnies, Inc., I was never paid for use of the title. Still, it was a proud feeling to be published by Curtis, publisher of the *Saturday Evening Post.*

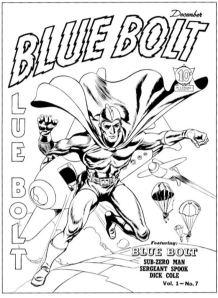

ABOVE: *Cover by Simon and Kirby. ©2003 the respective copyright holder.*

BELOW: *Young Joe Simon pauses at his art table.*

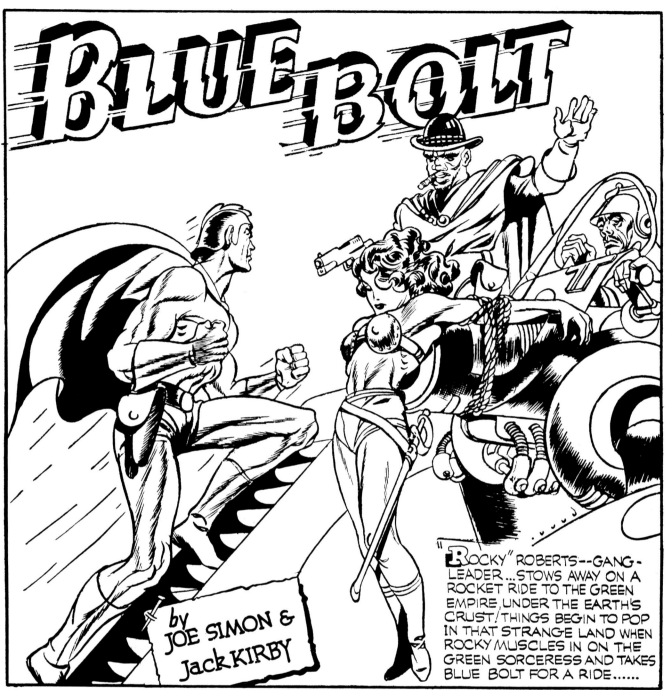

by JOE SIMON & Jack KIRBY

"ROCKY" ROBERTS--GANG-LEADER...STOWS AWAY ON A ROCKET RIDE TO THE GREEN EMPIRE, UNDER THE EARTH'S CRUST! THINGS BEGIN TO POP IN THAT STRANGE LAND WHEN ROCKY MUSCLES IN ON THE GREEN SORCERESS AND TAKES BLUE BOLT FOR A RIDE......

BARELY ESCAPING WITH HER LIFE FROM ROBERTS AND HIS GANGSTERS...WHOM SHE LEFT BATTLING BLUE BOLT IN THE SURFACE WORLD--THE SORCERESS EMERGES ONCE MORE IN HER GREEN KINGDOM BENEATH THE EARTH'S SURFACE!

SOMEHOW BLUE BOLT AND BERTOFF HAVE MANAGED TO REVERSE THINGS DURING MY ABSENCE!

1

Blue Bolt

Blue Bolt, created by Joe Simon for Curtis Publications, publisher of revered weekly family magazine the *Saturday Evening Post.* The character's identity is that of Fred Parrish, a Harvard gridiron champion, who is struck by lightning twice in a single day! Parrish is then kidnapped by a scientist only to be transformed into a superhero charged with electrical powers! The strip's most significant contribution was to feature the first teaming of longtime partners Joe Simon and Jack Kirby who would go on to becoming the most successful pair of creators in the history of the comic book industry. (Note below that even before Captain America, Simon and Kirby used Adolf Hitler and Benito Mussolini as symbols of evil. Later, in the pages of Timely's Star-Spangled hero, they would be portrayed as villainous buffoons.)

Chapter 7

Enter Jack Kirby

Jacob Kurtzberg had been working at Fox Publications for several months before I was hired. He was 21 years old, had a pale complexion and even facial features topped by thick eyebrows and thicker black crew-cut hair. Kurtzberg complained of an addiction to Danish pastries, the results of which tended to emphasize the fact that he stood no taller than five-and-a-half feet.

Without throwing much of a shadow, I towered over him, a gangling six-foot three-inches weighing in at a skinny 150 pounds after a full meal. We were a most unheroic looking odd couple — one that was to bring to life, between comic book covers, countless symbols of muscularity, daring and utter perfection in the American male.

Jacob's family lived in a Lower East Side tenement where his $15 a week salary was the steadiest portion of the family income. He had small confidence in his ability, requiring constant reassurance. After a while he asked if I could arrange extra work for him to do at home in the evenings. I had taken on more assignments than I could handle so the announcement that Jacob was ready to moonlight with me was good news.

INSET RIGHT: Joe Simon cover art for Blue Beetle *#3. ©2003 the respective copyright holder.*

BELOW: Yes, there really was a Charles Nicholas. But this art was by Jack Kirby. When Simon and Kirby left Fox Publications, Nicholas came along and stayed for over ten years. ©2003 the respective copyright holder.

I took Jacob to lunch to discuss our working together. We went to a mid-town restaurant where steaks sizzled over flaming charcoal pits and a stuffy waiter stood over our table. I ordered a hamburger steak.

The waiter turned to Jacob. Jacob fingered the large menu as if testing its thickness.

"Boston cream pie," he said quickly, refusing to look up.

The waiter stood with pencil poised. "Anything else?"

"A hot fudge sundae."

Confused, the waiter wrote the request and held his ground. "And?"

"Chocolate cake."

The waiter still didn't move.

"Brown Betty."

The wide-eyed waiter looked at me. "He's dieting," I quipped. I suspected that Jacob hadn't eaten out very much before, and I didn't want to embarrass him with a discussion of his strange orders.

The waiter walked off haughtily but soon returned with one medium-well done charbroiled ground round steak and four desserts. Jacob attacked the desserts as if their presence threatened his life.

He faced the Brown Betty, then sat back quickly, his face ashen.

"What's in this?"

"Raisins," I answered.

Jacob was indignant. "I know they're raisins! I can't eat any more!"

The raisins, he confessed, reminded him of crawling insects that infested the lower East Side tenements. It was to be a plot for my next story: raisins that grew into giant insects attacking the ghettos, devouring the tenements for dessert and, finally, after having eaten too many sweets, exploding colorfully on panel three of the first page.

The Blue Beetle by Charles Nicholas

RELEASE FRIDAY, FEBRUARY 16, 1940
DEAD MEN DON'T TALK

The Blue Beetle by Charles Nicholas

RELEASE SATURDAY, FEBRUARY 17, 1940
DEATH SWITCHES SCHEDULES

Jacob told me he had worked on salary for a brief time at Eisner and Iger's and later Lincoln Features, a small syndicate, before he came to Fox. I wondered aloud why he had never taken on freelance work, which paid much better.

"I tried," he said. "I brought my samples to Harry Chesler's studios."

"And?"

"Mr. Chesler told me my work was too loose."

"So you gave up?"

"Oh, no," he responded. "I made up new samples. I worked really hard on them! I went back to Chesler's."

Jacob paused as if sadly contemplating his career. "Mr. Chesler told me the art was too tight."

Jacob worked with me on the next episode of Blue Bolt. We rented a one-room office on West 45th near Funnies, Inc., where we turned out pages evenings and weekends. Jacob had a great flair for comics. He could take an ordinary script and make it come alive with his dramatic interpretation. I would write the script on the boards as we went along, sketch in rough layouts and notations, and Jacob would follow up by doing more exact penciling.

I did the inking with a brush to make it go faster. (Brushwork dried faster than the pen.) When we were rushed, there were artists available to do all or part of the inkling at a small fee. There were people who did only lettering; some who did only backgrounds. We had contact with all the specialists we needed.

Jacob would cringe when the phone rang. Once I was in the middle of a particularly involved scene and snapped, "Answer it, will you, Jake, for cris'sake!"

"I can't," he said. "Maybe it's Victor Fox!" Jacob was signing his work Jack Curtis or Jack Kirby and I thought that he was merely doing this to Anglicize the byline. But I realized his problem.

Freelancing was a lifestyle for a guy without responsibilities; a guy who didn't like to get up in the morning or ride the subways during the rush hours. But it was a hazardous business. There were plenty of worries when work wasn't available or when an editor got an idea in his head that he suddenly disliked your work.

There were no vacations; lost time was lost money. There was the fear of getting sick and not being able to work for a while. Comic artists were not known to be men of resources. Nobody ever got rich drawing or writing comics. I couldn't blame Jacob Kurtzberg for fearing to give up a steady job, but fifteen bucks a week?

"Dammit, Jake, here you're making over ten times what you get on that lackey's job. Why are you afraid to use your real name?"

"Don't you like Jack Kirby?" he asked.

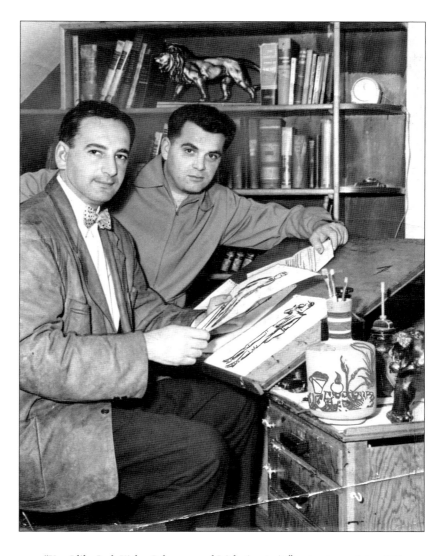

"Yes, I like Jack Kirby. It has a good Irish ring to it."

Many of our heroes had Irish names. They were "in" at the time, in movies, radio and fiction. James Cagney, Gene Kelly, Ronald Reagan. Irish actors were the most gallant, most swashbuckling, most popular.

Three months after I left the Fox organization, Jacob Kurtzberg joined me. "I would have quit sooner," he explained, "if I were taller."

"What the hell has that got to do with it?"

"Short people have a big handicap. It's hard to make people notice you. Did you ever see a short drill sergeant?"

A week later, Jacob Kurtzberg went to City Hall to, as they say in comics, change his identity. He returned with a legal document that said he was now and forevermore Jack Kirby. I noticed for the first time that he did have an Irish look to him, and, somehow, he seemed to stand taller.

Chapter 8

Captain America: Our Answer to Hitler

Superman was still the basic pattern for successful comic book heroes. The theory that a young reader would psychologically identify with an all-powerful crime fighter was accepted as the true formula for success. Nevertheless, only a handful of comic book heroes succeeded in capturing a profitable share of the audience.

Publishers kept searching for new genres. But the field was already crowded and innovation was expensive. New titles had a high mortality rate. Westerns never made it. Science fiction, although it seemed a natural, failed to capture enough of an audience. Kids didn't believe men could travel in space. Fly through the air, yes, but space ships?

Come on! Non-costume characters had been tried and abandoned many times.

The long underwear boys were where the money was.

Batman was enjoying strong sales and publishers were trying to analyze it. While Superman was indestructible and tried to police the world, Batman was mortal: he had to struggle to rely on his wits in order to survive. During a fight he traded puns instead of gasping for air. Bob Kane and writer Bill Finger were coming up with colorful villains, constructing plots around such weird arch-fiends as the Joker and the Penguin. These villains had character and intelligence. It was an interesting format which most of the competition hadn't milked successfully. But they kept trying.

In Europe, the Nazis were marching. Hitler and his Storm Troopers splashed across the headlines daily. News dispatches of the persecutions, the concentration camps, the incredibly cruel Gestapo tactics, seemed to Americans an ocean away more like a grade "B" movie than reality.

Then the idea struck home: here was the arch villain of all time. Adolf Hitler and his Gestapo bully-boys were real. There never had been a truly believable villain in comics. But Adolf was live, hated by more than half of the world. What a natural foil he was, with his comical moustache, the ridiculous cowlick, his swaggering, goose-stepping minions eager to jump out of a plane if their mad little leader ordered it. (After a stiff-armed Heil Hitler salute, of course.) I could smell a winner. All that was left to do was to devise a long underwear hero to stand up to him.

Our government's propaganda was preparing us for the day when the U.S. would enter the war. It was a time of intense patriotism. Children played soldiers, shooting war toys at imaginary soldiers. Wouldn't they love to see him lambasted in a comic book. By a soldier. A meek, humbling private with muscles of steel and a colorful, star-spangled costume under his khaki army uniform. Wouldn't we all!

Working on *Blue Bolt,* traveling on the subways and the top deck of the Fifth Avenue bus, my mind burned with the idea. This was an opportunity for big money if I could make the right deal, not to mention the chance to make a mockery of the Nazis and their mad leader.

I stayed up all night sketching the usual athletic figure: mailed armor jersey, bulging arm and chest muscles, skin-hugging tights, gloves, and boots flapping and folded beneath the knee. I drew a star on his chest, stripes from the belt to a line below the star, and colored the costume red, white and blue. I added a shield. (As a child, I had been hung up on shields, barrel staves that were good defensive weapons against stones in a tough neighborhood.)

ABOVE: *Without a doubt, Joe Simon's most famous creation is America's beloved super-soldier, Captain America (seen here with '40s sidekick Bucky), the shield-wielder who continues to be published today. ©2003 Marvel Characters, Inc.*

The design seemed to work; the muscles of the torso rippled gallantly under the red and white stripes.

There was one thing bothering me though: he had to have a companion. A comic book hero without a henchman would be talking to himself throughout much of the action. He would be forced to describe his thoughts through a device known as "thought balloons" — a series of bubbles containing the speech lettering coming out of his mouth. (This device could slow down the story if overused.) I sketched a boy with matching colors and a simpler costume. Too many stars and stripes were sure to confuse the colorist.

I wrote the name "Super American" at the bottom of the page. No, it didn't work. There were too many "Supers" around. "Captain America" had a good sound to it. There weren't a lot of captains in comics. It was as easy as that. The boy companion was simply named Bucky, after my friend Bucky Pierson, a star on our high school basketball team.

Martin Goodman had asked me for ideas, so I brought the presentation to him. He looked at it for a few minutes. "Let's do it," he said. "We'll give Captain America his own book."

The majority of comic books at the time were variety periodicals with several features and characters sharing the billing. "I'd like a piece of the action," I suggested. "This is a pretty unique thing."

Goodman offered 25 percent of the profits, 15 percent for me, 10 percent for the artists. We shook hands on the deal. Artists are notoriously poor businessmen.

Martin Goodman was entranced with the idea of using Adolf Hitler as the heavy, but he also had a problem with the idea. "The bastard is alive and in the center of a very explosive situation," he said. "He could get killed — even when our book is on the presses. Then where would we be?"

A lot better off, I thought. "Do you want to forget it?" I asked.

"No, but we should get it out as soon as possible!"

Goodman suggested that I put a team of artists on the new project who could work night and day until, "they completed it or dropped dead, whichever came first."

I didn't have a lot of objections to putting a crew on the first issue — as long as it was the right crew. There were two young artists from Connecticut that had made a strong impression on me. Al Avison and Al Gabriel often worked together and were quite successful in adapting their individual styles to each other. Actually, their work was not too far from Kirby's. If they worked on it, and if one inker tied the three styles together, I believed the final product

would emerge as quite uniform.

The two Als were eager to join in on the new *Captain America* book, but Jack Kirby was visibly upset.

"You're still number one, Jack," I assured him. "It's just a matter of a quick deadline for the first issue."

"We'll make the deadline," Jack promised. "I'll pencil it myself and make the deadline."

I hadn't expected this kind of reaction, and I wondered if it had been insensitive of me to suggest the new guys, but I acceded to Kirby's wishes and, as it turned out, was lucky that I did. There might have been two Als, but there was only one Jack Kirby.

I wrote the first issue of *Captain America Comics* with penciled lettering right on the drawing boards, with very rough sketches for figures and background. Kirby did his thing, building the muscular anatomy, adding ideas and pepping up the action as only he could.

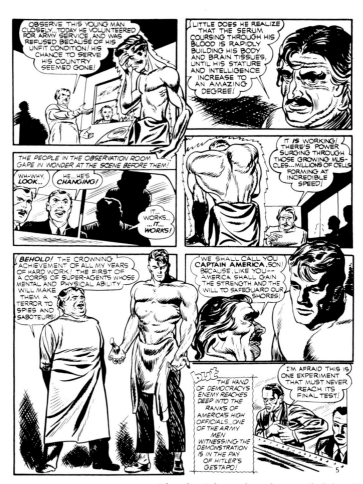

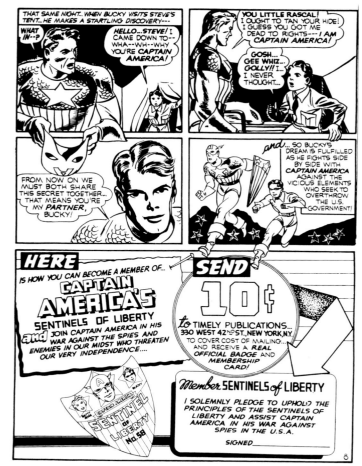

Then he tightened up the penciled drawings, adding detailed backgrounds, faces and figures. We searched around for an inker who wasn't busy, one who could give his full time to this first issue.

Al Liederman, the Fighting Cartoonist from upstate New York, had tracked me down. Al had moved on from the *Buffalo Evening News* to the *Akron Beacon Journal.* Then, when the *Rochester Journal American* shut down, Adolph Edler (my first boss) came to the *New York Post* and soon arranged for a job at the *Post* for Liederman.

Al came up to see me at our small office during his lunch break. He said that he had seen my name in the comic books and thought that I might get him work in the comics now that I was (sarcastically) a famous comic book man.

"Why do you want to do comics," I asked, "when you can work on all those big-time newspapers and get reprinted and quoted all over?"

"More money," Al answered. "I'd like to try this stuff after work. I may like it well enough to do it full time."

Al was a cartoonist who hadn't attempted the more illustrative action-adventure style we needed, but we gave him a shot at inking the very first *Captain America* story. I set up the penciled pages on a desk in the art department so Al could see the task he would face.

"As you can see, Al, there's a lot of fighting going on here."

Al studied the fight scenes.

"So don't bleed on them."

Much to our relief, the Fighting Cartoonist came through with a clean crisp style. The fight scenes in particular looked quite authentic.

Captain America was the first major comic book hero to take a political stand. Other superheroes were in the business of fighting crime, but the war in Europe was of far greater significance. As for capturing the attention of the comic book-reading public, it was natural that the adventures of our new red, white and blue hero would have the advantage over the others who were still challenging the mad scientists or the hoodlums robbing the corner candy store.

Hitler was a marvelous foil; a ranting maniac. It was difficult to place him in the standard story line of the cunning, reasoning villains who foxed the heroes through-

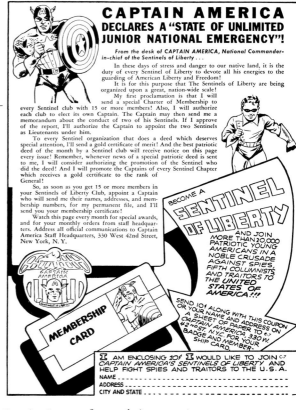

out the entire story before being ultimately defeated at the very end. No matter how hard we tried to make him a threatening force, Adolf invariably wound up as a buffoon —a clown. Evidently, this infuriated a lot of Nazi sympathizers.

There was a substantial population of anti-war activists in the country. "American Firsters" and other non-interventionist groups. Then there was the German American Bund. They were all over the place, heavily financed and effective in spewing their propaganda of hate; a fifth column of Americans following the Third Reich party line. They organized pseudo-military training camps such as "Camp Siegfried" in Yaphank, Long Island, and held huge rallies in such places as Madison Square Garden in New York. Our irreverent treatment of their Fuehrer infuriated them. We were inundated with a torrent of raging hate mail and vicious, obscene telephone calls. The theme was "death to the Jews." At first we were inclined to laugh off their threats, but then, people in the office reported seeing menacing-looking groups of strange men in front of the building on 42nd Street and some of the employees were fearful of leaving the office for lunch. Finally, we reported the threats to the police department. The result was a police guard on regular shifts patrolling the halls and office.

No sooner had the men in blue arrived than the woman at the telephone switchboard signaled me excitedly. "There's a man on the phone says he's Mayor La Guardia" she stammered. "He wants to speak to the editor of *Captain America Comics.*"

I was incredulous as I picked up the phone, but there was no mistaking the shrill voice. "You boys over there are doing a good job," the voice squeaked. "The City of New York will see that no harm will come to you."

I thanked him. Fiorello La Guardia, "The Little Flower," was known as an avid reader of comics who dramatized the Sunday funnies on radio during the newspaper strikes so that the kids could keep up-to-date on their favorite characters.

Nepotism at Timely

Captain America Comics was a tremendous success, the biggest "item" in comic books, bigger at the time than Superman and Batman. We knew it was big when so many publishers attempted an imitation.

Martin Goodman was elated, but cautious. "Don't tell anyone how good it is," he advised. "If they ask about sales, cry a little."

He turned over the editorial-and-art room to me and I organized a workable art department.

Goodman also asked me to take over the editing of all his comic books. Lloyd Jacquet and his Funnies, Inc., outfit were being phased out. Soon, we were buying only the *Human Torch* and *Sub-Mariner* from Jacquet and irritating the hell out of him with demands for script and art changes in the hopes that he would resign the features he had helped to build. Timely Comics had outgrown Funnies, Inc.

I brought in Jack Kirby to work in the art department with me. We gave up our little office on West 45th Street. It was a nice savings; twenty-five dollars a month.

We tried more new titles. Everything was selling. *The Young Allies,* another war comic book, was particularly popular. It was "inspired" by one of my favorite boyhood novels, *The Boy Allies,* set in World War I. Who would remember? *All Winners* was published quarterly, combining the three big hits of the organization, *Captain America, Human Torch* and *Sub-Mariner*. It was very profitable and caused Martin Goodman to look for another title.

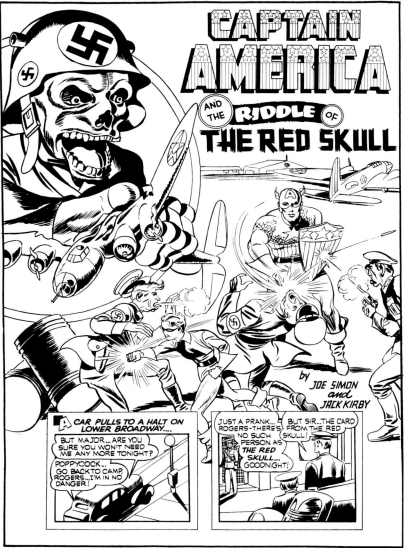

The proven success of the patriotic theme resulted in a proposal to name the new publication *U.S.A. Comics*. Martin feared that the government might object to the use of this title for a commercial comic book, until his attorney, Jerry Perles, suggested that the periods in *U.S.A.* be eliminated. Martin still harbored strong misgivings, but Perles, a young dynamo in the media legal field, talked him into it.

USA Comics was added to the line, and with bated breath, Goodman waited for a negative reaction from the government, but it never happened. The comic book was a winner.

It is interesting to note that during the early years of the American occupation of Japan, the Japanese established a town named USA where their then shoddy products could be stamped "Made in USA" before export to the United States.

Goodman's Timely Publications was a little beehive of nepotism. The staff consisted of brothers Abe Goodman, the bookkeeper; Dave Goodman, the one with the camera that was constantly checking out pictures of skimpily clad models who thought they were going to have their pictures published in one or the other Timely magazines, and Artie Goodman, the youngest. Artie busied himself doing color guides for the comics.

Another relative was Uncle Robbie, who kept getting in the way. Uncle Robbie was all over the place. He fancied himself an art critic, a story critic, a circulation trouble-shooter, when in fact he was a first class obstacle. He ran interference for Martin Goodman who was reluctant or too busy to confront people.

Printers, engravers, and others doing business with the company had to deliver their messages to Uncle Robbie, who would, in turn, relay them to Martin Goodman and return with the answers. He made sure that Goodman had fresh crackers and milk at all times, and that the pillows on Goodman's chair were always in place. We were told that Martin Goodman had very sensitive skin — all over.

It was also Uncle Robbie's job to take stacks of the company's comic books down to the local newsstand and trade them for competitors' comic books so that Goodman could see who was doing what in the business.

One day Uncle Robbie came to work with a lanky 17-year-old in tow. "This is Stanley Lieber, Martin's wife's cousin," Uncle Robbie said. "Martin wants you to keep him busy."

Stanley's main job was to erase the penciled drawings from the pages after they had been inked, a chore that was always drudgery for the artist. Stanley was as extroverted as Martin was introverted. He was into everything, his apple cheeks set in a perpetual grin. Anxious to help, he cheerfully dashed out for coffee or art supplies.

When Stanley wasn't busy as a gopher, he sat in a corner of the small art room blowing odd notes from a flute, causing Uncle Robbie to beam in approval but driving the rest of us up the wall.

In a week, Stanley asked for a promotion. "I know everything," he stated confidently.

I assigned him to write the two pages of text. (Comic books printed these "text-stories" to satisfy post office regulations for second class mailing privileges.) It was commonly believed in the trade that nobody read the two-page text stories, including the editors.

It remained for Stanley Lieber to treat the text with respect. To Stan, they were the Great American Novel. Two days later he came in with a couple of the one-page prose stories that he had written at home. They were signed "Stan Lee."

"Who's Stan Lee?" I asked.

"I'm changing my name," the former Stanley Lieber announced. "For journalistic reasons."

"It would be better for a laundry."

"I hadn't considered that," said Stanley. He paused in deep thought. "I wonder what the comic book prospects are in China."

Chapter 9

Pocket Comics: Two for the Price of One (Almost)

ABOVE: *Simon and Kirby cover art for Alfred Harvey's Champ Comics.*

INSET RIGHT: *The oft-pilfered Pocket Comics. ©2003 Harvey Entertainment, Inc.*

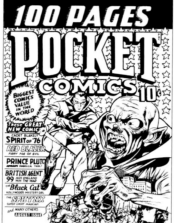

Al Harvey had stayed on at Fox Publications for over a year, a record accomplishment considering the volatile nature of Mr. Fox. Now he was working in an advertising agency named NYAD, but still fascinated by the comics. One day he called the Goodman office and invited me to lunch. When I met him at Child's restaurant next to the Paramount Theater on Broadway in Times Square, he was dressed in grey flannels and carried an attaché case instead of his old worn portfolio.

"You look very sincere," I greeted him.

"I hate this business of advertising."

We grabbed a table in a comer and ordered lunch. Al didn't have dessert. That was class, I thought. Soon he was opening a little homemade pamphlet. It was a comic book cut in half and stapled together. The cover was pasted over with a sheet of colored paper on which was lettered *Pocket Comics*.

"Look," he said, "two-thirds of the size of a regular comic book. I can give the kids a book and a half for the same money and still come out ahead."

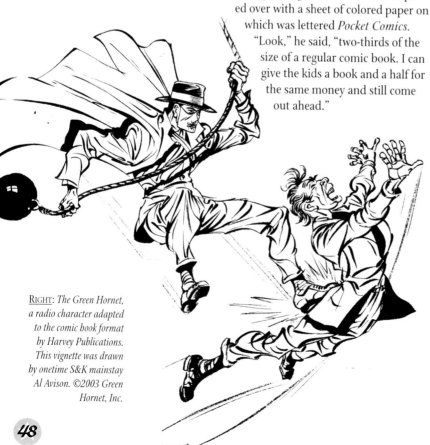

RIGHT: *The Green Hornet, a radio character adapted to the comic book format by Harvey Publications. This vignette was drawn by onetime S&K mainstay Al Avison. ©2003 Green Hornet, Inc.*

"It's half a comic book," I corrected him.

"But it looks like two-thirds," he insisted.

"A pocket-size comic," I said. "It's a new idea."

The standard size comic books were sixty-four pages and sold for a dime. Al explained his plan: "We give them 100 pages but the cost of printing and art are about the same. For a dime, the kids can get twice as much."

Of course his multiplication was not quite accurate, especially since he was including both sides of the front and back covers in his count. Still, it couldn't be denied that his sales pitch was impressive.

He promised he was going to find somebody interested in his idea to finance his *Pocket Comics*. Then he asked me to draw a cover for it.

I took the "dummy" with me and the next day returned it to Al with a typical adventure superhero on the cover. It was a colorful presentation which he took to one of the national distributors, Irving Manheimer, president of Publishers Distributing Corporation (PDC).

Manheimer was so impressed with the potential of the new idea that he agreed to back the project.

Incredibly, Al Harvey was now a publisher. The distributor had even arranged for the rights to a nationally known radio and book character, the Green Hornet, and secured the means to publish three pocket comic titles. I dropped in at Harvey's new, modest offices in the old Fawcett building, on West 44th Street. "I've sunk two hundred bucks into this business!" Al said.

He was sprawled in a secondhand swivel chair, his feet on the desk, and puffing a cigar. His other furnishings consisted of a battered drawing table, about a dozen sheets of cardboard, a jar of black India ink and two cigars. "I'm not playing school with chalk on the blackboard, you know…" He was doing the Fox impression again.

Then his face turned serious. "Match my three hundred, Joe, and we'll do this thing together."

"You just said two hundred," I reminded him.

"Did I? So much is happening so fast, I can't keep track," He slapped his hand on the desk. "Okay, make it

48

two hundred and you're a partner. Fifty-Fifty."

I couldn't make up my mind. "I've got a pretty good deal where I am. I'm getting paid good money and I've got twenty-five percent of *Captain America.*"

It was the safe move at the time, one that I would live to regret. I did contribute to the new Harvey organization with three covers for his first issues. No charge. When I had the chance to get away from my own work I also helped with the contents of the magazines.

Al did a credible job of turning out the new "pocket" sized magazines. His first publication caused a stir in comic circles. Publishers watched and waited for the sales figures. We kept our fingers crossed. It was a unique experiment.

It was the practice of national distributors to dispatch "road men" to various key cities to spot-check newsstands after a new magazine of special interest to them had been on sale for twenty days. They would make counts on the number of magazines received by individual "mom-and-pop" stores and the number remaining on each comic book rack after twenty days.

They'd project this check into an estimate of final sales. When the checkup on the comics proved encouraging, Al Harvey was ecstatic.

"We've got ourselves a hit," he proclaimed. "We're in business."

It was the Horatio Alger story; rags to riches, the American Dream.

The next time I saw Al Harvey, his mood had changed. "The dealers don't want any more pocket comics," he moaned.

"But why? I thought they were moving."

"They were moving, all right. The kids have been stealing more magazines than they've been buying." The size of the little magazines made it easy for kids to slip them into their pockets, or inside the pages of a standard-sized comic book, while browsing through the comic racks. Petty crime was a big problem in the little candy stores.

So the *Pocket Comics* were dead. But Al Harvey went on to bigger things.

Alfred brought his two brothers, Leon and Robert, into the business, making them equal partners. His fraternal twin, Leon, had attended art school. Leon's attempts at drawing were so bad that the instructors gave up on him and told him to try his hand at sculpturing. Leon took them at their word. He stuck his left hand into a lump of clay and had the mold cast as an artistic statuette. Leon told his friends it was done by hand. Of course, as you might have guessed, Leon assumed the position as art director of Harvey Publications.

Robert, the eldest, had recently been awarded a certificate as a certified public accountant. He was destined to take over the business affairs of the company. His first order of business was to retain a CPA, the formidable Sidney Gwirtzman, who was also the

accountant for Bill Gaines' E.C. Comics and others in the publishing business. You will hear more about Sidney Gwirtzman later in this book.

In the 1950s, Harvey Comics bought out the rights to Paramount Pictures' library of animated films for close to two million dollars, an enormous sum of money at the time. The most famous of the characters, Casper, the Friendly Ghost, paid off handsomely. Casper was a television star, in coloring books, licensing and merchandising, and a favorite of toy manufacturers.

Not bad for Alfred Harvey's two hundred dollar investment.

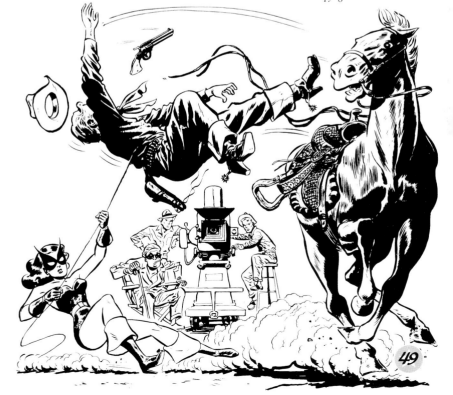

Captain Marvel: A Crude Beginning

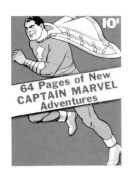

64 Pages of New CAPTAIN MARVEL Adventures

Captain Marvel first appeared as a feature in *Whiz Comics,* published by Fawcett Publications. The year was 1940 when Fawcett, a respected magazine publishing firm, was testing the waters to determine if comic books belonged in their line. The company had started in the flapper age with a racy little humor magazine named *Captain Billy's Whiz Bang.* In addition to *Whiz,* other comics in Fawcett's group included *Captain Midnight, Bulletman* and *Spy Smasher.*

The origin story of Captain Marvel, by editor Bill Parker and artist C. C. Beck, told of a newsboy named Billy Batson who met an ancient wizard in an abandoned subway tunnel and was instructed to shout the word "SHAZAM," which would transform him into the mighty Captain Marvel, a hefty superhero who would fly into the world of evildoers and right the wrongs of mankind.

Ed Herron, the gangling young man from West Virginia who billed himself as comics' first full-time scriptwriter, had by now talked his way into a job at Fawcett Publications.

He was grateful for the help I had given him when he came to New York, and had always been available to pitch in with scripts for any of my projects whenever I needed him.

Although he kept himself busy, having accumulated accounts with other comic houses, when Fawcett expand-

BELOW: *Simon and Kirby panels from the first issue of* Captain Marvel Adventures *featuring the exploits of the World's Mightiest Mortal.* ©2003 DC Comics.

ed their comic line, Ed was hired as one of the editors.

One morning at the Goodman office, I received a call from Ed.

"There are some people here at Fawcett who would like to talk with you and Kirby," he said. "Do you have some time to help me?"

Jack and I walked the two blocks to the Fawcett offices in the old Paramount building. In a conference room were Ed, two other editors, and Al Allard, the Fawcett art director.

Fawcett had always operated in style, with a generous staff and a sizeable budget. Allard showed us a feature in one of their comic books. It was an extremely well-drawn "long-underwear" character, rather chunkier than the usual comic heroes, rendered in more of a cartoon technique but still illustrative enough to effect a heroic impression. On his chest was a bolt of lightning, not unlike Blue Bolt.

"This is a new feature in one of our magazines," one of the editors explained. "He's been getting a favorable reaction from our readers. We're hoping to make him into another Superman."

"He's got class," I said.

Comic book heroes were almost real to the people who worked on them and we often found ourselves talking about them as if they were living flesh-and-blood people.

"What do you think of Captain Marvel having his own book?" Ed asked.

"Why ask us? We're doing *Captain America*."

The art director smiled. "We'd like you fellows to do the first issue. You would set the pace and then our people could take over."

Ed appeared nervous. He had recommended this strategy and he would lose face if we turned him down. We agreed to do it.

"You've got two weeks," Allard warned. "If you guys want to sign it, that's okay. Maybe your names will sell a few million more copies."

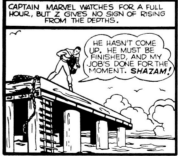

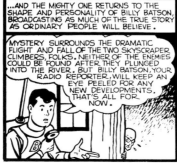

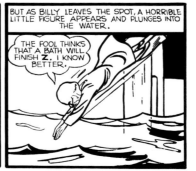

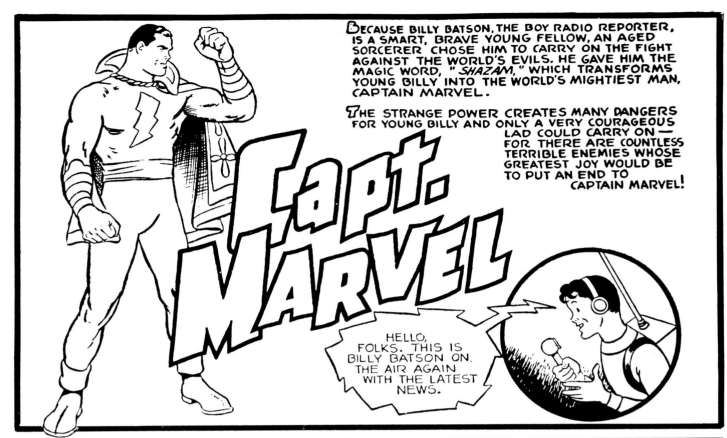

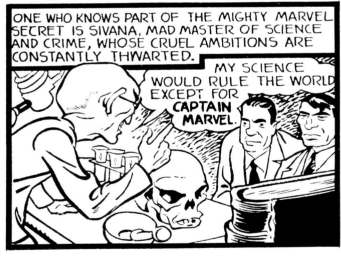

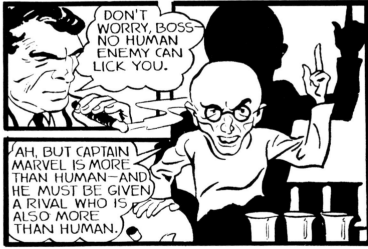

Allard was being a bit snippy, but still, it was a step forward since, to our knowledge, Fawcett was not in the habit of printing bylines.

Once again we rented a hotel room and set up shop with drawing boards propped against the small writing desk, between chairs, and even on the beds. After working a full day at Goodman's office, and gulping a quick sandwich, the night shift would begin. Jack Kirby and I would lay out the script and art on the boards; Kirby would "tighten up" the penciling. Inkers and letterers were called in to push out the pages to meet the tight deadline. It took almost a week of seemingly endless work that was

terminated each morning only when we dropped off to sleep against the drawing board or on the littered bed, in complete exhaustion.

The final pages were disappointing to us. They didn't match Charlie Beck's polished style we had been striving for.

Finally, the book was ready to hand in to the publisher. "What about the byline?" Kirby asked.

"I think this thing's going to bomb," I predicted. We decided not to sign it.

This was the first full issue of *Captain Marvel Adventures*, one of the most successful series in the history of comic books.

ABOVE: *Despite the C.C. Beck-type veneer, elements of the quintessential Simon and Kirby approach to action creep into these panels by the pair from* Captain Marvel Adventures #1. ©2003 DC Comics.

Hangman and the Threat of Litigation

Martin Goodman's silky face was creased with irritation. Tapping his finger at a page of *Captain America Comics,* he muttered indistinguishables while I waited to hear why he had called me to his office.

He arose to straighten the cushions on his chair, then settled back and spoke between clenched teeth. "We've got a lawsuit on our hands."

Goodman held up the latest issue, opened to a page that showed a villain called the Hangman. It was only one of several villains we had been using and of little importance to the success of the magazines.

Goodman explained: "John Goldwater has a character named the Hangman. John is very upset over this. Our Hangman is nothing like his. He hasn't got a case but lawsuits are expensive and we'd better go over there to talk to him."

With the abundance of characters in the comics, it was almost impossible to avoid repetition. However, publishers were constantly threatening one another with litigation, and it was true that lawyers could be costly. So Goodman, Kirby and I took a taxi downtown to Goldwater's office on Lafayette Street, a manufacturing district off the beaten path of New York's publishing houses.

John Goldwater was the dominant partner in M.L.J. Publications, a pulp and comic book house whose most successful title would be *Archie.* The initials M.L.J. stood for Morris (Coyne), Louis (Silberkleit), and John (Goldwater). They had been publishing a patriotic star-spangled character named the Shield for almost a year before Captain America, and Mr. Goldwater was admittedly upset that Captain America had far surpassed his hero.

The Shield character had been the cause of a prior controversy with John Goldwater when he had objected to the shape of Captain America's shield as it appeared in the first issue because it was similar to the imprint on the chest area of his character's costume. To placate him we changed Captain America's traditional shield to a round one, which was handier anyway since it became a convenient boomerang object to hurl at foes. Besides, the round shield turned out to be more colorful.

The two publishers compared the similarities of the two Hangman characters, and Martin Goodman's assurance that we would not use our Hangman again satisfied Mr. Goldwater.

Goldwater patted me on the shoulder. "You guys have the touch," he said. "If you want to make a change, we can make a deal."

Goodman smiled feebly, but inwardly was fuming. "Pirates," he muttered as we left. "This field is full of pirates."

I thought back to the time when he had hired us away from Funnies, Inc., and agreed.

Morris Coyne was the accountant for Goodman's publications. He was a grey-haired, jovial bachelor in his fifties — the antithesis of the stereotyped bookkeeper. Morris was often hovering over the artists, telling stories, asking questions. None of us, including Goodman, knew at the time that he was the "M" in M.L.J. Publications.

Morris made out our royalty checks for *Captain America.* The sum was disappointing in view of the immense popularity of the magazine. Once, when we were alone in the office, he confided to me that I was getting far less than the 25 percent that I had bargained for. "They're piling salaries and overhead for most of the operation on *Captain America,*" he said. "You're getting the short end, but I doubt if there's anything you can do about it."

There was one thing I could do. The team of Simon and Kirby had become synonymous with profits in the industry and this was the time to cash in on it. I made a call to Jack Liebowitz, who had taken over the administration of Donenfeld's DC Comics, the company that published *Superman* and *Batman.* DC was the biggest. Liebowitz was well aware of the Simon and Kirby accomplishments. "Simon and Kirby should talk to Jack Liebowitz," he said, matter of factly. "When can we get together?"

DC Comics' headquarters was several floors above Victor Fox's offices, almost as spacious. The executive suite was separated from the art and editorial rooms by several different offices in the wide hallway. Jack Liebowitz ushered Jack Kirby and me into his private quarters as if we were old friends.

BELOW: *Splash page from a Hangman story.* ©2003 *Archie Publications, Inc.*

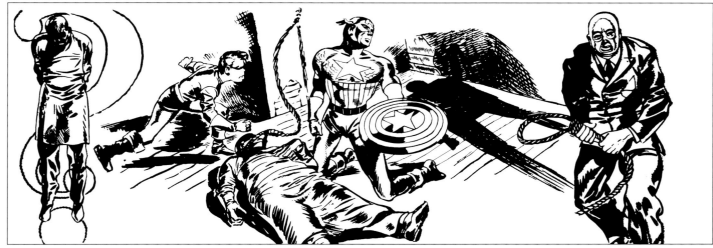

He struck me as an astute businessman who wanted to make a deal. His thin moustache was secured on a chiseled face that appeared to be in its late thirties, capping a slim frame that looked even younger. A short, brusque middle-aged man was stamping in and out of the office, followed by a huge, rough-looking aide in a chauffeur's uniform. Mr. Liebowitz collared the short man long enough to introduce us. "This is Harry Donenfeld, my partner."

Donenfeld was loud and happy. In the three years that we worked for the company, we were to be introduced to him at least a dozen times.

Liebowitz came right to the point. "Simon and Kirby should be with DC Comics."

I told him we wanted $500 a week between us, and a year's contract.

"I'll have the contract drawn up. Have your lawyer get in touch with us."

Donenfeld bounced in. "Have a drink, fellas." He had already forgotten our names. In a corner of the room was a bottle of Scotch about two feet square, held up by a swivel stand. The chauffeur tipped the Scotch into glasses for all and we toasted the deal. Donenfeld was still toasting when we left.

The next morning we showed up as usual at the Goodman offices and continued work as if nothing unusual had happened. Surrounded by members of Martin Goodman's family, Kirby and I avoided any mention of our proposed abdication. Yet, it was unavoidable that our creative interest in the company was secondary to the new ventures awaiting us.

So once again we sought a place where we could work evenings and weekends to prepare new projects. Our selection was an inexpensive hotel room a short walk from the Goodman office. There, once again on drawing boards set up on writing desks and end tables, we roughed up character sketches and cover ideas, confidently expecting to come up with another sensational best seller. One of our attempts was a new Sherlock Holmes, who donned a superhero "long-underwear" costume to fight crime in another secret identity situation.

The work at Goodman's became a chore as we gathered every spare moment to retreat to our secret hideaway where we could work on the new features. We even worked on Sherlock during lunch hours, having carried sandwiches and coffee up to the hotel room, where we munched while working or talking comics.

Stan Lee was visibly upset. Why didn't we send him out for sandwiches anymore? Had he done anything to offend us? One day at lunch hour, he tagged along refusing to be shaken. "You guys must be working on something of your own!" he said.

Our alienation with the Goodmans must have been more noticeable than we had anticipated.

"Go back to Uncle Martin, kid," I said. "You may be an editor soon."

But Stan wasn't to be put off so easily. "Come on, I'm your man. You guys need me," he grinned.

He was not to be dissuaded, and so we let him in on the secret. For the next few days, Stan was there, waiting for us at the hotel, getting in the way, running errands, and marveling at the sketches and ideas we had prepared.

Kirby was uneasy about Stan. "We expect you to keep all this in strict confidence, Stan."

"What kind of guy do you think I am?" Stan replied. His wide eyes were radiating innocence.

A few days later we were confronted by the entire Goodman crew of relatives. "You guys are sneaking behind our backs, working for someone else!" Uncle Robbie shouted. "Martin is furious!"

It was a most unpleasant moment.

"We're not going to deny it," I said. "I guess this is the time for us to leave."

"You'll finish the issue," Abe Goodman growled. "Then you're fired."

We finished the tenth issue of *Captain America Comics,* emptied our desk drawers, and departed without goodbyes. In fairness to Stan, I wasn't at all convinced that he was the one to spill the beans, so to speak. There must have been over a dozen people at DC Comics who knew of our arrangement and could gain points with Martin Goodman by telling him of our plans.

ABOVE: *Cap and Bucky confront the villainous Hangman from* Captain America Comics, *a bad guy created by Simon and Kirby who caused some trouble when the publishers of Archie Comics took offense. Panel vignettes by S&K. ©2003 Marvel Characters, Inc.*

Superman vs. Captain Marvel

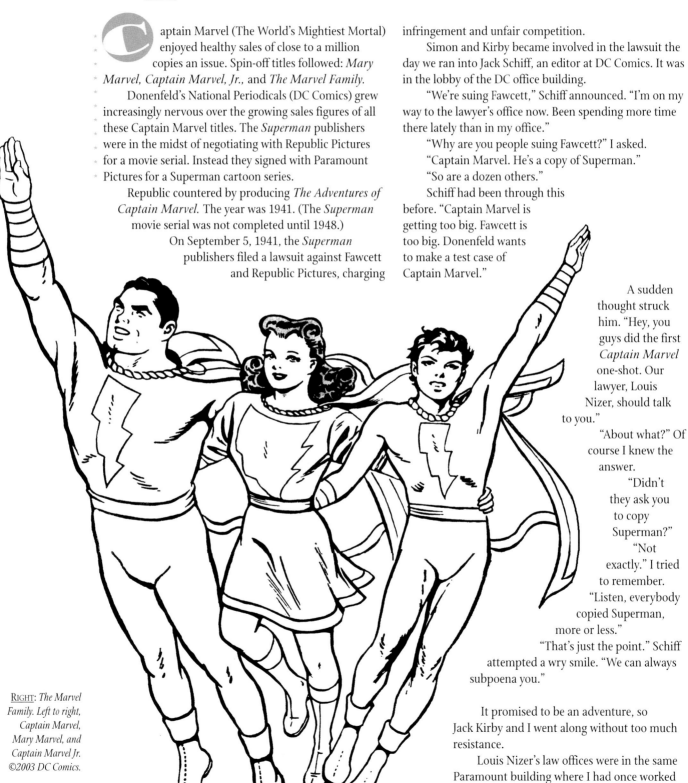

aptain Marvel (The World's Mightiest Mortal) enjoyed healthy sales of close to a million copies an issue. Spin-off titles followed: *Mary Marvel, Captain Marvel, Jr.,* and *The Marvel Family.*

Donenfeld's National Periodicals (DC Comics) grew increasingly nervous over the growing sales figures of all these Captain Marvel titles. The *Superman* publishers were in the midst of negotiating with Republic Pictures for a movie serial. Instead they signed with Paramount Pictures for a Superman cartoon series.

Republic countered by producing *The Adventures of Captain Marvel.* The year was 1941. (The *Superman* movie serial was not completed until 1948.)

On September 5, 1941, the *Superman* publishers filed a lawsuit against Fawcett and Republic Pictures, charging infringement and unfair competition.

Simon and Kirby became involved in the lawsuit the day we ran into Jack Schiff, an editor at DC Comics. It was in the lobby of the DC office building.

"We're suing Fawcett," Schiff announced. "I'm on my way to the lawyer's office now. Been spending more time there lately than in my office."

"Why are you people suing Fawcett?" I asked.

"Captain Marvel. He's a copy of Superman."

"So are a dozen others."

Schiff had been through this before. "Captain Marvel is getting too big. Fawcett is too big. Donenfeld wants to make a test case of Captain Marvel."

A sudden thought struck him. "Hey, you guys did the first *Captain Marvel* one-shot. Our lawyer, Louis Nizer, should talk to you."

"About what?" Of course I knew the answer.

"Didn't they ask you to copy Superman?"

"Not exactly." I tried to remember. "Listen, everybody copied Superman, more or less."

"That's just the point." Schiff attempted a wry smile. "We can always subpoena you."

It promised to be an adventure, so Jack Kirby and I went along without too much resistance.

Louis Nizer's law offices were in the same Paramount building where I had once worked

RIGHT: *The Marvel Family. Left to right, Captain Marvel, Mary Marvel, and Captain Marvel Jr.* ©2003 DC Comics.

as a retoucher. It was a large complex of offices with many lawyers scampering about. Nizer himself was handling the case. Nizer was one of the country's most celebrated attorneys, a small, dark, intense man, impeccably dressed, with the silvery voice of an orator.

He was the most organized man I had ever met, but then, it was the first time I had ever been involved with a lawyer preparing a case. Nizer's staff had accumulated reams of material on comic book heroes and comic books in general. He skillfully led us into the testimony he was seeking. We spent many days at his office and evenings at his apartment, where we were examined and cross-examined in preparation for the actual trial. Nizer was anticipating any and all questions the defense might come up with. He was brilliant. The other participants and witnesses, most members of the National Periodicals comics staff, were always present at our briefings. They observed us. We observed them. Nizer wanted no surprises. It was my understanding that he was basing his case on one major basis: that Captain Marvel, in flying without wings or artifacts, plagiarized Superman.

At the trial, I was the only artist put on the witness stand. I felt uncomfortable when I saw the faces of the Fawcett people in the courtroom but quickly put them from my mind as I prepared my psyche for the infighting and cross-examination I anticipated from their attorneys.

The cross-examination turned out to be mild and brief. The defense was not overly interested or concerned with my testimony. Actually, the law firm representing Fawcett and Captain Marvel specialized in copyright and trademark. They produced example after example, from fiction and legend, of supermen, mighty men, men who flew, and those who came to earth from other planets. They displayed large blow-ups of the *Superman* comic's failure to post proper copyright notices and McClure Syndicate's flawed copyright procedures, which, they claimed, resulted in the "abandonment" of the character. The Captain Marvel lawyers pointed out the differences in the characters. They said that Superman came from another planet, with powers that were inherent to all people from that planet, while Captain Marvel's powers were magical and the stories were whimsical and played for laughs.

The judge decided in favor of Fawcett and Republic Pictures. He ruled: "The evidence does not justify any finding of unfair competition by either Fawcett or Republic; there is no proof either of palming off or of confusion; nor is there any misrepresentation of what equitably belongs to a competitor."

National Periodicals appealed and was granted a new trial. The court reversed the earlier ruling stating that National's claim of "misappropriation and unfair competition" was correct, and that the Superman character copyrights were never lost because the publishers had never intended to abandon their rights.

Fawcett had spent huge amounts of money on legal fees, while the sales of their comic books were dropping. By the early '50s, they decided to abandon further defense and reached an out of court settlement in which they agreed to pay the Superman publishers $400,000 in damages and, in 1953, agreed to cease publication of the Captain Marvel comic line.

I was saddened by the decision. Even though I had testified against Fawcett, I felt that comics had lost a wholesome and fanciful product that could only bring dignity to an industry that sorely needed a touch of class.

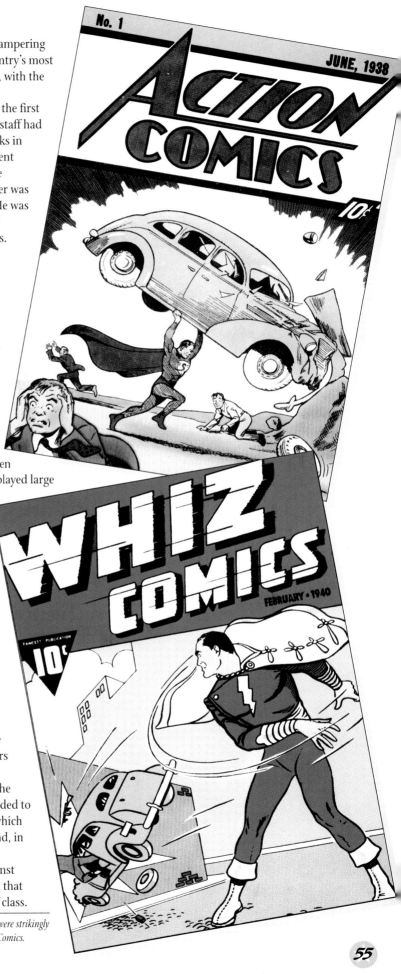

RIGHT: *DC found that it was more than the cover designs of their respective first issues that were strikingly similar as Fawcett later learned defending itself against charges of plagiarism.* ©2003 DC Comics.

Crime Does Not Pay?

Charlie Biro and Creig Flessel had been working all day on a ten-page comic book feature on Jesse James. They had almost forgotten the dinner hour, but finally the job was finished and they left the studio in search of a good eating place in which to relax.

The flamboyant Biro wasn't the type to frequent dull or cheap joints. He led Creig to Armando's Hi-De-Ho Club in the East 50s. Hi-De-Ho was a phrase made popular by Big Band leader Cab Calloway, but that was as far as the relationship to the black singer went. Armando's was an intimate, softly lighted supper club with a clientele that Creig characterized as "unsavory." At the club, Biro soon caught the eye of a buxom showgirl type sitting at a nearby table. She was dining with a wide, muscular, swarthy man who bulged in

the places where a gun could be trying to hide. The girl was returning Biro's winks, and Creig shuddered. Soon, the couple arose to leave. The wide man pushed past the table of the two artists, almost knocking Biro over. Flessel restrained Biro. It wasn't difficult.

Charlie Biro should have been in show business. He was always the first to admit it, and we all agreed that he had what it took. In 1941, he was in his early twenties, over six feet tall, slim and athletic, a shock of red hair topping off a flush complexion.

His blue eyes fixed in a constant squint, Charlie was always proposing ideas for new titles to anyone who would listen, especially a "money man" or publisher. Charlie was an artist with a style halfway between adventure (illustrative) and cartoon. As an artist, he would most likely not have made a great impression in the world of comic books. But Charlie was also a writer and, as it turned out, a comic book editor whose products later proved to be very successful.

Creig Flessel, a year or two older than Biro, was one of the best artists in the business. He had been around from the very beginning, longer than all of us. Creig had drawn the first Sandman before Simon and Kirby revamped the character for DC Comics. As Flessel would later tell it, the two were anxious to finish the meal and go home, when a flabby, limp-eyed man, seated at a comer table, nodded at the waiter. The waiter scowled at the pair. Then he looked back to the flabby man. Obviously, the man was well known at Armando's. The man got up to approach them. Now standing, he was short, well dressed, nervous.

"You looking for a girl?" he stuttered to Biro.

Biro was taken aback.

"I've got a beauty upstairs, in my room. Come on."

An adventurer at heart, Biro played along. "What are you, some kind of pimp?"

BELOW: Despite the magazine's title, publishers of crime comics found that murder and mayhem was indeed a highly profitable enterprise. ©2003 the respective copyright holder.

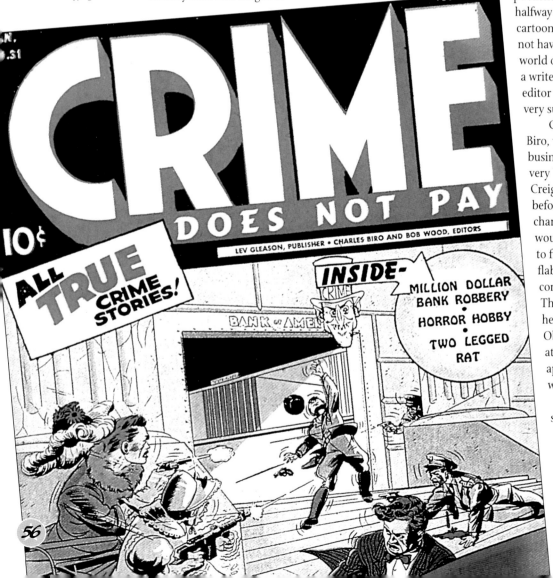

"It won't cost you a cent," the short man said. "I just want to watch."

Biro shuddered as he declined. The two artists paid the check and left. The next day, Flessel excitedly brought the morning newspaper up to the studio. On the front page was the little man's picture. It was identified as Mickey Jelke. The headline read:

"POLICE NAB OLEO MARGARINE HEIR IN KIDNAPPING."

Mickey Jelke, the man at Armando's, was accused of holding a woman in bondage.

Charlie Biro scanned the story, fascinated. "Can you see a story like this in a comic book?" he exclaimed. "A book about weirdos and gangsters — it could go on forever."

In a Broadway tavern, Biro ventured his thoughts about a crime comic to artist Bob Wood. Wood was an extremely mild man. He would periodically show up bruised and battered from encounters with loan sharks who were disappointed by his payment plan. Bob never fought back. He was a hard drinking man who found solace in the interesting bars along the Great White Way. Sometimes he persuaded Charlie Biro to join him.

Charlie was an extrovert who drank to meet people, especially on Broadway where one was likely to run into a celebrity, or at least someone in radio or the press. Together, their ideas glowed like sapphires over the alcoholic spirits and, then and there, they pledged a partnership that would last over a decade and bring in a million dollars of publishing profits, most of the money, in the custom of the business, going to the publishers.

Bob Wood was a cartoonist of minor abilities. But he must have added valuable talents to the team, because together they prospered where each alone had been ordinary. They put together a comic book package entitled *CRIME*, in huge letters. Much smaller, underneath, were the words "*Does Not Pay*," a cop-out aimed not at the youthful consumers, but at parents who were beginning to organize small local rumblings against violence in comics.

The stories centered on true crime cases, told in dramatic detail with more and smaller art panels, heavier dialogue and a new look, inasmuch as the usual black shading was eliminated completely to accommodate more color. They sold the package on a royalty basis to Lev Gleason, a small book and paperback publisher. Gleason financed and published the comic book while Biro and Wood hired the best artists and writers available to them. Biro rounded out packages like a Broadway producer, testing and polishing the dialogue and seeking the most dramatic scenes. One of his steady artists, Alphonse Bare, related stories of Biro banging his head against the wall when a particular scene did not meet his demands. Knowing Charlie, we suspect it was all for effect. He was a dramatic personality, an undiscovered actor.

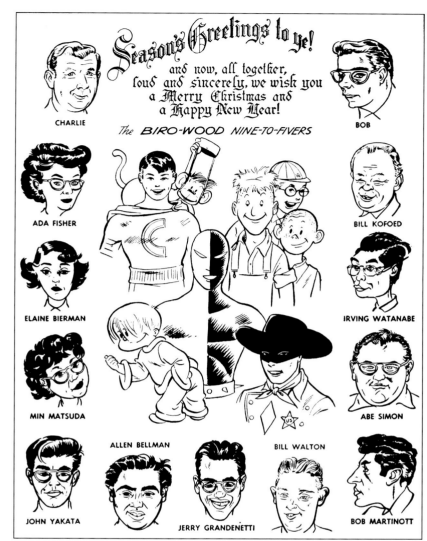

CRIME Does Not Pay soon became one of the leading staples in comics. It was imitated by several competitors, with mixed results. Biro and Wood added more strong titles to the Lev Gleason line. *Daredevil* was one of their better attempts. They also attempted a slick, more expensive supplement-sized, comic magazine called *Tops*. It died a horrible death, but fortunately they could afford the losses. Comic book people were always striving to break into a more respectable media.

In the early 1950s, when the cry against violence in comics was reaching epidemic proportions, local distributors and retailers began to resist magazines such as *CRIME Does Not Pay*. Bundles were returned unopened and, although the books still showed a profit, sales declined considerably.

Bob Wood's drinking increased. He was absent for days at a time. Frequently, he would show up bruised by loan-sharks and then disappear again. The beatings became more brutal because now Bob was affluent and the stakes were bigger than in his earlier days. Bob's life became as bizarre as the gangsters he dramatized in *CRIME Does Not Pay*.

ABOVE: *Charles Biro and Bob Wood Christmas card from 1942. Characters ©2003 their respective copyright holders.*

The Move to DC Comics

Jack Liebowitz's contract was equitable, with one clause that our attorney wanted changed. It read that our work must meet the approval of DC Comics. We had it revised to state that the work should be up to our usual standards. We were to turn in 25 pages a month, and would be paid extra for any additional pages.

After signing, we presented our sketches and proposals. Liebowitz lingered on the *Super Sherlock* pages. "This looks interesting," he mused. "I'll have the lawyers check it out."

It turned out that the rights to publish any Sherlock Holmes material might end up in the courts. "I think we should create our own original characters," Liebowitz announced. "We'll talk about it." It was obvious that *Super Sherlock* was dead before he was born.

Jack Liebowitz set up a luncheon so that we could meet his editors and discuss new projects.

The luncheon meeting took place in a Hawaiian restaurant on Lexington Avenue, with lovely hula dancing girls. Present were Liebowitz, Whit Ellsworth, the senior editor, tall, puffy, blond in his middle thirties, along with Mort Weisinger and Jack Schiff, two younger editors who had recently been recruited from the pulp magazine field.

Jerry Siegel was brought along to impress us. Siegel, the co-creator of Superman, was a man-about-town whose press clippings left no doubt as to his celebrity status.

The party was greeted with impressive cordiality by the *maitre d'*, and our group was graciously seated at the best table in the house. Inevitably, the small talk centered on Siegel, the symbol of success. Just that week, he and Joe Shuster were the subject of a spread in the *Saturday Evening Post*. It read like a *Lifestyles of the Rich & Famous* episode, describing how two Cleveland teenagers had gone from poverty to riches, seemingly overnight. The story related how the boys had met in Glenville High School; Siegel was depicted as a lackluster student yet possessed with a tremendous capacity for fantasy, and fueled by an obsession with science fiction stories. Dreaming up outrageous ideas, writing them down between classes and during any available moment, he gravitated to a new classmate whose preoccupation was drawing. The young art student behind the double-thick eye lenses was Shuster.

JOE SIMON + JACK KIRBY

He had his own makeshift studio in an unheated room at home, where the two boys spent countless hours fantasizing over ideas for new comic strips. The artist's family, like the families of so many other future comic book writers and artists, struggled to make ends meet, and lived crowded together in a tenement flat. Siegel's family was somewhat better off, although his father, who had operated a men's clothing store, had died six years before. Shuster attended evening art school courses, paying 10¢ a lesson, his free hours spent helping to support his family as a newsboy and apprentice sign painter.

But now the article sensationalized their assumed fortune. A quarter-page photo showed the two men at twenty-six years of age: Shuster penciling colorful action scenes, writer Siegel standing over him. If the photo had carried a soundtrack, we most likely would have heard the voice of Siegel creating the blurbs and balloon dialogue.

Eventually, Liebowitz led the conversation to the team of Simon and Kirby. What was the company going to do with us? What were we going to do for the company? Did we have any ideas for new features? Was the company ready to risk its money in new titles, or would it be wiser to assign us to take over already established characters?

BELOW: The Manhunter menaces America's criminal element in this dramatic cover detail from the character's debut issue, Adventure Comics #73. *Art by Simon and Kirby. ©2003 DC Comics.*

The latter would be the wise choice. But then again, we constituted too large an investment to be spent on secondary features. Nobody could figure out exactly what to do with Simon and Kirby. Kirby finally came up with the best idea of all: he ordered two desserts.

We spent a couple of weeks tinkering with ideas, while drawing new characters and our salaries. Somewhat deflated, but with the courage inspired by our one-year contract, we rented a large comfortable studio room in Tudor City, a residential hotel complex overlooking the present site of the United Nations.

What the room actually overlooked was a dock on the East River, which served as some kind of loading platform or slaughterhouse for shiploads of cattle. It was a bit disconcerting watching the cattle being led to slaughter but was certainly not a portent of things to come, we assured each other.

Drawing boards and tables were set up around a double bed, which swung miraculously into the wall. It would come in handy if one of us wished to sleep over after a late night of work. As it turned out, we never used the bed ourselves, although we graciously lent it out to DC artists and editors for romantic trysts.

Finally, assignments were sent to us by the editorial staff. They consisted of scripts for insignificant features currently appearing in the DC Comic magazines. We were instructed to imitate the styles of the artists who had been drawing the features.

Our efforts were abominable. All the heroes turned out looking like Captain America. Artists in the DC bullpen had to retouch or redraw the figures and faces. We were a dismal flop.

It was with an air of despair that Leibowitz suggested we do our own thing. We did so gladly, resurrecting a defunct series called the Sandman, about a long-under-wear character who materialized out of dreams to fight and triumph over injustice. The new Sandman was lithe, lean and muscular. He was a Captain America lookalike. It was the only

way we could go. We contrived another hero comic series, Manhunter, having adopted the title from a recent movie of the same name about an English gentleman hunter who set out to stalk and kill Adolf Hitler.

Our Manhunter, too, had a strong resemblance to Captain America, and consequently, the Sandman. It didn't matter. Sales zoomed for both magazines in which the new character appeared.

We followed with the Newsboy Legion, a group of dead-end kids teamed up with a cop who donned another long-underwear costume and another secret identity to fight crime. The kids resembled the kids in *The Young Allies,* and the cop — as expected — Captain America.

All three magazines became leaders in sales. Our publisher was redeemed. Our bylines were printed in bold type on the covers of each magazine. This was a first in comic books.

The Boy Commandos

Around this time, British Commandos were getting a big press, their daring raids had captured the imagination and admiration of Americans. Jack and I devised the *Boy Commandos,* a feature about a group of colorful kids of internation-al origin — one from each of the Allied countries. A crude, but personable and comical lad named Brooklyn represented

the U.S.A. He wore a derby hat and carried a violin case for his tommy gun in the gangland fashion of the day. Captain Rip Carter led the kids. ("Rip" came from Rip Collins, a home run slugger with my hometown baseball team, the Rochester Red Wings.)

Young readers immediately related to the *Boy Commandos,* especially to "Brooklyn," the loveable little clown whose outrageous antics caught on from the first. The DC stable soon had three major hits — *Superman*, *Batman*, and *Boy Commandos*.

Our *Commandos* consistently sold over a million copies a month.

But Jack Liebowitz was concerned. It was only a matter of time before we would be drafted. Many artists had already left for the military service and there was nobody available to give the same flavor to the characters we had originated. He requested that we go on a crash program to build up an inventory.

We filled our new office with inkers, letterers, colorists and writers. We piled up an inventory of our features that would last more than a year. Thus when I enlisted in the Coast Guard, and Kirby went into the Army, we had money in the bank and the satisfaction of knowing we had done our duty to DC Comics.

The Boy Commandos was the last of the comic book mega-hits of the war years.

Captain America Goes Hollywood

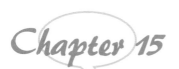

he Coast Guard assigned me to the Mounted Beach Patrol. I was considered an expert in horsemanship because I had written on my application that my hobby was cantering along the horse trails of Forest Park in Queens, just over the bridge from Manhattan.

After I was sworn in at New York headquarters I was given a bus ticket to Barnegat Island, a summer resort strip near Atlantic City in New Jersey. The following day, upon reporting to the Commandant of the island (a slim, gum-chewing, easy-going youth whose only previous experience in uniform was ushering at Radio City Music Hall), I was handed a .38 caliber side arm and ordered to patrol the beach, while "keeping an eye out for Nazi subs or landing parties."

The Commandant's quarters were in an old wooden beachfront hotel. It was littered with comic books, a fact that shook my confidence in the military service. I handled the pistol respectfully. I had drawn many guns, but never held a real one in my hands.

"How do you shoot this thing?" I asked.

"You've got to load it first," the Commandant, a Lieutenant, j.g., answered, shrugging. Then he flopped into an oversized stuffed chaise, picked up a copy of *Donald Duck* comics and immediately became engrossed in the contents. I took it that I was dismissed.

The hotel's dining room had been converted to barracks, with about 50 double-decker bunks lined in neat rows. The Bos'n's Mate, a grizzled veteran with a leathery, lined face, handed me my clothing gear. The man, like many of the other non-coms, was a native of the island who had earned his living as a clam digger before the war. I guessed that he was in his fifties, although I later learned that he was pushing thirty.

"You get out on that beach," he instructed, "and ride your horse south until you come to a phone, which is connected to our headquarters. You call in, then proceed north. You'll be relieved in four hours."

INSET RIGHT: Joe Simon in respite during his days on the Mounted Beach Patrol of the U.S. Coast Guard during the anxious days of World War Two.

"Don't I have to know any more?" I asked.

"Yeah," he said, grinning. "When you head north, dress warm. It's cold in the north country."

He guffawed uproariously.

Most of the guys in the mounted unit were from the south and Midwest. They were young, unsophisticated sons of farm families and hillbillies who were equally at home with horses and firearms. The outfit also included a dog unit where one guard dog trained to attack was assigned to each member of the unit. The dogs were German Shepherds, Boxers and Standard Poodles that had been donated to the service by their owners who for one reason or another were glad to get rid of them. This resulted in some wildly unpredictable beasts. More than one Coast Guard beach-patrolman was injured or killed by a dog in the year I was on duty at Barnegat Island.

Boy Commandos comics was one of the leading forms of literature in the company. The servicemen reserved their copies at the town candy store where the dealer tried to increase his orders, often without success since the printer couldn't keep up with the demand.

We were each assigned our own horse, usually an older mount that had once served in the army cavalry. We patrolled the beach in four-hour shifts, four on, four off, with instructions to report any unusual sightings.

On Long Island, the Coast Guard actually did intercept a German landing party, foiling a plan to sabotage U.S. armament plants and transportation targets. Explosives and maps were confiscated from the captured Nazis.

In winter the beach was mercilessly frigid, lonely and boring at all times. A horse can see ten times farther than man and in the solitude of the night was likely to balk at the slightest hint of a stray animal or windswept debris, often dumping his dozing rider who would then have no alternative but to follow the beast back to the stables in humiliation.

One night, a young rider, out of his skull with the loneliness, called in a report that he had sighted a German submarine. In minutes soldiers and marines from nearby army bases overran the place. Navy and Coast Guard ships appeared out of nowhere while great searchlights made day out of night.

Secret Service officers, expert at such things, interrogated the young man all night. Then he disappeared from the base. It was rumored that he ended up in a psycho ward in Philadelphia.

After a year of service patrolling the beaches, it was decided that my unit was to be replaced by a new crop of recruits and that we were to be shipped out to sea. For the first time, we were assigned to boot camp to learn the fundamentals of military life.

The Coast Guard boot camp was just outside of Baltimore — a lively wartime city, wide open for bars, camp followers, even culture if one was so inclined. Being stationed there was a lot better than Barnegat Island, where a big movie night meant a Roy Rogers film. Most important to me were the first-run films. Movies were always good for an inspirational scene for a comic book plot. And an artist could learn more about drawing from an interesting camera shot than from almost any other medium, including real life; mainly because the cameraman had already done the work of setting up the drama and shadow composition that an artist would have to create.

Baltimore was quaintly picturesque, with rows of two-story homes rising and falling on blocks of hills. The local householders, sweeping and scrubbing their concrete stoops and sidewalks, made up a scene worthy of a few minutes with a sketchbook. But liberties or leaves were not plentiful, and if I timed it right, there was a chance I could get in two movies in one day.

One Saturday, as I walked the unfamiliar streets, seeking the newest movie features, I couldn't believe the marquis suddenly blinking brightly in front of me. It flashed in neon: "*Adventures of Captain America.*"

Republic Pictures had made a movie serial based on *Captain America.* Real actors playing the roles Kirby and I had dreamed up: our costumes — colors and all. I searched for our byline or credit, something in the bottom of my heart knowing it wouldn't be there. It wasn't.

I brooded about the money that must have been paid for the rights. *Captain America* had gone Hollywood, and Hollywood was Fort Knox, spending fortunes for writers, actors, ideas, anything creative.

For years after that incident, I was obsessed with the thought of the money that should have been ours. Years later, in 1968, while attempting to secure the copyright renewal on Captain America, my attorney subpoenaed the records of Marvel Comics. The film company, it was revealed, had paid nothing for the rights. The publisher, Martin Goodman, had given them the rights, *gratis*, expecting to reap his rewards from publicity.

The Combat Art Corps

After basic training, I unexpectedly received orders to report for duty in the Combat Art Corps in Washington, D.C. In a building a few short blocks from the Capitol, a short, nervous, former newspaper photographer with a handlebar moustache and a Boston accent held sway over the Coast Guard Public Information Division.

The unit, occupying an entire floor of the large build-

LEFT: *Though they took away his wings and gave him a gun, the Sentinel of Liberty made it to Tinseltown in a 15-chapter Republic motion picture serial released in 1944. Dick Purcell is seen here as Captain America taking aim at evil Fifth Columnists.* ©2003 Marvel Characters, Inc.

ing, resembled a newspaper office. Officers and enlisted personnel worked side-by-side, pounding away at typewriters, reading copy, scattered about with piles of photographs.

The Coast Guard's combat art specialists had been garnering even more publicity than the Army, Navy and Marine Corps. They had attracted some of the finest painters and illustrators in the nation.

The art department was at the far end of the floor, lined with high windows that were darkened by scores of restless pigeons. It was here that Coast Guard artists returned to shore from sea duty, to paint on canvas the sketches they had composed at sea.

The officer with the handlebar moustache and Boston accent came over to me. "Glad to have you aboard," he said. "I'm Commander Dixon. Grab yourself a drawing board and look busy until we can assign you to a ship."

For weeks at my drawing table, I drew comics in the midst of the fine art painters, all along feeling as if I were a fish out of water.

The year was 1944. We lived and worked like civilians in a city of transients. Washington was crowded with thousands of servicemen and government workers flopping in rooming houses and hotels. It seemed as if every home in the center of the city had been converted into makeshift apartments to house the swollen population. There were hordes of girls from all over the country; government workers to replace the men who had gone off to war.

I teamed up with a black-haired, beetle-browed, sports columnist from the *New York Post* named Milton Gross. He worked as a "War Correspondent" in our Coast Guard Public Relations Unit. One day I asked him what his title meant. He grumbled, "I write publicity captions

for local photo releases. I've never been on a ship."

Milton was an intense man and an intense grumbler. His main beef was the humiliation of having to wear the hip-hugging, bell-bottomed, sailor pants.

"I'm 35 years old," Milt would mutter, "dressed in a Little Lord Fauntleroy outfit."

None of the officers had anything like Milt's experience or stature in the newspaper business; some had been local correspondents for small town weeklies. But the best Milt could swing was a third class Petty Officer rating, and it soured his disposition more than somewhat, as Damon Runyon might have said. Milt and I agreed to share an apartment.

We were lucky to find a large, high ceiling, three-room-and-bath apartment in a building that had once been the Egyptian Embassy. The entrance to our apartment was a set of swinging, glass-paned doors that were unlockable and kept neither light, noise, nor visitors out. Across the hall lived John Norman, an Army cartoonist, who was later to become a cartoon editor for Dell Publishing.

It didn't take us long to discover that an alarm clock was unnecessary. Every morning at the same time, we were awakened by what became a familiar sound: the cork popping from one of John's bottles. The man owned a liquor cache that was a delight to behold. There was always a supply for an unexpected party. And unexpected parties soon became the expected. Our tired doors, like those in the old western cowboy saloons, seemed to be constantly swinging.

It was in this atmosphere that I chose to set up a drawing table and turn out comic book pages after the day's work at Coast Guard headquarters.

The job of the Public Relations Unit was to publicize the Coast Guard. This was important to influence the

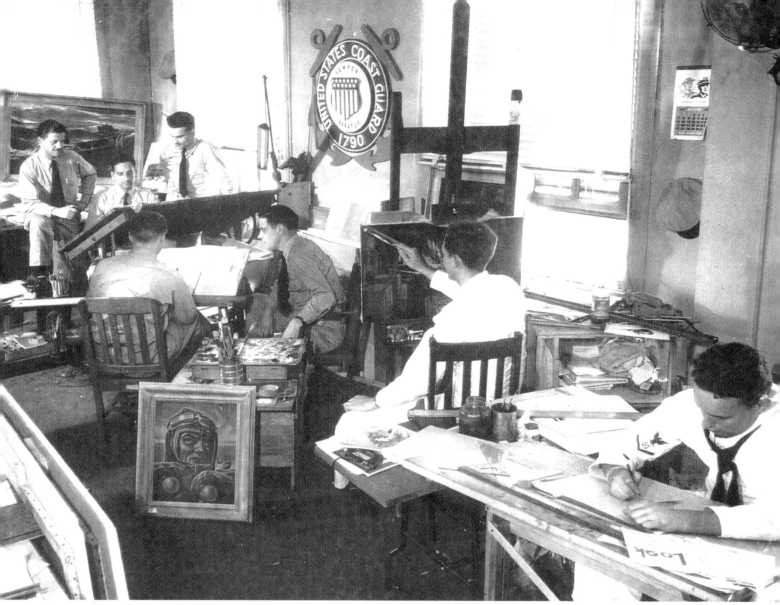

ABOVE: *Some of the artists in the Combat Air Corps at Coast Guard headquarters, Washington, D.C., in 1943. The author is at the drawing board, upper left.*

Congress in appropriating more substantial funds for the Coast Guard budget. Coast Guard photographers were sprinkled in every theater of operations, taking pictures of individual Coast Guardsmen, which were then sent back to headquarters for processing, captioning, and finally for submission to their hometown dailies and weeklies for publication. It was a lively, aggressive operation.

The unit was always open to new avenues of publicity. With that in mind, I suggested to Commander Dixon that the department do true adventure exploits of Coast Guard heroes for commercial comic book publication. Commander Dixon was interested in the idea, and when he learned of the tremendous readership of the comics, he eagerly instructed me to proceed with the plan.

The comics that I did for the Coast Guard followed a simple pattern: a portrait of a hero, his place of birth, the adventure in typical comic book continuity, with liberal references throughout to the Coast Guard. I sent samples to DC Comics, which agreed to publish them. Commander Dixon jubilantly displayed the reproductions with pride equal to a spread in the *New York Times*. After all, the comics had a much larger circulation.

The Commander arranged for more of the strips to be published nationally in Sunday color comics newspaper sections under the title of *True Comics*. Syndicated by *Parents* magazine, they appeared in such newspaper stalwarts as the *New York Post*, the *Washington Star*, and other papers all over the country.

Once I wondered out loud how many Congressmen actually read comics, but Commander Dixon was ahead of me. "Their kids read them," he reasoned, "and papa will hear about how great the Coast Guard is, you can be sure."

One day, Commander Dixon summoned me to his desk. He straightened his tie and slicked his moustache. "Something big is happening," he said without looking up. I suspected that my orders for sea duty had arrived.

Commander Dixon arose and beckoned me to follow him. He led me to the office of the Commandant, tapped at the door and ushered me inside. After the appropriate salutes, I was introduced to the Admiral, an amiable, elderly gentleman who wasted no words in communicating my new assignment.

The Coast Guard, he revealed, was embarking on a

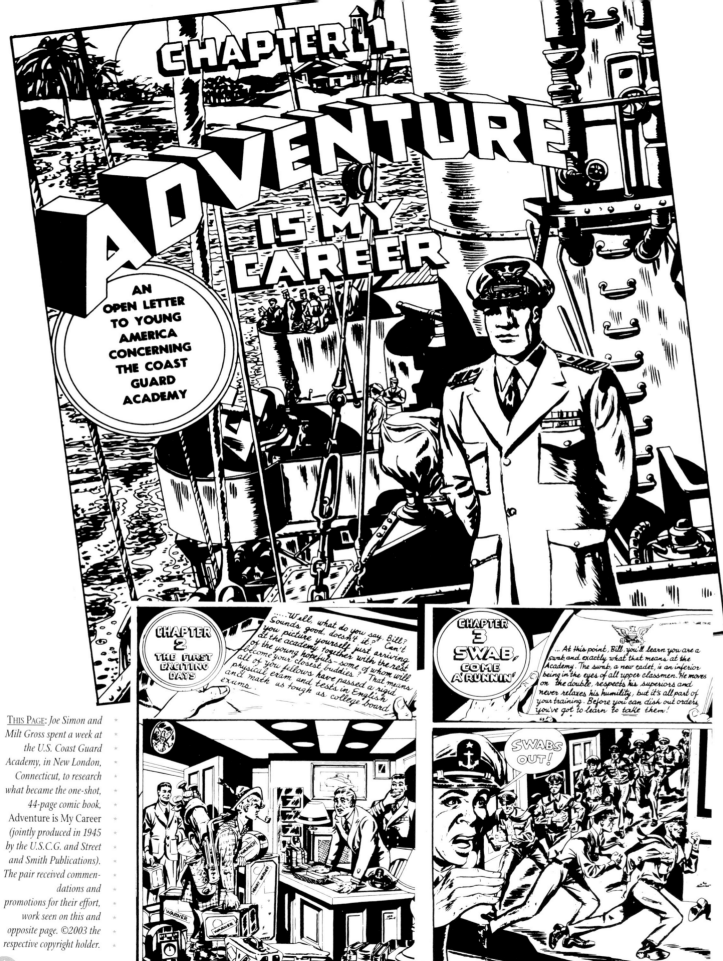

THIS PAGE: Joe Simon and Milt Gross spent a week at the U.S. Coast Guard Academy, in New London, Connecticut, to research what became the one-shot, 44-page comic book, Adventure is My Career (jointly produced in 1945 by the U.S.C.G. and Street and Smith Publications). The pair received commendations and promotions for their effort, work seen on this and opposite page. ©2003 the respective copyright holder.

new recruitment drive to increase enlistment in the officer training program at the Coast Guard Academy, and they had decided that the most unique and popular way to accomplish this was with a comic book.

I was flabbergasted. Although I was immersed in the medium, it occurred to me that a military service should attempt to recruit its future officers from a more cultural readership than the typical comic book audience. But my opinion wasn't asked for and, perhaps, after all, I had underestimated this business of comic books.

"You'll be shipped to the academy at New London," the Admiral ordered, "on temporary assignment so you get the feeling of the place. How long will you need?"

I wondered if I could arrange for a companion. "Sir, it would go faster if I could bring along a collaborator, a writer."

The Admiral agreed.

I chose Milt Gross as my partner, and the following day we cheerfully departed for a fun-filled experience in New London, Connecticut. We occupied quarters at the Coast Guard Academy set aside for the press. We observed the cadets, their routine, athletics, studies, and military training. We had complete freedom to come and go as we pleased, a delightful commodity in military life.

A week later we returned to Washington to produce the comic book. The title settled upon was *Adventure Is My Career.* The Coast Guard, in order to assure a large distribution of the book, arranged for it to be published and distributed by Street and Smith Publications. It was sold on the newsstands for the standard price of a dime.

The Admiral was extremely pleased. Milt and I received official commendations and promotions in rank.

After the war, Milt Gross returned to the *New York Post* to resume writing his daily sports column. He soon called to inform me that he was instituting legal proceedings against Street and Smith to collect his fee for writing the comic book. After all, he reasoned, it was a commercial venture and a profitable one. He suggested that I join him in the lawsuit. I declined. He proceeded without me. I never heard about the final outcome of the case. But I still wonder if Milt ever got his revenge for being forced to wear that Little Lord Fauntleroy suit.

ABOVE AND BELOW: *More examples from Joe Simon and Milt Gross's 1944 comic book* Adventure is My Career. ©2003 the *respective copyright holder.*

The Non-Superheroes

The comic book field, in its most abundant years, lacked permanence. The fact that it survived mystified many prophets in and out of the business. As the field of publishers became more or less stable, a continual barrage of comic book titles bombarded the newsdealers, over 300 each month. The majority was dropped after the sales figures were assessed. But there were new titles to take their place. There was always hope for the magic spark that would ignite the cash box. The prize for the winners was a long run of profitable sales. Some of the profits would go to finance more experiments. The losers hurt for only a few issues. The winners lasted a long time, as a rule. Nobody could guess, really, what factors were responsible for success. Yet, after the success, everybody seemed to identify the ingredients responsible.

During World War Two, one of the big sellers was *Frankenstein*. Artist/writer Dick Briefer's style, a cross between cartoon and illustrative, was grotesque in proportions, not the accepted or preferred ingredient for sales. Yet, the ink rendering was clean, crisp, professional. It worked.

Frankenstein was truly a freak. It began as an attempt at horror, but Briefer's heart wasn't in it. Gradually, the horror characters evolved into satirical characters. The monster developed a definite personality — cute, friendly, humble. He was known as Franky Stein, and all his once grotesque friends became lovable.

The sales soared. Briefer had a ball. He was doing his thing. The success lasted for a couple of years, and then, inexplicably, gradually exhausted. The magic had faded. A crisis was faced. The verdict of the publishers: return to horror.

The result was catastrophe. *Frankenstein*'s remaining fans deserted and, eventually, the title was dropped.

The pages shown here were done after the axe fell. They have not been published before.

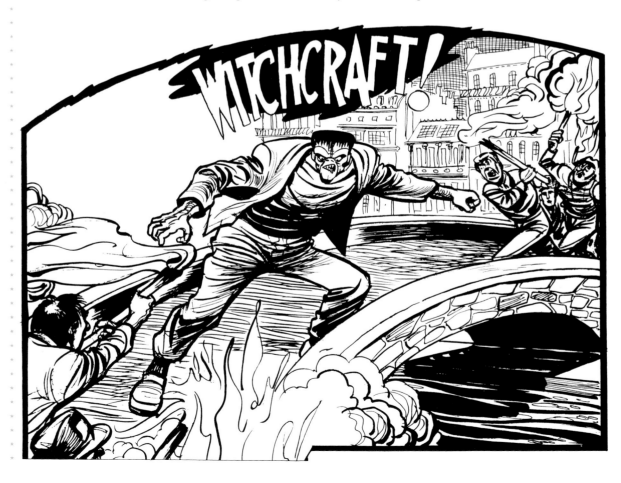

THE FRANKENSTEIN MONSTER IS TRAPPED! AT EACH END OF THE BRIDGE ARE THE FIRE-BRANDS... BELOW HIM IS THE WATER...

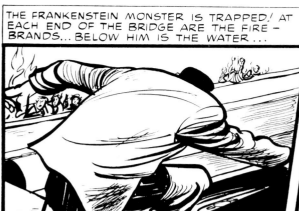

ONLY ONE WAY OF ESCAPE... THE WATER... AND THE MONSTER TAKES IT! BUT HOW CAN HE ESCAPE IN THE RIVER WITH ALL EYES UPON HIM ?

SWIMMING UNDERWATER, NOT KNOWING WHERE HE IS GOING, THE HUNTED GIANT'S LUNGS NEARLY BURST FOR AIR! HE MUST COME UP!

ANOTHER HUGE GULP OF PRECIOUS AIR, AND THE MONSTER SUBMERGES INTO THE INKY DEPTHS! THIS TIME HE STAYS CLOSE TO THE CONCRETE WALL OF THE RIVER BANK, FEELING HIS WAY ALONG...

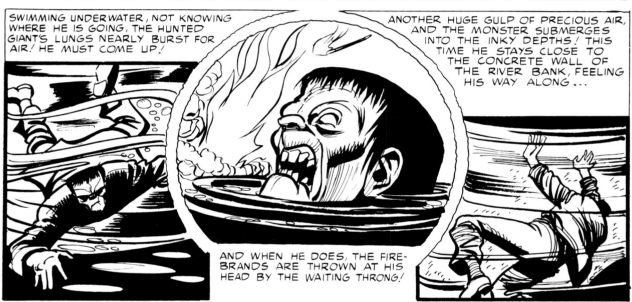

AND WHEN HE DOES, THE FIRE-BRANDS ARE THROWN AT HIS HEAD BY THE WAITING THRONG!

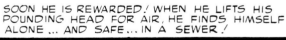

AN OPENING! IN THE WALL! BUT THE FLOW OF WATER FROM THE HOLE IS STRONG! WITH A LITTLE BREATH LEFT, THE BEAST EXERTS GREAT STRENGTH TO SWIM INTO THE HOLE AGAINST THE CURRENT!

SOON HE IS REWARDED! WHEN HE LIFTS HIS POUNDING HEAD FOR AIR, HE FINDS HIMSELF ALONE ... AND SAFE... IN A SEWER!

Sad Sack

Cartoonist George Baker was born May 22, 1915 in Lowell, Massachusetts. After graduating from high school, he held various jobs, including fitting paper bags on newly pressed clothes in a cleaning establishment, loading and driving trucks, and finally, working as a commercial artist drawing pots and pans for newspaper advertisements.

In 1937, Baker went to Hollywood to work for Walt Disney. For the next four years he worked on virtually all of Disney's well-known pictures including *Pinocchio, Fantasia, Dumbo,* and *Bambi*. From there he was inducted into the U.S. Army in June 1941.

Most of his evenings in the service were spent drawing cartoons of army life using Sad Sack as the bewildered civilian trying to be a soldier. *Yank Magazine,* which was then forming, invited Baker to join its staff. To keep Sad Sack abreast of developments, *Yank* sent Baker to dozens of army camps around the world.

After the war, Baker and Alfred Harvey formed a partnership to publish *Sad Sack* comic books. Baker was godfather to Alfred's son, talented cartoonist Russ Harvey. Joe Simon was godfather to his younger son, Eric.

The portrait on this page was drawn by one of Baker's close friends, Sgt. Gregor Duncan of the European *Stars and Stripes,* a short time before Sgt. Duncan was killed in the line of duty.

MILITARY BEARING

SGT. GEORGE BAKER

SEX HYGIENE

THE BAYONET

SGT. GEORGE BAKER

SGT. GEORGE BAKER

Chapter 17

A House in the Country

INSET RIGHT AND OPPOSITE PAGE FAR RIGHT: *A bunch of impressive postwar comic book covers by the Team Supreme, Joe Simon and Jack Kirby. Noted comics artist and former DC publisher Carmine Infantino notably contributed to* Charlie Chan. *©2003 the respective copyright holders.*

OPPOSITE PAGE TOP: *The author pauses for a picture portrait in his Long Island home studio during the late 1940s.*

BELOW: *The Simon family living the American Dream in the suburbs of Long Island, New York.*

With the return of the war veterans, the nation faced an acute housing shortage. Even hotels were booked solid and were expected to discourage lengthy reservations so that, in New York City, the transients wouldn't be forced to sleep in Grand Central or Penn Station. The situation was that critical.

Jack Dempsey, the legendary ex-heavyweight boxing champion, owned the Great Northern Hotel in New York City on West 57th Street, four blocks from the Harvey Publications office. I knew Dempsey from the Coast Guard Public Information Division where he served as an officer assigned to travel around the country to Coast Guard Stations, boosting the morale of the men. In between his travels, he would hang out in our art room watching the artists at work while chain-smoking huge expensive Cuban cigars, but taking less than a half dozen puffs from each cigar before discarding it and lighting up a fresh one. More than one of the artists collected the butts after he left and sometimes they wound up scuffling for the booty with the winners puffing the butts down to their fingernails.

After my discharge, I returned to New York, still in uniform, carrying my seabag and checked into the Great Northern Hotel where the desk clerk told me I could stay no longer than three days. I asked to see Jack Dempsey. The great man greeted me warmly. When I explained that I was homeless, he instructed the desk clerk that I could stay as long as I wished. He lit up a huge cigar, took a few puffs and then abandoned it in the ash tray. I passed it up.

Suddenly, housing developments were springing up all over the countryside. Farmers were getting rich selling their land. Every other entrepreneur, it seemed, became a builder. They were accountants, bankers, clothing manufacturers, merchants hoping to clean up on the building boom. It was almost a replay of the early comic book gold rush. Only the arena was changed — potato fields instead of newsprint.

Kirby's wife, Roz, and their first child, Susan, a three-year-old, lived at her family's house in Brooklyn during the war. I was newly wed to Harriet, Alfred Harvey's lovely secretary, who harbored an intense dislike for city living. Harriet was a very persuasive young woman. She convinced us that we should all move to the suburbs in the same neighborhood where "the boys can work together in the good, clean air amidst green grass and lush shrubbery."

Every weekend we would all pile into my 1941 red Buick convertible, traversing the highways and byways of Connecticut and Long Island in search of the house of our dreams.

What we found were housing developments partially constructed, some with only foundations and piles of lumber gathering dust, window units covered with canvas to keep the sun from drying and cracking the unpainted wood frames, and plumbing pipes rusting away. The new builders were waiting for Congress to pass a promised Veteran Administration Housing Act that would provide

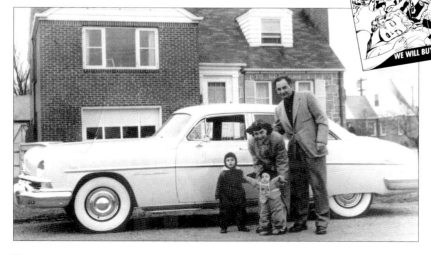

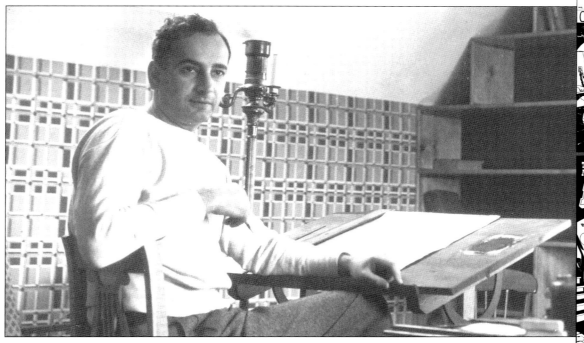

financing for the builders along with four percent interest mortgages with little or no down payments for the G.I.s.

Until the VA bill passed, construction companies were reluctant to do any business at all. Meanwhile, we continued our search for a solvent builder who was willing to sell us a house.

Our search ended in Mineola, Long Island, on Brown Street —a former potato field — where several houses of a proposed one-block development were almost completed. It was twenty-five miles from the city, though at the time it seemed like the edge of the world. The builder, upon hearing that we were willing to pay him a substantial down payment of $3000 each, agreed to sell us two houses, diagonally across the street from the other. Each house, on a 60' x 100' plot, was priced at $11,000. Since most of the lovely, well-built pre-war houses in the area had sold for no more than $3,000, we were under-standingly reluctant at first, until we recognized the fact that this was the going rate for the inflationary times. Even the original Levittown houses — that mass-built assembly-line tract development would run to over $6,000 before a vet could move in.

By the time the houses were completed, the VA bill had passed Congress, so after inspection of the completed houses, we closed title with a local bank, which by the way, also financed the builder. Since neither of us owned any furniture nor household utensils, we ordered the barest essentials: beds, kitchen tables and pots and pans from Macy's. At an appointed time, the Kirbys and the Simons drove in my red Buick convertible to our new addresses to meet the furniture delivery truck. We would be the first kids on the block.

When we arrived, there was something different about the place. It seemed ugly and barren.

Harriet was fuming. "We've got rocks for a lawn!"

The developer had stripped the top soil from the entire development and sold it to finance his construction.

"Maybe he's gonna give us new dirt," Kirby, the city boy, commented.

We all looked at him.

"Well, the damn stuff was old," Kirby persisted. Roz shook her head, perplexed.

We stormed into the builder's home a few blocks away, screaming mild obscenities. The crook didn't even have an office.

"I never sold you top soil," he blustered. "If you must have top soil, I'll sell you some." Much as we tried, we couldn't get satisfaction.

"It's like dealing with a goddamn comic book publisher," Kirby lamented.

We moved into our respective houses and each had a studio built in the attic where we could work separately or together, and keep our work reason-ably separated from our family lives.

Our furnishings were sparse and inexpensive. My picture window faced Kirby's house across the street. The window was adorned with post-war paper draperies that looked and felt remarkably like cloth.

It was a quiet, tree-lined neighborhood which soon became populated by other veterans, where the neighbors wondered about the two young men who didn't go off to work every morning like the rest of the husbands. We spread the word that we were bookies. It was more prestigious than being known as comic book artists.

Alfred Harvey

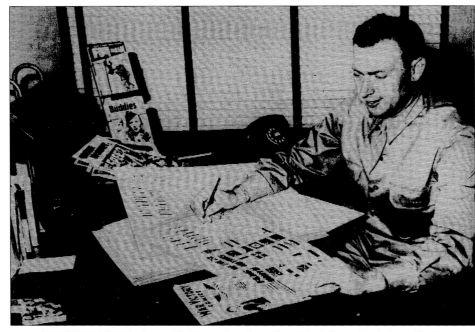

he year was 1941. Young Al Harvey, an Eagle Scout from Brooklyn, N.Y., had an idea for a different kind of comic book. With an initial investment of less than four hundred dollars, and a little help from his friends, he became a Comic Book Maker and built an empire of entertainment. Here he is (right) at the Pentagon during World War Two, along with the actual caption (below right) that accompanied the photo. Alfred rose in rank to captain, turning out a host of service-oriented comic books for the United States government.

ABOVE: COMICS SELL BONDS—*Private Alfred Harvey, formerly president of Family Comics, Inc., looks over* War Victory Comics *magazine, the first government-sponsored comic book, which he produced for the U.S. Treasury Department to promote War Bonds and Stamps to children. Magazine is crowded with contributions by famous cartoonists.*

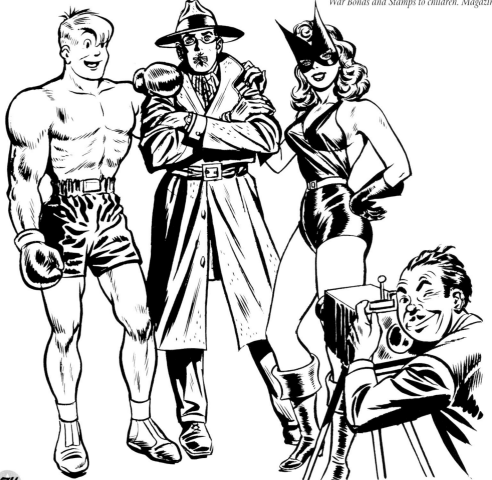

ABOVE: *The aforementioned Alfred Harvey-produced comic book, featuring contributions from a plethora of cartoonists, put together for the U.S. Treasury Department.* ©2003 the respective copyright holder.

LEFT: *1940s comic book pin-ups, Joe Palooka, Green Hornet and Black Cat pose for Harvey's readers.* ©2003 their respective copyright holders.

Dick Tracy

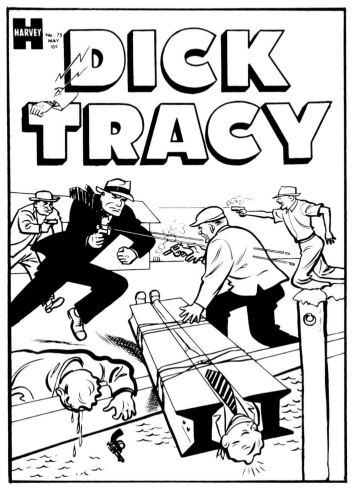

THIS PAGE: *Some more Harvey-related miscellanea. At left, Joe Simon drew this Dick Tracy cover. At right, comicdom's great detective pursues yet another bizarre villain. ©2003 Tribune Media Services, Inc. Below is a handsome model sheet for Green Hornet artists, drawn by Al Avison in the 1940s. ©2003 the respective copyright holder.*

Chapter 18

Post-War Bust

everal of the artists we knew had died in the war. My friend Jimmy Miller, the copy boy at the *Syracuse Herald*, was killed in action.

The creative talent returning from the services was eagerly courted by the publishers. Al Harvey who had held the rank of Captain, stationed at the Pentagon in Washington, D.C., where he specialized in graphics and small publications, including military-oriented comics, had been in constant touch with me in the capitol, and when the war was winding down, Alfred made a tempting offer. Harvey Comics would publish a new line of Simon and Kirby comic books at a fifty percent profit-sharing split.

My landlocked "shipmates" in the Coast Guard Combat Art Corps had expressed a strong desire to come to New York with me and make their fortunes in the lucrative comic book business, and so it was with Jack Kirby and a new staff of five war-rested veterans — artists, writers, officers, and enlisted men — that I invaded the Harvey offices to organize our new line of comic books.

The Harveys had moved their offices from 44th Street to the entire fifteenth floor of 1860 Broadway near Columbus Circle.

Each of the three brothers had a huge office with an adjoining smaller office for his secretary. Alfred, the president, brought in a crew of cabinet makers to construct a massive oval, redwood desk, much too large to be moved if the company should decide to vacate the premises. It was like building a yacht in one's living room. You would have to launch the house with the ship.

Another good-sized room held the art department. Otto Pirkola was the actual art director, regardless of Leon's title. Otto and Harlan Crandall, the former art director at Macfadden Publications who had steered me into the comic book business, had spent time moonlighting as an advertising agency. The endeavor had faltered and the part-time partners decided to search out other means of employment. When Alfred Harvey told them he had an opening for an art director — but that he could hire only one of them — the two ex-advertising guys flipped a coin in Alfred's office. Otto won and remained for over twenty years until he retired.

Otto's young assistant was Ken Selig, a graduate of the High School of Music and Art, and just discharged from the army. A bullpen of letterers and three production artists occupied the remaining drawing tables.

Another large office was occupied by the business department where three pretty young ladies constantly punched adding machines while an eagle-faced young man totaled up the profits on ruled yellow pads.

My crew of military veterans commandeered the only remaining quarters, a small office supply room that also contained the executive men's room. The three Harvey brothers did not condescend to use the employees' facility a half-flight up the stairway which my Naval boys called "the ladder."

To say that we cluttered our new quarters with personnel and equipment wouldn't be quite accurate. It was cluttered before we came. Here, in our closet-sized office we confidently proceeded to produce comic books.

Our plan was to first establish a beachhead and gradually expand to larger space.

<u>ABOVE AND RIGHT</u>: *Kid Adonis and the Duke of Broadway were two back-up strips produced for Harvey Comics which were wholly written and drawn by Joe Simon alone. ©2003 Joe Simon.*

Alfred Harvey's great passion in life was scouting. It was said that he had been awarded every Boy Scout merit badge ever devised, and in his teens was scoutmaster of his own very select troop in Brooklyn. He tried to keep in touch with his troops through the years as they were growing up and, as a result, his office staff was now populated by many of his former scouts.

One day, when the executive men's room was occupied, Alfred made use of the employees' facility (up the ladder) where he noticed a lot of mail on the floor in one of the stalls. He lifted his chin over the swinging door to see what was going on. One of his ex-Boy Scouts, sitting on the toilet, was opening the envelopes and shoving the subscription money into his pants pockets. After a brief scolding, Alfred accepted the man's weeping apology and his vow never to steal the subscription money again. Scout's honor! It is a testimonial to Alfred's devotion to the scouting movement that he kept the wayward young man on the payroll.

Kirby and I thought we did some of our best work on the comic books we produced for Harvey Comics. All the ingredients of our former successes were jammed into *Boy Explorers,* a peacetime follow-up to *Boy Commandos*; Stuntman, a former circus acrobat who committed spectacular heroics for his look-alike leading man, a handsome but cowardly heel; and several "filler" features which were innovative and experimental. There was the Duke of Broadway, a non-costumed hero with a cast of Damon Runyon-type characters; Kid Adonis, a prize fighter; the Demon, a judge who assumed a secret identity to violently carry out a sentence upon the guilty when justice failed, and the Vagabond Prince, a greeting card writer who with his cohorts, Jester and Chief Justice, donned colorful costumes to fight evil everywhere, leaving at the scene of the crime a scribbled jingle for the police, along with the trussed-up criminal.

<u>INSET LEFT</u>: *Two more comic book covers by Simon and Kirby produced during lean times in the late 1940s. ©2003 Joe Simon and the Estate of Jack Kirby.*

<u>NEXT PAGE</u>: *The Duke of Broadway was, in a 1945 coupon mail-in poll, voted the most popular of Harvey Comics' adventure series, in spite of the fact that he was not a costumed superhero. Words and pictures by Joe Simon. ©2003 Joe Simon.*

79

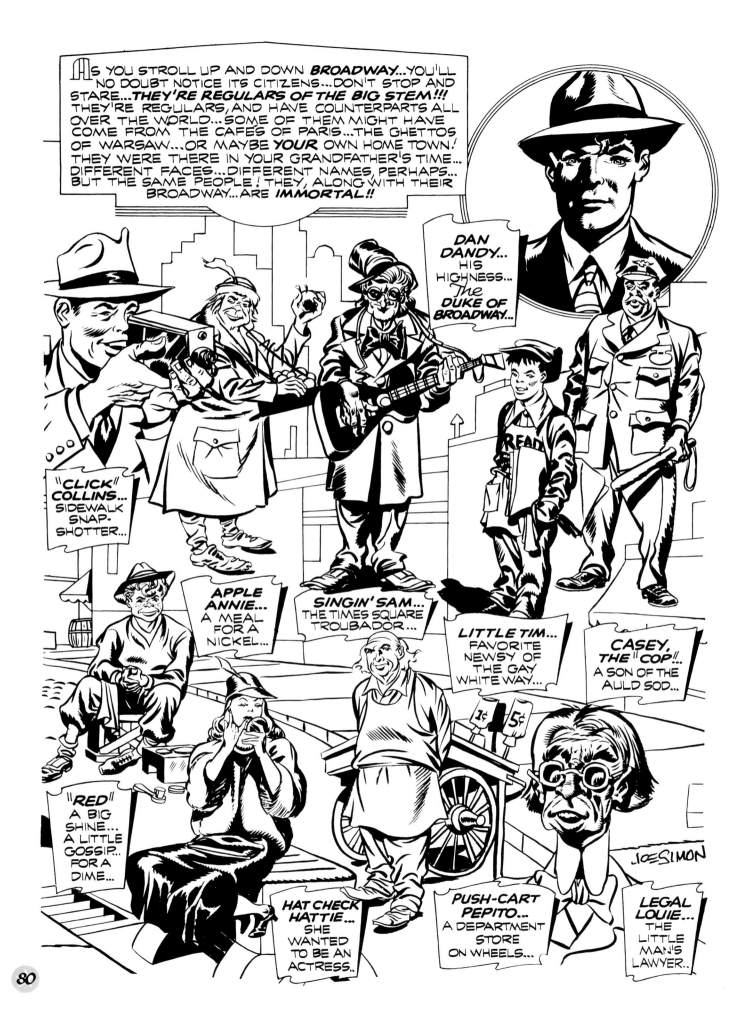

AS YOU STROLL UP AND DOWN *BROADWAY*...YOU'LL NO DOUBT NOTICE ITS CITIZENS...DON'T STOP AND STARE...*THEY'RE REGULARS OF THE BIG STEM!!!* THEY'RE REGULARS, AND HAVE COUNTERPARTS ALL OVER THE WORLD...SOME OF THEM MIGHT HAVE COME FROM THE CAFES OF PARIS...THE GHETTOS OF WARSAW...OR MAYBE *YOUR* OWN HOME TOWN! THEY WERE THERE IN YOUR GRANDFATHER'S TIME... DIFFERENT FACES...DIFFERENT NAMES, PERHAPS... BUT THE SAME PEOPLE! THEY, ALONG WITH THEIR BROADWAY...ARE *IMMORTAL!!*

DAN DANDY... HIS HIGHNESS... *The* DUKE OF BROADWAY...

"CLICK" COLLINS... SIDEWALK SNAP- SHOTTER...

APPLE ANNIE... A MEAL FOR A NICKEL...

SINGIN' SAM... THE TIMES SQUARE TROUBADOR...

LITTLE TIM... FAVORITE NEWSY OF THE GAY WHITE WAY...

CASEY, THE "COP"... A SON OF THE AULD SOD...

"RED" A BIG SHINE... A LITTLE GOSSIP.. FOR A DIME...

HAT CHECK HATTIE... SHE WANTED TO BE AN ACTRESS..

PUSH-CART PEPITO... A DEPARTMENT STORE ON WHEELS...

LEGAL LOUIE... THE LITTLE MAN'S LAWYER..

JOE SIMON

80

Project Fighting American

Young Nelson Flagg's heart pounds wildly as he waits for the unknown. There is no sound, no pain — just the weightless sensation of risking —and suddenly being everywhere at once — of watching a glowing ball dart frantically about on a screen — knowing that it is he himself being transferred into the muscular body of his mortally-wounded brother.

In this secret government lab, in the year 1954, Jack Kirby and I are the only witnesses to the creation of the world's first high-tech super-agent.

Joe Simon

The gun in the fat man's hand belched and roared, and that was when O'Shean saw that his own gun was working

Above: Pulp magazine illustration by a young Joe Simon from the August 1940 issue of Detective Short Stories.

Bellow : Original Mainline Publications stock certificate, signed by officers Joe Simon and Jack Kirby.

Sick Cover Art

Harvey Kurtzman, a talented cartoonist and editor, was acknowledged as the force behind the original success of *Mad* magazine. At a Christmas party, publisher Bill Gaines was stunned when Kurtzman demanded a controlling interest in the magazine. Gaines refused and Kurtzman walked out, taking top star artists Jack Davis and Will Elder, with him.

They went into business for themselves, packaging new satire magazines, two in a row, which both failed in just over a year.

Joe Simon said it was his good fortune that Davis couldn't return to *Mad*. Davis worked with Simon on *The Adventures of the Fly, The Double Life of Private Strong,* and other projects. He was a steady contributor to *Sick* magazine for years. Later, he did return to *Mad* and became the nation's leading commercial cartoonist.

Reproduced here, from the original paintings, are covers by Jack Davis, one of the greatest ever.

Dick Briefer's unpublished *Frankenstein* cover was utilized with embellishments as a 2-page spread in *Sick* magazine.

The original Vision by Joe Simon and Jack Kirby for Timely Comics circa 1940.

The Double Spread

The comic book centerfold was devised by Joe Simon and first introduced in 1941, the sixth issue of *Captain America Comics*, ten years before *Playboy* entered the market and made "centerfold" a household word. It was known in the trade as the "double spread" and it became a distinct concept in the Simon and Kirby adventure books. The expansive drawing area of two pages (plus "gutter" space, the empty area where the two pages are staple-bound) afforded the artist an exceptional opportunity for exciting design and action,

Old Mother Hubbard went to her cupboard to get some food for her dog, "Buff"... Although one was aware that her cupboard was bare... She claimed it was crammed full of stuff!

YES...

MOTHER GOOSE MANIA RAN RAMPANT BEHIND THE GRIM, FOREBODING WALLS OF THE CHALKER REST HOME AND SENT FRED DRAKE, IN HIS DISGUISE AS

STUNTMAN

ROARING INTO THE NIGHT ON HIS STRANGEST RESCUE MISSION! FOR HE KNEW THAT BENEATH THIS WHIRLPOOL OF INSANITY WAS A DIABOLICAL NETWORK OF EVIL... WITH DON DARING AND SANDRA SYLVAN HELD FAST IN ITS DESTRUCTIVE GRIP!

resulting in some of the truly spectacular products of this new American art form. Comic books were made up of 64 pages plus covers, so there wasn't much concern about wasting story space.

The double spread was used in much the same fashion as a movie "Coming Attractions" promotion, the idea being to excite the potential comic book buyer into become an actual buyer when browsing through the comics at the newsstands.

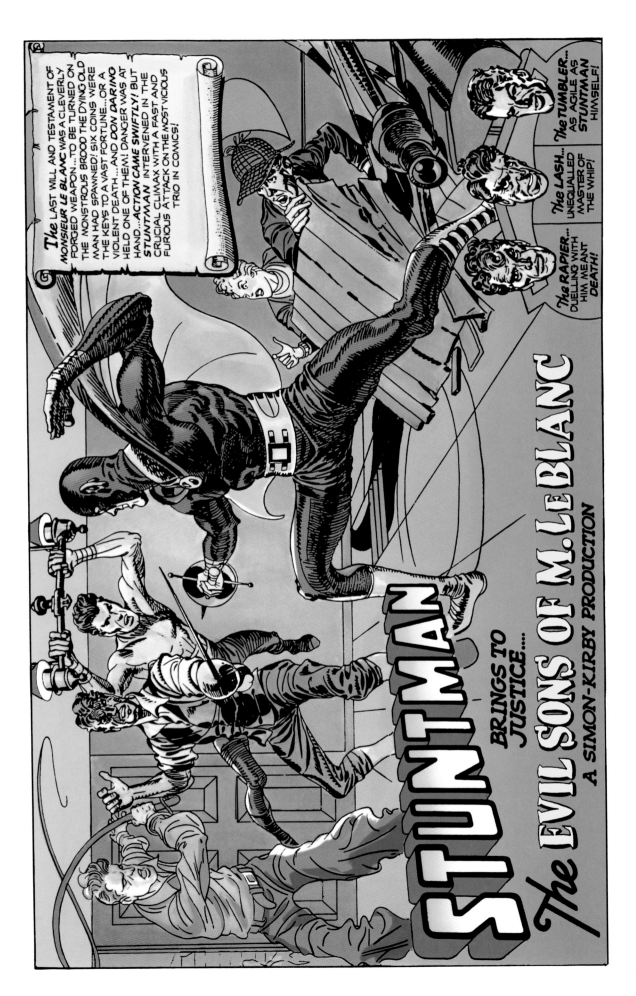

Stuntman

These treasured 1945 double spreads are previously unpublished. The original art was discovered in a warehouse in 1980.

Boys' Ranch

The double spreads in *Boys' Ranch* attempted a different concept. They had no relation to the story line but instead dealt with the characters, the *Western* locale, and sometimes "cowpoke" legend.

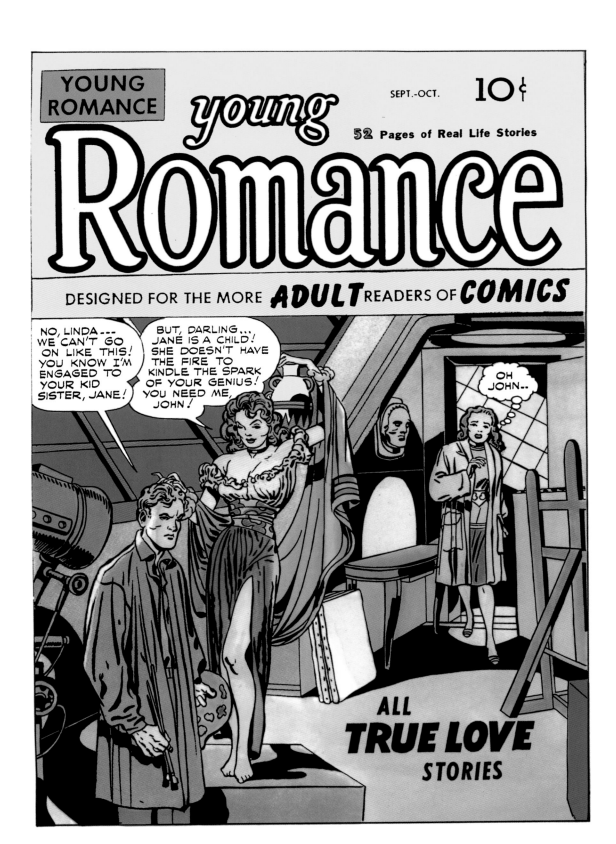

Young Romance

The first cover. It shook up the entire comic book industry, spawning over 600 imitations. Martin Goodman, publisher of *Captain America Comics,* wrote to Harry Donenfeld, whose Independent News Corporation distributed *Young Romance,* accusing him of helping to foster obscenity. Donenfeld, who was making big money distributing the runaway best seller, instructed Simon and Kirby to remove the word "adult" from the subtitle. Goodman, in response, put out dozens of imitations. *Young Romance* survived and prospered for generations.

Fox Publications:
Slavery, servitude, sex!

Bondage had its own little niche in Fox Publications' comic book itinerary as demonstrated by Joe Simon's covers of 1939. "I would take a feature from inside the comic book" Simon relates, "and attempt to translate it to a saleable cover design." "My greatest satisfaction was working from Lou Fine's incomparable, inside story art."

CAPTAIN AMERICA

STARS & STRIPES IN LOGO

MAILED ARMOR

SOLID BLUE

MARTIN —
HERE'S the CHARACTER - I THINK HE
SHOULD HAVE A KID BUDDY OR HE'LL BE
TALKING TO HIMSELF ALL THE TIME -
I'M WORKING UP SCRIPT - SEND SCHEDULE -
REGARDS -
JOE

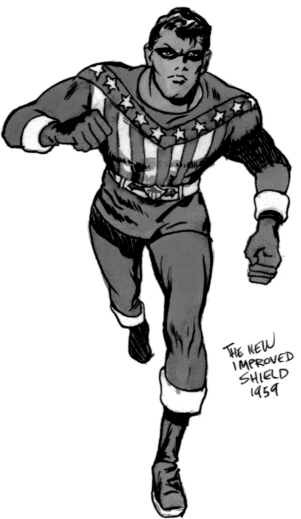

THE NEW IMPROVED SHIELD 1959

The first-ever sketch of Captain America. It was a costume design by Joe Simon, even before the kid companion, Bucky, was born. The note is to publisher Martin Goodman.

To avoid a lawsuit, the vertical shield was later changed to a round shape when the publisher of the Shield protested that it looked too much like the insignia on the costume of his character.

Nineteen years later, Simon was to revive and revise the original Shield character in *The Double Life of Private Strong.*

This new Shield was cancelled after two issues — not because of poor sales but because DC Comics threatened a lawsuit, claiming that the super-powered Shield was too similar to Superman.

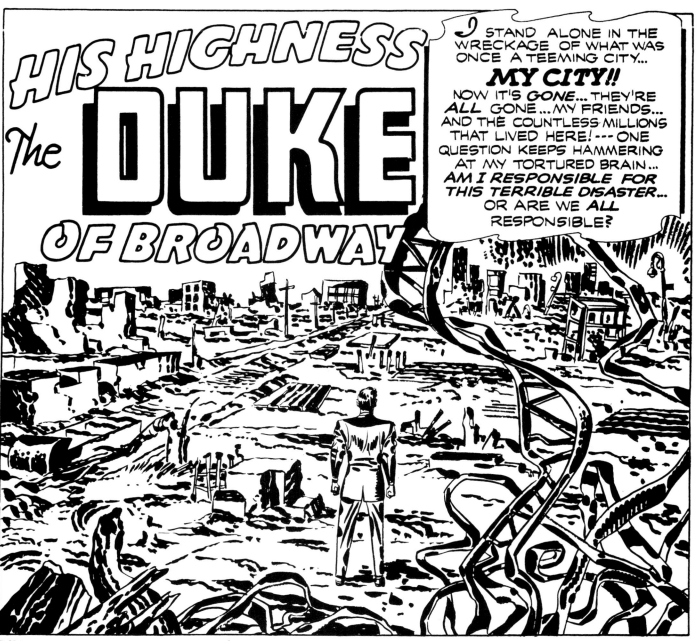

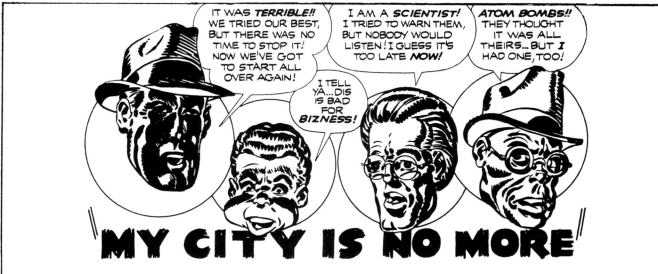

BROADWAY... CARPET FOR A MILLION FEET DAILY...

CLICK!

HOLD THAT POSE, MISTER!

BLAST YOU SIDEWALK PHOTOGRAPHERS!

CLONK!

WELCOME

WELCOME ATO

APPLE, MISTER?

NEIN

APPLE ANNIE

BROADWAY... GREAT GREETER OF MULTITUDINOUS EXTRAVAGANZAS... PICTURES, PLAYS, FAIRS, AND ONE ATOM COMMITTEE DESIGNED TO SAVE MAN--- FROM MAN!!

WELCOME ATOM COMMITTEE

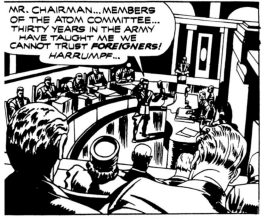

MR. CHAIRMAN... MEMBERS OF THE ATOM COMMITTEE... THIRTY YEARS IN THE ARMY HAVE TAUGHT ME WE CANNOT TRUST FOREIGNERS! HARRUMPF...

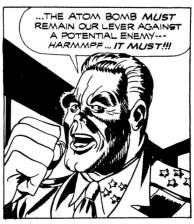

...THE ATOM BOMB MUST REMAIN OUR LEVER AGAINST A POTENTIAL ENEMY--- HARMMPF... IT MUST!!!

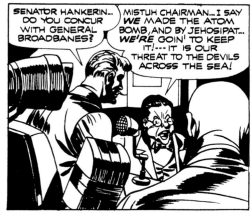

SENATOR HANKERIN... DO YOU CONCUR WITH GENERAL BROADBANES?

MISTUH CHAIRMAN... I SAY WE MADE THE ATOM BOMB, AND BY JEHOSIPAT... WE'RE GOIN' TO KEEP IT!--- IT IS OUR THREAT TO THE DEVILS ACROSS THE SEA!

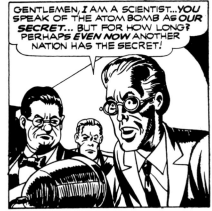

GENTLEMEN, I AM A SCIENTIST... YOU SPEAK OF THE ATOM BOMB AS OUR SECRET... BUT FOR HOW LONG? PERHAPS EVEN NOW ANOTHER NATION HAS THE SECRET!

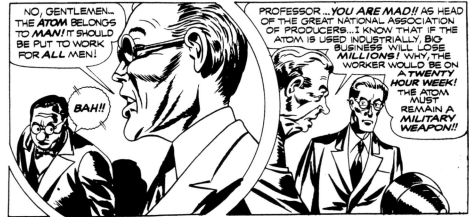

NO, GENTLEMEN... THE ATOM BELONGS TO MAN! IT SHOULD BE PUT TO WORK FOR ALL MEN!

BAH!!

PROFESSOR ...YOU ARE MAD!! AS HEAD OF THE GREAT NATIONAL ASSOCIATION OF PRODUCERS... I KNOW THAT IF THE ATOM IS USED INDUSTRIALLY, BIG BUSINESS WILL LOSE MILLIONS! WHY, THE WORKER WOULD BE ON A TWENTY HOUR WEEK! THE ATOM MUST REMAIN A MILITARY WEAPON!!

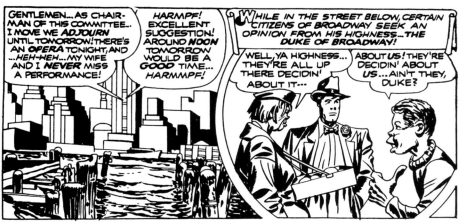

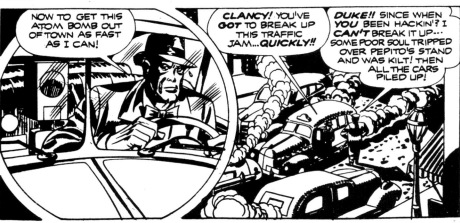

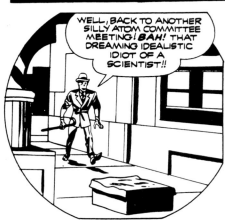

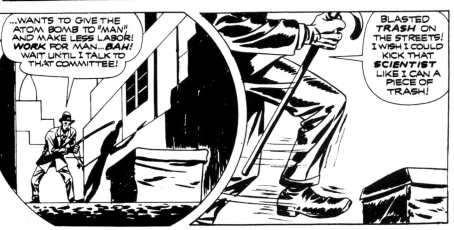

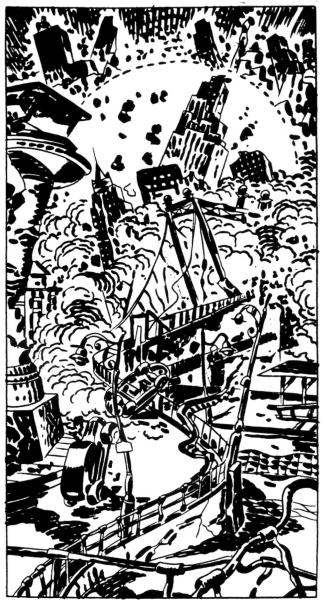

On the Ranch

After the war, the government had cancelled its paper rationing program. Publishers, inspired by the high sales percentages of the war years, raised their print orders and rushed to add more titles. New publishing companies ventured into the field. The big companies thought they could "freeze" the newcomers out by over-saturating the market and were willing to suffer a temporary loss to get rid of them. The news dealers were chaotic. There was no room on their newsstands for all the comic books. They kept only established titles.

Bundles were returned, unopened, for credit. The Simon and Kirby comics were cancelled after we had completed two issues. *Boy Explorers* #2 was not even published (at least for newsstand distribution, as subscribers received a reduced-size, black and white "ashcan" edition).

We didn't come back to Harveys until 1950, when once again we prepared to make good with a "kid" comic book. This time it was a feature about a group of youngsters who settled on their own Western spread. It was named *Boys' Ranch*.

BELOW: *Reproduced directly from the original art, a quartet of panels from the story, "Meet Wee Willie Weehawken," in* Boys' Ranch #1. *Written and drawn by Joe Simon and Jack Kirby, published by Harvey Comics in 1950. ©2003 Joe Simon and the Estate of Jack Kirby.*

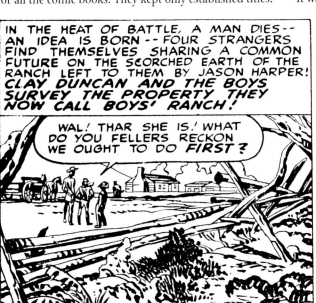
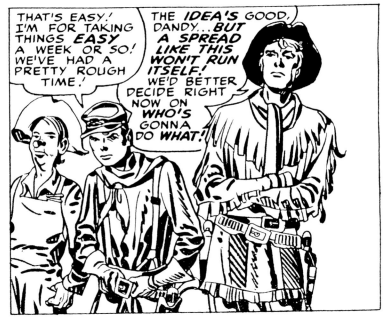
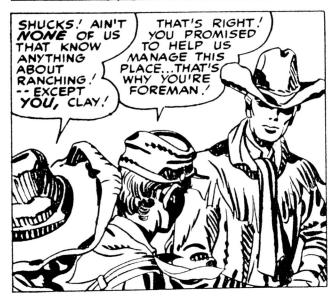
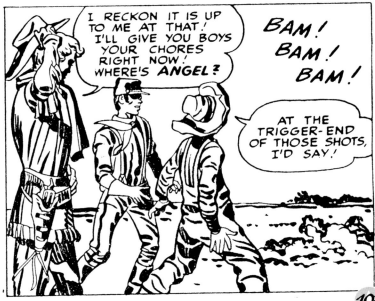

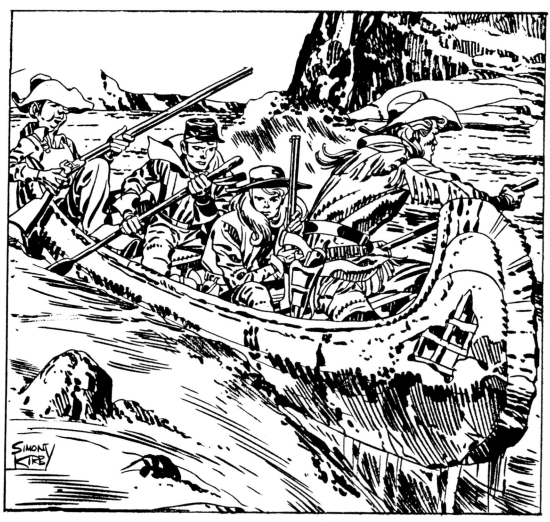

In September, 1950, after the lawsuit resulting in Siegel and Shuster's surrender to the forces of DC Comics, Jerry and Joe attempted a humorous newspaper strip, anticipating that their byline and publicity would insure its success. The title of their new hero was *Funnyman*. It had a short run and failed but not before a six-issue comic-book run through 1948. Jerry dropped in on me at Harvey unannounced. He was greeted with the respect and cordiality reserved for the royalty of comicdom.

Jerry looked none the worse for wear, considering his recent reversals. I ushered him into our little office and removed a pile of boards from a chair. Jerry settled into it heavily.

"Sorry to hear about your problems with DC," I said. "It must have been rough."

"I'm putting all that behind me," he sighed. "There are other fish to fry."

I remained silent, contemplating how I would respond if he asked for work. Considering

his prominence, it would be embarrassing to turn him down.

But my fears turned out to be groundless. "Joe," he said, "I'm starting a new comic book program for Ziff-Davis Publications. They've made me a very attractive offer and I expect to make it pay off big."

Siegel was recruiting talent and digging for ideas for a full line of comic books. Ziff-Davis was known to be a quality publishing house with excellent distribution. They were aware of Siegel's part in the fabulous fortunes of Superman, and felt that it would be a good investment to give him a second chance to strike it rich — this time for Ziff-Davis.

"What about Shuster?" I asked.

"We'll find work for Joe if he wants it," Siegel replied. "I'll be the editor and part of management. Frankly, at this point, Shuster's not involved."

We couldn't help Jerry in any way since we were committed to our own program with the Harvey organization. Our staff was small, but each man had been carefully chosen and nurtured. They were extremely valuable to us if we expected to maintain the schedules we had mapped out. Jerry said he understood. He stood up and glanced around the room. "What kind of stuff are you doing here?" he asked.

I reasoned that it would do no harm to show him our products, since they were already in production. He examined the covers thoroughly. He lingered on the *Boys' Ranch* art. "This is really a coincidence," he said, drawing out his words slowly. "I'm working on the same title."

"Really?" I said. "I'd like to see what you've done on it."

"We'll be in touch," Jerry said. We shook hands and he departed.

Almost immediately after our *Boys' Ranch* went on sale, Harvey received a letter from Ziff-Davis Publications accusing us of lifting the idea of *Boys' Ranch* from Jerry Siegel. Alfred Harvey requested to see their version. They had nothing to show. The matter ended there.

Boys' Ranch Action Portfolio

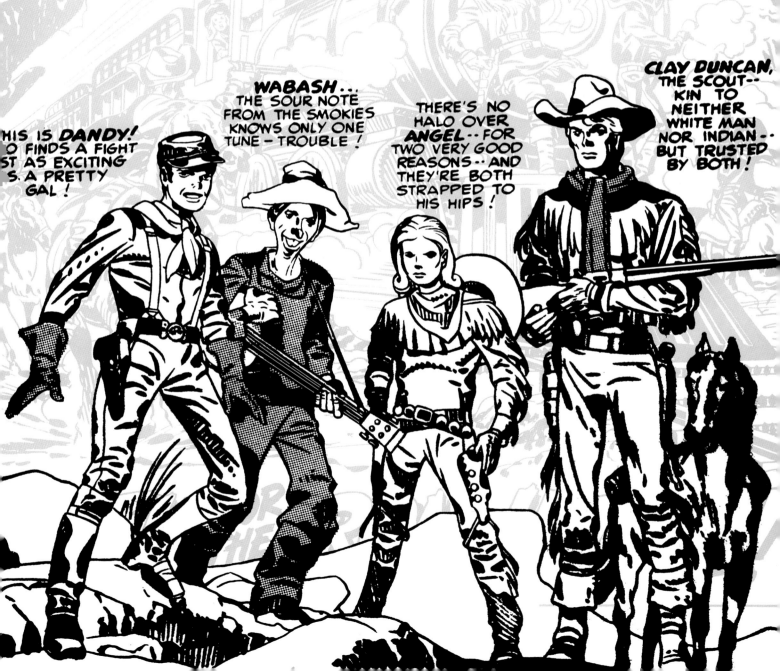

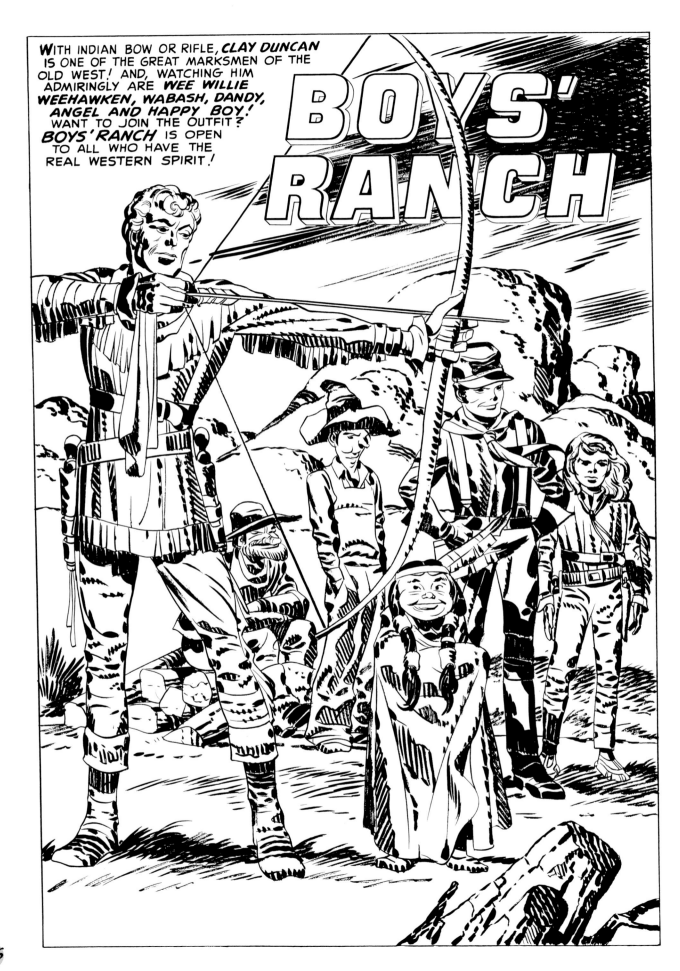

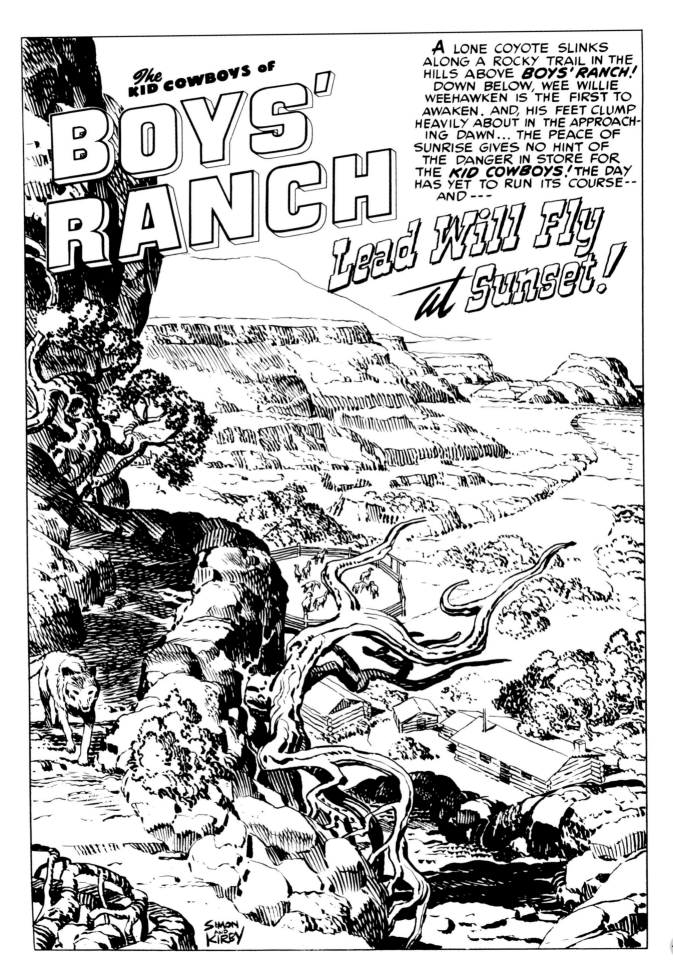

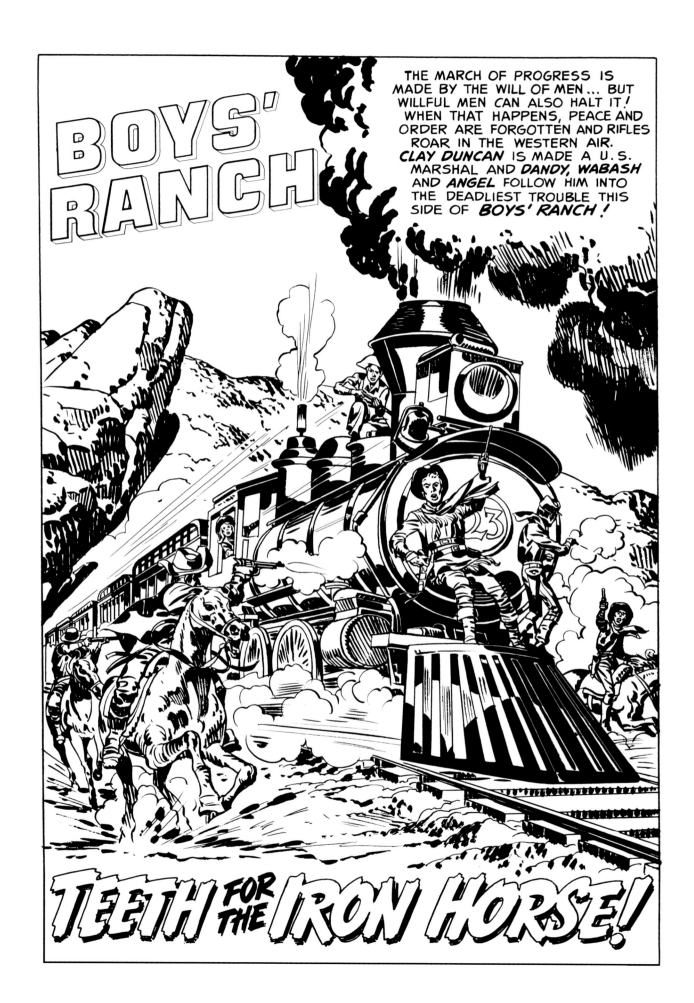

BOYS' RANCH

THE MARCH OF PROGRESS IS MADE BY THE WILL OF MEN ... BUT WILLFUL MEN CAN ALSO HALT IT! WHEN THAT HAPPENS, PEACE AND ORDER ARE FORGOTTEN AND RIFLES ROAR IN THE WESTERN AIR. *CLAY DUNCAN* IS MADE A U.S. MARSHAL AND *DANDY, WABASH* AND *ANGEL* FOLLOW HIM INTO THE DEADLIEST TROUBLE THIS SIDE OF *BOYS' RANCH!*

TEETH FOR THE IRON HORSE!

The Years of Romance

illman Publications occupied two floors of an older but fashionable building on 42nd Street and Broadway. The polished, marble-facade elevator was used by prosperous-looking people. A uniformed elevator operator let me off in a thickly carpeted waiting room staffed by two elegant female receptionists at adjacent desks in the center of the room. In neat rows on paneled walls hung framed covers of Hillman's slick magazines and books — automobile manuals, radio journals, women's service magazines, boating magazines. There were no comic book covers displayed.

The grandeur of the office gave me an exhilarating sense of accomplishment, which was quickly muted when the receptionist led me through the halls, past neat, carpeted offices and into a seedy, bare-floored, loft-like room where one had to move around cardboard boxes of magazine returns.

Tacked on the wall was a sketch of a comic book character, "The Heap." The Heap was much like a comic book character that DC published later, called Swamp Thing. The Heap was one of Hillman's more successful characters.

In a comer of the room, before the only window, a graying, mustached, distinguished looking man in a fashionable three-piece business suit was holding a story conference for a comic book writer. He paused to introduce himself as Ed Cronin, the Hillman comic book editor, then quickly returned to his labors.

As he warmed to his fantasy, he darted about the room; leaping over imaginary buildings, flapping his arms as if in flight; never pausing in an incredible monologue.

I soon gathered that this was "Gunmaster," soaring high above the metropolis, then sprightly landing to combat evildoers. Although Gunmaster had unique powers which included an unparalleled collection and mastery of firearms his plot line degenerated like most other crime fighters, into a punch in the mouth.

And now, as I watched in amazement, the man in the three-piece suit was thrashing out at his imaginary tormentors with a flabby left and an arthritic roundhouse

right. Mr. Cronin was huffing and puffing audibly, but he didn't slow down.

Because I had covered the boxing beat on the newspapers, I worried about Mr. Cronin's thumb sticking straight up from his fist. "Gunmaster's going to get his thumb broken," I predicted.

The writer was nodding in agreement and admiration, and Cronin was encouraged. He was banging two heads together — *SMASH!* — a favorite form of punishment for foes of superheroes. He slapped his fists together — *BAM!* — dropped one hand down sharply and —*OUCH!* — his hand pierced the pointed metal paper holder on the cluttered desk, sending spurts of blood flying about the scattered scripts. Ed Cronin finished the pantomime with the pointed object dangling

BELOW: *Typically evocative Simon and Kirby panel detail expressing the melo-dramatic approach which made their romance comics so successful, the best-sellers of their heyday in the late '40s and early '50s. From* Young Romance. *©2003 DC Comics.*

DARLING...YOU SHOULDN'T BE HERE! YOU KNOW IT'S UNLUCKY FOR THE GROOM TO SEE THE BRIDE BEFORE THE CEREMONY!

THERE ISN'T GOING TO BE ANY CEREMONY -- NOT AFTER I TELL HIM WHAT I KNOW!

from his bloody palm.

Tugging away the paper sticker, Cronin wrapped his fist in a handkerchief and frowned. "Where was I?" he asked.

"Gunmaster has just kayoed Public Enemy Number One and Public Enemy Number Two," said the writer.

"Oh, yes. We need a new episode. Finish the one I just described. Here's Simon."

The writer got up and walked out of the cramped room. I occupied his chair. Cronin straightened his blue tie and asked if Simon and Kirby would work for him. I agreed. I felt that our interview was more of a battlefield briefing than a story conference.

Young Romance— A New Role for Comics

It had long been a source of wonder to me that so many adults were reading comic books designed for children, and now I was finding myself increasingly wondering why there was such a dearth of comic book material for the female population. Women factory workers, housemaids, housewives, and teen-age girls were settling for *Donald Duck, Mickey Mouse* and the adventure books. I wondered how they would accept a comic book version of the popular *True Story* magazine, with youthful, emotional, yet wholesome stories supposedly told in the first person by love-smitten teenagers. Visually, the magazine love stories seemed a natural conversion for comic books.

I mocked up a cover dummy. It was titled *Young Romance.* Above the title was the blurb: "DESIGNED FOR THE MORE ADULT READERS OF COMICS."

Our work at

Hillman publications was sporadic. There were rumors that the company was growing disenchanted with the comic book field. Our families were growing, and, to accommodate them, the Kirbys and the Simons had bought new, larger houses in East Williston, a short distance from our first homes.

I took the *Young Romance* cover across the street to Kirby's house. Roz was busy in the kitchen. "Jack's in the bathroom." She nodded toward the upstairs.

"I'll wait," I said.

"You'd better go up," she said. "He's been there for days."

The Kirby house was a two-story Tudor structure with wartime stucco that lost parts of itself in every rainstorm. The one bathroom at the top of the stairs was quite ample, actually extravagant for the postwar construction.

The door was open and a strong smell of turpentine emanated from the interior. Dozens of paint cans covered the tiled floor. Kirby was in the midst of painting the plastered walls, with an amazing montage of blue water and tropical fish, from floor and bathtub to ceiling. Kirby wiped his brush with a color-stained rag when I walked in.

"What else is there to do?" he shrugged.

"This paint smell will kill you," I said. "Let's go up to your studio. I've got something to show you."

Kirby's studio was in the attic. The stairway was a ladder-like contraption, which swung into the ceiling on huge hinges. He pulled the rope and the ladder descended. After we had climbed to the attic, the stairs closed, shutting us off from the kids and the suburban world.

The attic walls were covered with the new building material named plasterboard, still unpainted. Dozens of printed comic book covers adorned the walls. I had to walk cautiously to avoid slivers from the rough-hewn floors. A drawing board nudged the one small window. An elaborate, oversized cherry wood taboret, custom carpentered to Kirby's specifications, took up much of the space. A comfortable couch completed the decor.

I flopped on the couch and displayed the cover mock-up.

"*Young Romance,*" Kirby observed. "Terrific idea."

"It's time we went into business for ourselves," I announced with bravado.

"At this time? It's too much of a gamble," he said. "Let's get someone to finance it."

Admittedly, going into debt on a risky business investment wasn't a well-calculated venture during this period of failing publications. We decided, instead, that there was only one way to show the proposal to a publisher: complete the contents of the book first so we'd have a head start if anyone tried to steal the idea.

The comic book field, for the artist, was falling into a periodic pattern of feast or famine. Preparing for the good sales periods (during the summer school vacations or in early January) afforded seasonal work. Publishers curtailed production for the weak sales periods during school terms. Then many artists went begging for work. Traditionally, the weakest season for artists came just before Christmas. One publisher was notorious for taking off for a Florida vacation every Christmas after giving orders to lay off dozens of artists.

The health of the industry was also affected in one way or another by the state of the economy or the abundance of titles being published. With the industry wallowing in the post-war deflationary period, living on our savings, we had ample time to complete the entire first issue of *Young Romance*.

Young Romance consisted of confession stories told by teenage girls, illustrated in comic book format, with speech balloons and captions longer than commonly used in adventure comic books. It offered more reading material and less art than usual.

Each romance "confessor" was typically plagued by guilt for such acts as falling in love with a delinquent, or kissing an older man of, perhaps, 25. All stories ended happily, however, with the girl thoroughly cleansed of "sins."

Story titles were sensationalized: "I Was A Teenage Hitchhiker," "They Called Me Boy Crazy," or "I Was A Gangster's Moll." The "filler" features consisted of short articles of incredible pathos, such as a teenager's plea for advice: "Won't Somebody Help Me?"

All stories were shamelessly billed as true confessions by young women and girls, when in actuality, all were authored by men. In the years of producing love comics, we were unable to come up with one female script writer who could satisfy our requirements for dramatic love confessions in comic book script form.

Maurice Rosenfeld, a transplanted Texan, held the title of general manager for a small comics house at 1790 Broadway, near 57th Street, named Crestwood Publications. Crestwood's only title of significance was *Frankenstein* comics, by Dick Briefer, which started out as a serious horror character then gradually became a humorous caricature of the classic novel. The creature was a copy of Boris Karloff's characterization for Universal Pictures, with a major change: in the original story, the monster's creator was Dr. Frankenstein; in the comic book, the creature was called Frankenstein or Franky, and the doctor was omitted.

We called on Rosenfeld, in his Crestwood office, to take a look at our new idea. "What do you think of it, Maurice?" I asked.

"Call me Reese," he said. "I changed my name."

"Reese Rosenfeld or Maurice Reese?"

"Just Reese. Cuts down the time in signing correspondence." Reese struck me as an extremely efficient executive. Charts and graphs virtually covered the walls. That made quite an impression on a guy who spent most of his life hunched over a drawing board at home.

"What do you want for this?" he asked, after reading the presentation.

"Fifty percent of the profits."

"Fifty percent?" He raised his jet-black eyebrows.

"We'll supply the artwork. We'll be paid for the art from the first profits and then we'll split the net."

Crestwood was owned by Mike Bleier, a brusque, burly middle-aged man, and Teddy Epstein, who was somewhat older. They published a few second rate comics

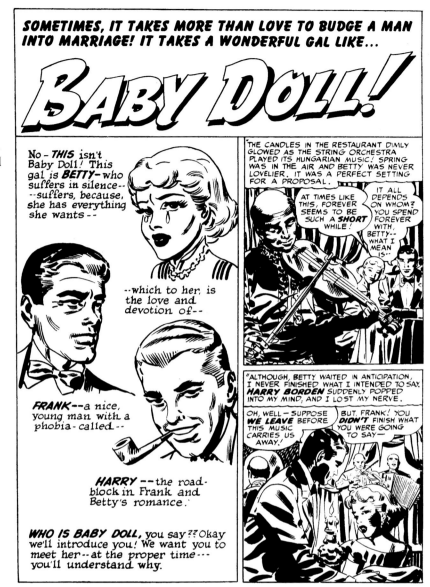

ABOVE: *Corny? Sure! But readers ate up the romance work of Simon and Kirby & Company, who produced hundreds of comics pages to fill the increasing demand.* ©2003 DC Comics.

"I WONDER IF MR. EDWARDS EVER KNEW THAT HE HAD SET OFF A CHAIN REACTION? MR. EDWARDS WAS THE MAN WHO OWNED THE HOTEL IN WHICH I LIVED... IT WAS HIS DECISION TO TEAR DOWN THE HOTEL TO MAKE ROOM FOR A NEW OFFICE BUILDING THAT STARTED ALL MY TROUBLES..."

OH!

CRASH!

"AFTER ALL, IT WASN'T MY FAULT IF I HAD BEEN DEEP IN THOUGHT AND HADN'T NOTICED THE RED LIGHT! THERE REALLY WASN'T ANY CAUSE FOR THE -- THE INDIVIDUAL IN THE OTHER CAR TO LOSE HIS TEMPER!"

A WOMAN DRIVER! I MIGHT HAVE KNOWN!

REALLY! IT WAS YOUR FAULT AS MUCH AS MINE!

ABOVE: It Happened One Comic! Simon and Kirby give the Clark Gable/Claudette Colbert film classic a nod in this Mort Meskin-drawn page from one of their romance comic books. ©2003 DC Comics.

OPPOSITE PAGE: Some comic book historians and critics consider Simon and Kirby's "Different"(Young Romance #30) to be an astonishingly sensitive and insightful, if veiled, look at the devastating effects of anti-Semitism, one of the finest comic stories ever produced. House ad promoting the tale. ©2003 DC Comics.

as well as love story and adventure magazines, mildly sex-oriented, under various corporations.

Teddy also owned a printing plant downtown that published, among other things, a daily racing sheet providing handicappers with betting information on the ponies, in competition with Walter Annenberg's *Racing Form.*

Teddy often boasted of his friendship with Annenberg, who later brought out a little publication named *TV Guide.*

Mike and Teddy heard our proposition and expressed the usual outrage at the terms of sharing the profits with a couple of artists. In reality it was a stupid deal for us since the likelihood of a comic book losing more than the cost of the artwork was remote.

Because their chance of losing money on the deal was small they agreed.

Arrangements were made, contracts signed, and we turned in the finished pages for publication. The first issue hit the stands in 1947. I remember because my first child, Jon, was born that year in a small private hospital in Roslyn, Long Island. Jack Kirby accompanied me to visit the new mother and greet the husky newborn. On the way,

we stopped at a local candy store to pick up some small gifts. A group of at least a dozen teenage girls in bobby sox were gathered around the newsstand rifling through pages of the newly arrived *Young Romance* comics, giggling and squealing with delight.

"I hope they put out more of these," one of the girls exclaimed. The others agreed in shrill sounds.

Jack and I were as excited as the girls.

Young Romance was a complete sell-out. The industry was stunned. What had been labeled a non-comic item rejuvenated the comic book market.

Independent News, an affiliate of Donenfeld's DC Comics, was distributing *Young Romance* for Crestwood Publications and they were delighted with the profit potential. But *Captain America* publisher Martin Goodman dampened their enthusiasm. He wrote a letter to Donenfeld criticizing the idea of a love comic book for kids. "It borders on pornography," he complained. "It will do irreparable harm to the field." The result was an order from Donenfeld to delete the words "DESIGNED FOR THE MORE ADULT READERS OF COMICS" from the covers of future issues.

The sales and print orders continued to soar, and soon a companion title, *Young Love,* was added. Each had the same type style for the logo. They were look-alikes, with the same artists and writers, and the contents of both magazines actually coming from a common inventory. *Young Love* did nearly as well. The two "love" books sold two million copies per issue between them. Almost every publisher in the business leaped on the bandwagon with multiple titles imitating the *Young Romance* format. Martin Goodman led the procession, flooding the stands with over a dozen imitations. Yet none of the competitors scored sales approaching the innovators, and *Young Romance* and *Young Love* soared to even greater popularity.

An interesting feature of the romance comics was their advice-to-the-lovelorn columns. Nancy Hale was a name we chose for our first "love counselor." Nancy Hale received mail sacks full of letters from emotion-torn teenage girls seeking advice of the heart. They poured out intimate facts that not even their mothers were aware of. We took turns being Nancy Hale, answering letters to the column, giving comfort and advice. Advice was easy to dispense, and surprisingly, we got away with it. Thousands of girls were eased into puberty by a couple of comic book artists who were too cheap to hire a competent female counselor. After a few issues, it was pointed out to us that there actually was a successful novelist named Nancy Hale. Strictly a coincidence. We never heard from her.

Young Romance was sold in every English-speaking country, and translated elsewhere throughout the world. In Hawaii, it outsold every other publication. The magazines prospered and endured with the same format for three generations.

YOU'RE NOT ONE OF US! YOU NEVER WILL BE! WHY DON'T YOU GO BACK WHERE YOU CAME FROM! STAY AWAY FROM MY SON! YOU'RE DIFFERENT! DIFFERENT! **"DIFFERENT!"**

ANOTHER GREAT FIRST FOR YOUNG ROMANCE...

HERE IS THE STORY THEY DARED US TO PRINT!

YOU CHALLENGED US TO PUBLISH IT! NOW WE CHALLENGE YOU TO READ IT!

THIS STORY IS SO SHOCKING BECAUSE IT'S SO FAMILIAR! YOU ALL KNOW SOMEONE LIKE THE GIRL WHO TELLS THIS STORY-- PERHAPS **YOU'VE** BEEN ONE OF THOSE WHO SCORNED HER, DROVE HER AWAY -- ROBBED HER OF THE CHANCE FOR LOVE AND HAPPINESS!

YOU CAN'T AFFORD TO MISS THESE SHOCKING REVELATIONS OF A GIRL WHO WAS ---

"DIFFERENT!"

IN THE FEBRUARY, NO.30 ISSUE OF

young Romance

Read THE STORY THEY DARED US TO PRINT!

YOUNG ROMANCE

young Romance

Big 52 pages! DON'T TAKE LESS!

TRUE LOVE stories

FEBRUARY NO.30

10¢

"DIFFERENT!"

Big 52 pages! DON'T TAKE LESS!

Straight Into the Third Dimension

BELOW: *Cover detail of Simon and Kirby's* Captain 3-D #1, *produced on the run for Alfred Harvey. Simon worked with a group of artists on this project including Mort Meskin, and a young Steve Ditko. ©2003 Joe Simon and the Estate of Jack Kirby.*

It was a rainy afternoon in August 1953. Simon and Kirby, with a staff of six people, shared a suite of offices with Crestwood Publications. I received a phone call from Al Harvey. "Joe, can you bring some of your guys over? We've got a crash assignment and need some pros to get a lot of books out quickly."

"I don't know, Al," I answered. "We've got our schedules."

"We'll pay you double the going rate." Al spoke the magic words.

"When do we start?"

"How about tonight?"

I put the proposal to Jack Kirby, Steve Ditko, Mort Meskin and other key artists working on our comics. They all agreed. I rounded up a couple of letterers, and we all marched the four blocks to Harvey Publications on Broadway just two blocks uptown of Columbus Circle.

Harvey's office was on the fifteenth floor of the building, but he had rented the entire vacant fourth floor on a temporary basis for his new project. There we found drawing tables set up adjacent to the windows, adequately supplied with the artists' tools needed for our staff. It was a small oasis in a dusty desert of empty space.

We each chose our position, about to start on a new venture — an art form that was to prove completely foreign to us — a task that we would regret before it was completed.

Archer St. John, a minor publisher of marginal comic books, mostly Westerns, had come up with the blockbuster. His first 3-dimensional comic book was a sell-out. It was a startling, ingenious departure which shook the industry and was all the more important since it sold for 25¢ where other comic books sold for 10¢.

3-D comics were printed in two colors. Red was the key with blue supplementing the red, not as an additional color, but to create the dimensional illusion. Two-color "spectacles" were stapled inside the front cover with the binding. The specs consisted of a wide cardboard frame with a red plastic lens marked for the left eye, and green plastic for the right eye. A string was taped to the cardboard with instructions: "Tie knotted string in holes. Adjust for head size."

Al Harvey came in with a copy of St. John's *3-D Comics.* "This is not bad," he acknowledged, "but we've perfected the technique."

"How is it done?" I asked.

"We'll take you through all the steps. We've set up a procedure."

The Harvey staff had obtained the fundamentals of the new, improved technique from an artist who claimed to have figured it out all by himself. It was explained to our staff and we quickly got to work.

Drawings were done on hole-punched plastic acetates set into pegs on the drawing boards. There were two to four dimensional planes, each a separate acetate requiring individual drawing, all part of the main drawing. It was extremely tedious work, rendering on the slippery, unfamiliar plastic and matching the registration from overlay to overlay.

We learned as we progressed. Highly exaggerated perspective magnified the dimensional effects. A fist pointing at the reader would be larger than the entire body. Action would always be coming toward the reader — never going sideways and never backwards into the picture, with a few exceptions that were considered mistakes.

After a while we decided that script was unimportant: it was merely a vehicle to convey the graphics. Besides, the lettering was too difficult to read. Everything was in outline. Black shading had to be eliminated for the substitution of the red or green. It was a lot to digest in a short time.

When the books were finally printed, the red acetate was offset slightly to the right of the green. Without the

glasses, the pages of the comic were a reddish green blur. The illusion of "3-D" would not be visible until seen through the glasses, but we were all too weary to care. We worked on the project a couple of weeks and finally packed up, exhausted, glad to get back to our regular tasks. When we tabulated our time, it proved to be a financial loss for us.

3-D comics were not without critics and detractors. Parents and educators complained of eye strain. The publishers countered with disclaimers by eye doctors. Harvey's instructions read in part: "Reading these 3-D comics is similar to the eye exercises doctors have been using for years... to see 3-D, your eyes must work as a team. If you cannot see the third dimension, your eyes are not working together properly..." And then, to court the medical profession: "...in this way, 3-D helps discover eye difficulties early so that your doctor can correct it before it becomes severe..."

The public didn't buy it. After the initial sell-out of the novelty, news dealers' returns were enormous. The publishers learned too late that they had bet on a loser.

Before the results were in, however, there developed an acute shortage of the "3-D spectacles." In anticipation of big sales, publishers had outbid one another to corner the market. Harvey Publications stacked their warehouse with the specs. With lack of foresight, the company had imprinted their logo on the cardboard frames. The spectacles were no longer negotiable and there was no way of turning them back. Now, Harvey, with millions of the 3-D specs in storage, faced still another problem.

David Alterbaum was an attorney specializing in publishing. Among his clients were Harvey Comics and EC Comics, a firm headed by Bill Gaines, who was later to publish *Mad* magazine. Alterbaum phoned Alfred Harvey.

"I'll come right to the point, Alfred. Bill Gaines claims you plagiarized his 3-D process. I'd like to mediate — get you two together. Otherwise, I have to step out of the picture."

Harvey was perplexed. "How did we plagiarize?"

"Basically," the lawyer explained, "Bill claims you copied his patented third dimensional process. That is his allegation." Alterbaum was direct. "Look, Alfred, you're

each my client and my friend. I'm not going to advise either of you. It's not ethical."

Alfred Harvey had not been aware that the artist who brought him the 3-D technique had lifted it from Bill Gaines. Representatives of the two companies met and came to an agreement. Harvey would cease and desist publication of the 3-D comics.

It was, after all, a decision he had made even before the Gaines incident. The three-dimensional comics had already cost him a quarter of a million dollars. It was now a matter of survival.

ABOVE: *The wrong way. In explaining 3-D, artist Bob Powell committed the mistake of forcing the action away from, rather than toward, the reader. ©2003 the respective copyright holder.*

Mort

Mort Meskin was one of those special artists who could take an ordinary script and interpret it with extraordinary graphic excitement. He had been a mainstay at DC Comics where he worked with Bob Kane and Jerry Robinson on countless *Batman* stories among other adventure characters.

Mort's employment at DC was, however, interrupted by occasional interludes in mental institutions. He claimed that this was a natural extension of his comic book work, and there came a time when he had difficulty in differentiating reality from his comic book drawings. His work, as a result, was considered akin to genius by his peers. Nobody could depict a dream scene, a villain or a monster with as much imagination as Mort did so often. The artist had a head full of the most gruesome, out-landish goblins, which he translated to the pages of comic books with ease.

But there came a time when he could no longer function as a comic book artist. He was in such a condition when he came to our Crestwood office, out of work, out of hope and nearly out of funds.

Just the day before, Mort had performed his last duty at DC Comics. In a sudden bizarre act, he had snatched a two foot metal T-square from an artist's drawing board and proceeded to leap from chair to desk to chair, brandishing the T-square like a sword in a duel to the death with an imaginary foe.

Since I had been a longtime fan of Mort's, I urged him to try one of our scripts. It was a story for *Black Magic*, the comic book billed as "The Strangest Stories Ever Told." The stories were advertised as true, although, unlike *Young Romance*, we didn't expect any reader over ten years old to believe that. Mort, I was convinced, could visualize these scripts as no one else could, but it wasn't to be — not yet. Mort took the script home, and didn't show

up for weeks. When he did return, he shoved the script at me. It was rumpled and soiled. There was not a single drawing.

"I can't do it," he sighed. "There's no way I can get started."

I was disappointed. "Take it back, Mort," I suggested. "We won't schedule it until you feel you're ready."

Mort took the script back and returned a week later in the same condition. "It's not the first time," he said. "I had the same experience with Batman. T--they f--finally gave up on me." Mort stuttered when he was frustrated.

An idea struck home. "Why don't you work here, Mort, in the office with us." It occurred that he might have a problem working alone in his studio.

Mort agreed. We gave him a drawing table, centrally located, and a fresh script, and he sat down, pencil poised,

examining the script. He examined it for hours. All of us pretended not to notice his work — or lack of it. For days he would come in punctually, face the blank drawing board, and sit there without drawing a line. He would join us at lunch at the bowling alley over the Automat across the street, return to his board with the others, and continue his inactivity until the end of the working day. Unlike a conventional business office, the art department was a totally informal place where the artists were constantly engaged in small talk; joking about their work, their out-side activities, families and friends. Mort would participate, regaling us with his stories: romances in the asylum, the girls and dances and life there in general. Nobody would ever mention his blank drawing board. Finally, however, we reached a crisis. On a Friday afternoon, when the paychecks were being distributed (all the artists were paid on a freelance basis), Mort approached me sheepishly. "I'm getting low in funds," he said. "How about an advance?"

"I'd like to, Mort," I apologized, "but you haven't done any work."

"I can't," he said. "I can't face that blank page. I panic." I walked over to his desk and penciled in some lines and circles on the board.

"There. It's not blank now."

Mort sat down, glanced at the script, then drew around the lines and circles, continuing with the most expert penciled drawings until the page was complete. From that day on, every morning, I or one of the other artists, would draw the meaningless lines and circles on his blank page and Mort would draw without further problems all day. He was probably the fastest, most inspired artist in the room, and certainly one of the most dependable.

ABOVE: *Are we having fun? Comic books, which had been living off odd villains for years, became the villain itself as America waged an unrelenting war against the "depravity" of the horror, violence and crime of the big-selling magazines. The title* Guilty *was too often superimposed or placed on top of a pile of comic books in photos illustrating the daily media coverage of the comic book outrage.*

In November 1953, when the Senate was preparing an investigation of the field, the studio of Simon and Kirby—Crestwood—had the gall to come out with the above cover, showing the staff in a police line-up. (From left) Ben Oda, letterer, best known for opening a Japanese restaurant a week before Pearl Harbor; Joe Simon, the guilty one; Joe Genalo, production man; renowned artist Mort Meskin; and Jack Kirby. ©2003 Joe Simon and the Estate of Jack Kirby.

Horror, Crime and Punishment

For years, there had been scattered attacks on the comic book industry. Comic books had joined the ranks of popular entertainment that so often inflame the wrath of dubious moralists. Previous victims had been dime novels, pulp fiction, Hollywood movies, music, and some comic strips. Comic books were popular with the public because they offered sensational adventure, action, love and romance in full color at a price within reach of every man, woman, and child. With the growing popularity of comic books the moral vigilantes directed their outrage to the news media, which eagerly jumped on the anti-comic book bandwagon.

A National Disgrace
(And a challenge to American Parents)

Save for a scattering of moral or less innocuous 'gag' comics, and some reprints of newspaper strips... the bulk of these publications depend for their appeal upon mayhem, torture, and abduction — often with a child as the victim. Superman heroics, voluptuous females in scanty attire, blazing machine guns, hooded justice and cheap political propaganda were to be found on almost every page... Badly drawn, badly written, and badly printed — a strain on young eyes and young nervous systems.

This editorial was reprinted on the first page of a feature article in the wholesome family-oriented magazine, *Parents*. But it also noted that the comic book business was generating more than $15 million annually. *Parents* magazine jumped on the bandwagon with their own line of comic books. The first title was *True Comics*. The stories dealt with true accounts of people and history. It was dull and graphically static.

The publisher set up an advisory board to ensure that the comics were wholesome. These Junior "Editors" were listed on the comics' mastheads: Janet Cantor, 13-year old daughter of Eddie Cantor; movie stars Gloria Jean, Shirley Temple, Mickey Rooney, and Virginia Weidler. George H. Gallup, director of the Institute of Public Opinion was one of the Senior Advisory Editors.

Although *True Comics* was followed by *Real Heroes* and *Calling All Girls,* the kids didn't buy it, and the wholesome *Parents* magazine comic books eventually faded away. Janet Cantor, for one, admitted to me that she was never once consulted on anything relating to the *Parents* comic books.

Adolescents read the majority of comic books, and adolescents were often accused of various kinds of unorthodox conduct, reading a comic book being one of them. Neither image apparently helped the other. In Milwaukee, parochial schools tried to ban teenage "Be-boppers" from enrolling in 49 schools. A United Press article

described the kids as distinguishable "by their dress, freakish haircuts, gang threats, and abuse..." It was also a time of "Atomic Jitters," a term coined by the Mental Health Association to describe teenagers' fears of life in the Atomic Age. Much of the media pandered to the alarmists who were eager to tie in comic books with teenage anxiety and juvenile delinquency.

By 1948, there were publicized comic book burnings in Binghamton, New York, in New York City, and in Chicago. The number of cities that participated in banning, burning, or decrying of comic books mushroomed. Comic book publishers were concerned. The field, which ran the gamut from non-offensive funny animal comics to violence-filled crime and horror titles, was taking the full rap. Even the once aloof syndicated comic strip was finding itself caught in the turmoil since many popular comic strips

were now being reprinted in comic book format. Anti-comic book fanatics railed that any teenager could learn to pull off a crime simply by reading the *Dick Tracy* detective strip, which was once endorsed by FBI Chief J. Edgar Hoover.

In Cincinnati, Ohio, comic books were evaluated by a citizen's group which published ratings of each comic book according to the degree of violence. The subject often surfaced in debates at local PTA and library meetings. Groups of incensed mothers were known to march into grocery stores that sold comics, load their carts with the dime dreadfuls, stroll up to the checkout counter staring down the cashier with puritanical fierceness, abandon the comic book filled carts in the middle of the checkout aisle and stomp out of the store.

Meanwhile, as cities nationwide prepared bulky bureaucratic reports on how to handle the so-called comic book problem, the public relations director for New Orleans Mayor deLesseps S. Morrison hailed comics on a level to "rank with jazz music as being one of the few truly American art forms." In 1948, New Orleans — birthplace

of jazz — inspired us in the comic book business to walk a little taller and breathe a little easier, at least for a while.

The smaller publishers, bowing under the pressure, were finding it difficult to compete with their affluent counterparts. Their only hope was to try for material more sensational than the crime stories. They soon discovered that there was an audience for ghoulish drawings and crude stories. The publishers grew bolder, vying with one another to portray the most gruesome scenes of dismembered victims and bloodthirsty villains killing and maiming in outrageously inventive, horrible scenes. The plots for the most part were weak or non-existent, as the comic books relied on the bloody graphics to carry them.

It was during this period that Bill Gaines ventured into the horror field. His comic books, in their superiority, were more damaging as they created a loyal following. Madmen were drooling blood as they chewed limbs off their victims; eyes were gouged out by the hundreds, always in the most creative ways. People were devoured

ABOVE: *Panels from the "Gruesome Age" of comics—the early 1950s— when hundreds of magazines flooded the stands with sometimes truly horrific images, often shown with a "nudge-nudge, wink-wink" attitude, as seen here. Art by Howard Nostrand. ©2003 the respective copyright holder.*

"OF COURSE, IT HAS MINOR DRAWBACKS. IT ALL COMES SO EASILY, WE HAVE A TENDENCY TO *OVER EAT*---AND WE STILL DON'T HAVE ENOUGH WILL POWER TO *DIET!* OUR LITTLE HOUSES ARE GETTING *TOO* LITTLE FOR US!"

JUST AWFUL, THE WAY WE PUT ON WEIGHT--- BUT WITH *SCIENCE* TO HELP--WHAT DIFFERENCE? I'M SURE WE CAN EMPLOY CARPENTERS TO MAKE *NEW HOMES*--WITH WINDOWS -- AND MAYBE EVEN FANS! IT'S A WHOLE NEW AGE, AND HAS *TREMENDOUS POSSIBILITIES!*

YOU SEE... NOW WE CAN BE *FRIENDS! WE'RE* TRYING SO HARD... WON'T *YOU* CO-OPERATE? INVITE US TO YOUR HOME... *NOT FOR DINNER*...OF COURSE... WE CAN ...HEH...HEH... BRING *OUR OWN* ...JUST A SOCIABLE EVENING... *LIKE FRIENDS!*

THIS IS A PUBLIC SERVICE LEAFLET, PUT OUT BY THE COMMITTEE TO IMPROVE RELATIONS BETWEEN HUMANS AND VAMPIRES! INVITE A VAMPIRE TO *YOUR* HOUSE! AFTER ALL, WE ARE *BLOOD BROTHERS!* PLEASE PASS THIS ON TO A PUBLIC SPIRITED FRIEND WHEN *YOU* HAVE FINISHED READING IT!

ABOVE: *Yet another horror comic book page laced with grim humor. ©2003 the respective copyright holder.*

OPPOSITE PAGE: *EC Comics head honcho Bill Gaines was fearless in his doomed defense of EC's horror titles, often attacking those intent on driving the innovative publisher out of business. With the able help of cartoonist Jack Davis, Gaines penned this house ad that appeared throughout his line at the height of the hysteria. ©2003 William M. Gaines, Agent.*

educators, and concerned citizens.

The first session came to order at 10 A.M., with the Chairman's opening words announcing that the committee "is going into the problem of horror and crime comic books. By comic books, we mean pamphlets illustrating stories depicting crimes or dealing with horror and sadism..."

The first speaker sworn in was Richard Clendenen, executive director of the committee.

"We have prepared a number of slides which show pictures taken from comic books of the type to which we have addressed ourselves... the first such crime comic is entitled *Black Magic,*" said Clendenen.

Watching this on television, I cringed — like I was suddenly thrown into a steaming vat in a horror comic.

Black Magic was a title Simon and Kirby were producing with Crestwood Publications. Of all the crime and horror comic books, it was a surprise to discover our title brought up as first evidence. *Black Magic* was an excellent comic book with art and stories about the supernatural that were pure as Ivory soap compared to EC Comics and the rest of the horror field.

Clendenen said, "You will note one man in the picture has two heads and four arms, another body extends only to the bottom of his ribs. But the greatest horror of all the freaks in the sanctuary is the attractive looking girl in the center of the picture who disguises her grotesque body in a suit of foam rubber.

"The final picture shows a young doctor in the sanitarium as he sees the girl he loves without her disguise.

"The story closes as the doctor fires bullet after bullet into the girl's misshapen body.

"Now, that is an example of a comic of the horror variety..."

That was all that was said about *Black Magic* by Mr. Clendenen. Other titles he brought up included *Fight Against Crime, Mysterious Adventures, Crime Must Pay the Penalty,* and *Haunt of Fear.* Our other comic book

by every kind of monster one could fantasize, and Gaines' writers and artists fantasized with the best of them. The marginal publishers struggling to stay in business smelled out the profits and joined in the blood and gore.

Things were not going well for comic books, and the mounting pressure finally came to a head with an investigation into the industry. Invariably, in the news photos of a group of comic books, the title shown in the center of the heap was our own *Justice Traps the Guilty.*

On April 21 and 22, 1954, the United States Senate Committee on the Judiciary to Investigate Juvenile Delinquency launched an investigation into the comic book industry. A subcommittee took session at the United States Court House at Foley Square in New York City.

The subcommittee was composed of Senator Robert Hendrickson, chairman; Senator Herbert Hannoch, chief counsel; Richard Clendenen, executive director; Herbert Beaser, associate chief counsel; Senator Thomas C. Hennings; and Senator Estes Kefauver. Writers, artists, publishers, distributors, retailers, and advertisers were called to testify. Professional opinions as well as personal viewpoints were heard from mental health professionals,

ARE YOU A RED DUPE?

IN THE TOWN OF GAZOOSKY IN THE HEART OF SOVIET RUSSIA, YOUNG MELVIN BLIZUNKEN - SKOVITCHSKY PUBLISHED A *COMIC MAGAZINE*...

...SO THEY CAME AND *SMASHED* HIS FOUR-COLOR PRESS...

...AND *HUNG* POOR MELVIN THE NEXT MORNING!

- HERE IN AMERICA, WE CAN *STILL* PUBLISH COMIC MAGAZINES, NEWSPAPERS, SLICKS, BOOKS AND THE BIBLE. WE DON'T *HAVE* TO SEND THEM TO A CENSOR FIRST. NOT *YET*...

- BUT THERE ARE SOME PEOPLE IN AMERICA WHO WOULD *LIKE* TO CENSOR... WHO WOULD *LIKE* TO SUPPRESS COMICS. IT ISN'T THAT THEY DON'T LIKE COMICS FOR *THEM!* THEY DON'T LIKE THEM FOR *YOU!*

- THESE PEOPLE SAY THAT *COMIC BOOKS* AREN'T AS GOOD FOR CHILDREN AS *NO* COMIC BOOKS, OR SOMETHING LIKE THAT. SOME OF THESE PEOPLE ARE NO-GOODS. SOME ARE DO-GOODERS. SOME ARE WELL-MEANING. AND SOME ARE JUST PLAIN MEAN.

- BUT WE ARE CONCERNED WITH AN AMAZING REVELATION. AFTER MUCH SEARCHING OF NEWSPAPER FILES, WE'VE MADE AN ASTOUNDING DISCOVERY:

THE GROUP MOST ANXIOUS TO DESTROY COMICS ARE THE COMMUNISTS!

- WE'RE SERIOUS! NO KIDDIN'! *HERE! READ THIS:*

THE [COMMUNIST] "DAILY WORKER" OF JULY 13, 1953 BITTERLY ATTACKED THE ROLE OF :

"...SO-CALLED 'COMICS' IN BRUTALIZING AMERICAN YOUTH, THE BETTER TO PREPARE THEM FOR MILITARY SERVICE IN IMPLEMENTING OUR GOVERNMENT'S AIMS OF WORLD DOMINATION, AND TO ACCEPT THE ATROCITIES NOW BEING PERPETRATED BY AMERICAN SOLDIERS AND AIRMEN IN KOREA UNDER THE FLAG OF THE UNITED NATIONS."

THIS ARTICLE ALSO QUOTED *GERSHON LEGMAN* (WHO CLAIMS TO BE A GHOST WRITER FOR *DR. FREDERICK WERTHAM*, THE AUTHOR OF A RECENT SMEAR AGAINST COMICS PUBLISHED IN *"THE LADIES HOME JOURNAL"*). THIS SAME *G. LEGMAN*, IN ISSUE #3 OF *"NEUROTICA,"* PUBLISHED IN AUTUMN 1948, WILDLY CONDEMNED COMICS, ALTHOUGH ADMITTING THAT:

"THE CHILD'S NATURAL CHARACTER... MUST BE DISTORTED TO FIT CIVILIZATION... FANTASY VIOLENCE WILL PARALYZE HIS RESISTANCE, DIVERT HIS AGGRESSION TO UNREAL ENEMIES AND FRUSTRATIONS, AND IN THIS WAY PREVENT HIM FROM REBELLING AGAINST PARENTS AND TEACHERS... THIS WILL SIPHON OFF HIS RESISTANCE AGAINST SOCIETY, AND *PREVENT REVOLUTION."*

- SO THE *NEXT* TIME SOME JOKER GETS UP AT A P.T.A. MEETING, OR STARTS JABBERING ABOUT THE "NAUGHTY COMIC BOOKS" AT YOUR LOCAL CANDY STORE, GIVE HIM THE *ONCE-OVER.* WE'RE NOT SAYING HE *IS* A COMMUNIST! HE MAY BE INNOCENT OF THE WHOLE THING! HE MAY BE A *DUPE!* HE MAY NOT EVEN *READ* THE "DAILY WORKER"! IT'S JUST THAT HE'S *SWALLOWED* THE *RED BAIT... HOOK, LINE,* AND *SINKER!*

titles were left relatively unscathed by the investigation.

The Simon and Kirby comic book titles, published by Crestwood or their affiliates — Feature or Prize Publications — were distributed by Harry Donenfeld's Independent News. It was when Harold Chamberlain, circulation director of Independent News, took the witness stand that *Black Magic* was mentioned again. This time it was Mr. Beaser, associate chief counsel, doing the questioning.

Said Beaser, "What others have you decided not to distribute?" Beaser was referring to comic book titles Independent News claimed it would never distribute if the comic book was found to be beyond decent taste.

Chamberlain responded:

OPPOSITE PAGE: *However oppressed by the powers-that-be, the EC horror line was very highly regarded by older comic readers and have remained in print for many of the nearly fifty years since their demise. At the time, the staff cultivated the rabid fan following by establishing the EC Fan-Addict Club. Jack Davis' house ad appears here.* ©2003 William M. Gaines, Agent.

"In the case of *Adventures of the Unknown*, the editorial content of that is to change, to bring it entirely out of the realm of the present editorial content. The title will remain the same for the time being.

"The same holds true for *Black Magic*, wherein the editorial content will be changed completely..."

It should be mentioned here that we were never notified of any changes to be made in *Black Magic* and that we continued to produce it in the same old way.

When Bill Gaines was called to testify, it was time for a moment of reflection among those of us in the comic book business. Bill was the son of Max C. Gaines, known as Charlie Gaines, who was credited with first publishing reprints of syndicated comic strips in comic book format.

"Two decades ago," said Bill, "my father was instrumental in starting the comic book industry. He edited the first few issues of the first modern comic magazine, *Famous Funnies.* My father was proud of the industry he helped to found. He was bringing enjoyment to millions of people.

"The heritage he left is the vast comic book industry which employs writers, artists, engravers, and printers.

"It has weaned hundreds of thousands of children from pictures to the printed word. It has stirred their imagination, given them an outlet for their problems and frustrations, but most important, given them millions of hours of entertainment.

"My father before me was proud of the comics he published. My father saw in the comic book a vast field of visual education. He was a pioneer.

"Sometimes he was ahead of the time. He published *Picture Stories from Science, Picture Stories from World History,* and *Picture Stories from American History.*

"He published *Picture Stories from the Bible.* I would like to offer these in evidence." Now Bill Gaines had set the scene.

"I published comic magazines in addition to *Picture Stories from the Bible,*" he began. "For example, I publish horror comics. I was the first publisher in these United States to publish horror comics. I am responsible, I started them.

"Some may not like them," said Gaines. "That is a matter of personal taste. It would be just as difficult to explain the harmless thrill of a horror story to a Dr. Wertham as it would be to explain the sublimity of love to a frigid old maid."

Dr. Wertham had testified just before Gaines. For years Dr. Wertham had been leading an anti-comic book crusade. Although he was a psychiatrist with a long fist of impressive-sounding credits, his detractors in the mental health fields accused Wertham of studies that were unscientific and biased. Wertham was a sensationalist. To him, Batman comforting Robin was indicative of homosexuality. If a superhero stood with his legs spread, it was something sexually suggestive. He saw children as victims of everyday temptation and seduction, and it was comic books upon which Wertham rested much of the blame of juvenile delinquency. At the height of his campaign against comic books, he authored a book called *Seduction of the Innocent.* Years later he would turn his anger against television. Eventually Dr. Wertham would fade away like so many other alarmists. But in 1954, Dr. Wertham was on a mission to set the comic book publishing houses afire.

Bill Gaines went on, stating that EC had the largest sales among the horror comics. "The comic magazine is one of the few remaining pleasures that a person may buy for a dime today. Men of good will, free men, should be very grateful for one sentence in the statement made by Federal Judge John M. Woolsey when he lifted the ban on *Ulysses.* Judge Woolsey said, 'It is only with the normal person that the law is concerned.'

"[New York City mayor] Jimmy Walker once

SO WHAT? SO YOU, TOO, CAN JOIN THE
E.C. FAN-ADDICT CLUB!

FOR AN *INDIVIDUAL MEMBERSHIP,* FILL OUT THE *COUPON* AND SEND IT IN, TOGETHER WITH *25¢.* IF *FIVE* OR *MORE* OF YOU WISH TO JOIN AS AN *AUTHORIZED CHAPTER,* ENCLOSE *EACH MEMBER'S* NAME AND ADDRESS, ALONG WITH *25¢* FOR *EACH NAME,* AND INDICATE THE *NAME* OF THE *ELECTED CHAPTER PRESIDENT.* WE WILL NOTIFY EACH PRESIDENT OF HIS *CHAPTER NUMBER. EVERY* MEMBER, *CHAPTER* OR *INDIVIDUAL,* WILL RECEIVE HIS KIT *DIRECTLY...* BY RETURN MAIL.

THE E.C. FAN-ADDICT CLUB
ROOM 706
225 LAFAYETTE STREET
NEW YORK 12, N.Y.

SO, ALL RIGHT! SO HERE'S MY TWO BITS. SO MAKE ME A MEMBER, ALREADY, AND SEND ME THE THINGS AND STUFF LIKE WHAT THE KID UP THERE GOT... SO!

NAME _____

ADDRESS _____

CITY _____ ZONE NO. ____

STATE _____

123

remarked that he never knew a girl to be ruined by a book. Nobody has ever been ruined by a comic.

"As has already been pointed out by previous testimony, a little, healthy, normal child has never been made worse for reading comic magazines.

"The basic personality of a child is established before he reaches the age of comic-book reading. I don't believe anything that has ever been written can make a child overaggressive or delinquent.

"I would like to discuss, if you bear with me a moment more," said Gaines, "something which Dr. Wertham provoked me into. Dr. Wertham, I am happy to say, I have just caught in a half-truth, and I am very indignant about it. He said there is a magazine now on the stands preaching racial intolerance. The magazine he is referring to is my magazine. What he said, as much as he said, was true. There do appear in this magazine such materials as 'Spik,' 'Dirty Mexican,' but Dr. Wertham did not tell you what the plot of the story was.

"This is one of a series of stories designed to show the evils of race prejudice and mob violence, in this case against Mexican Catholics.

"Previous stories in this same magazine have dealt with anti-Semitism, and anti-Negro feelings, evils of dope addiction and development of juvenile delinquents.

"This is one of the most brilliantly written stories that I have ever had the pleasure to publish. I am very proud of it, and to find it being used in such a nefarious way made me quite angry.

"Let us look at today's edition of the *Herald Tribune*," Gaines continued.

"On the front page a criminal describes how another criminal told him about a murder he had done. In the same paper, the story of a man whose ex-wife beat him on the head with a claw hammer and slashed him with a butcher knife.

"In the same paper, a story of a lawyer who killed himself.

"Another, a story of a gang who collected an arsenal of guns and knives. There are many stories of violence and crime in the *Herald Tribune* today.

"I am not saying it is wrong, but when you attack comics, when you talk about banning them as they do in some cities, you are only a step away from banning crimes (stories) in the newspapers."

"Mr. Gaines," said Executive Director Beaser, "let me ask you one thing with reference to Dr. Wertham's testimony."

Gaines listened.

Said Beaser, "You used the pages of your comic book to send a message across, in this case it was against racial prejudice; is that it?"

"That is right," answered Gaines.

"You think, therefore," said Beaser, "you can get a message across to the kids through the medium of your magazine that would lessen racial prejudice; is that it?"

"By specific effort and spelling it out very carefully," Gaines replied, "so that the point won't be missed by any of the readers — and I regret to admit that it is still missed by some readers, as well as Dr. Wertham — we have, I think, achieved some degree of success in combating anti-Semitism, anti-Negro feeling, and so forth,"

Beaser asked, "Then why do you say you cannot at the same time and in the same manner use the pages of your magazine to get a message which would affect children adversely, that is, to have an impact upon their doing these deeds of violence and sadism, whatever is depicted?"

"Because no such message is being given to them," Gaines answered. "In other words, when we write a story with a message, it is deliberately written in such a way that the message is spelled out carefully in the captions. The preaching, if you want to call it, is spelled out carefully in the captions. Plus the fact that our

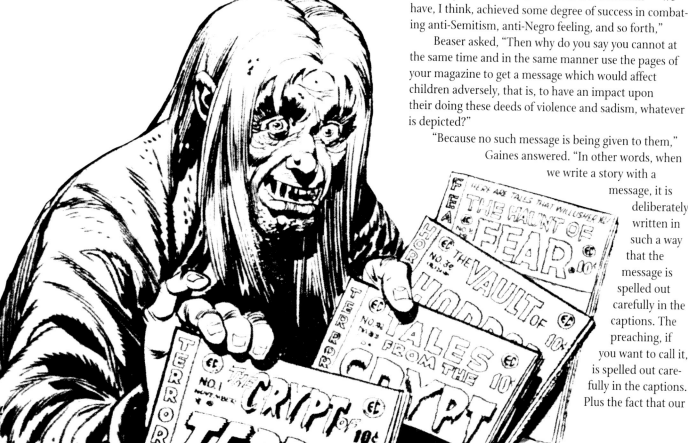

THE OLD WITCH

THE VAULT-KEEPER

THE CRYPT-KEEPER

readers by this time know that in each issue of *Shock SuspenStories,* the second of the stories will be this type of story."

"A message," said Beaser, "can be gotten across without spelling out in detail. For example, take this case that was presented this morning of the child who is in a foster home who became a werewolf, and foster parents —"

"That was one of our stories," Gaines cut in.

"A child who killed her mother," Beaser continued. "Do you think that would have any effect at all on a child who is in foster placement, who is with foster parents, who has fears? Do you think that child in reading the story would have some of the normal desires heightened, increased?"

"I honestly can say I don't think so," said Gaines. "No message has been spelled out there. We were not trying to prove anything with that story. None of the captions said anything like 'If you are unhappy with your stepmother, shoot her.'"

"No " Beaser returned, "but here you have a child who is in a foster home who has been treated very well, who has fears and doubts about the foster parent. The child would normally identify herself in this case with a child in a similar situation. And there, a child in a similar situation turns out to have foster parents who became werewolves.

"Do you not think that would increase the child's anxiety?" asked Beaser.

"Most foster children, I am sure, are not in homes such as were described in those stories," Gaines said. "Those were pretty miserable homes."

"You mean the houses that had vampires in them, those were not nice homes?"

"Yes," said Gaines.

Now Hannoch spoke: "Do you know any place where there is any such thing?"

"As vampires?" said Gaines.

"Yes!"

"No sir," Gaines answered. "This is a fantasy. The point I am trying to make is that I am sure no foster children are kept locked up in their room for months on end except in those rare cases that you hear about where there is something wrong with the parents..."

"Yet," said Beaser, "you do hear of the fact that an awful lot of delinquency comes from homes that are broken. You hear of drunkenness in those same homes.

"Do you think those children who read those comics identify themselves with the poor home situation, with maybe the drunken father or mother who is going out, and identify themselves and see themselves portrayed there?"

"It has been my experience," answered Gaines, "in writing these stories the last six or seven years that whenever we have tested them out on kids, or teenagers, or adults, no one ever associates himself with someone who is going to be put upon. They always associate themselves with the one who is doing the putting upon."

"You do test them out on children, do you?" Kefauver asked.

"Yes," said Gaines.

"How do you do that?" asked Beaser, but before Gaines could reply, Senator Hennings asked, "Is that one of your series, the pictures of the two in the electric chair, the little girl down in the comer?"

"Yes," said Gaines.

"As we understood from what we heard of that story," said Hennings, "the little girl is not being put upon there, is she? She is triumphant apparently, and that is insofar as we heard the relation of the story this morning."

"If I may explain," said Gaines, "the reader does not know that until the last panel. One of the things we try to do in our stories, is have an O. Henry ending for each story."

"Now, in that one," said Hennings, "what would be your judgment or conclusion as to the identification of the reader with that little girl who has, to use the phrase, framed her mother and shot her father?"

POGO **Walt Kelly**

ABOVE: *Walt Kelly's comic strip,* Pogo, *on the last day in the life of the* New York Star *(Jan. 28, 1949). ©2003 the Estate of Walt Kelly.*

BELOW: *Walt Kelly's playful 'possum goes formal in this cartoon by the artist. ©2003 the Estate of Walt Kelly.*

Gaines objected. "In that story, you should read it from the beginning, because you can't pull things out of context —"

"That is right: you cannot do that," Hennings shot back.

"Is that the O. Henry finish?" Hannoch wanted to know.

"Yes," said Gaines.

"In other words," continued Hannoch, "everybody reading that would think this girl would go to jail. So the O. Henry finish changes that, makes her a wonderful looking girl?"

"No one knows she did it until the last panel," Gaines explained.

"You think it does them a lot of good to read the thing?" Hannoch asked.

"I don't think it does them a bit of good," said Gaines, "but I don't think it does them a bit of harm either."

It was all sounding like both a comic book story conference and a confrontation with a crotchety relative.

"There would be no limit actually to what you put in a magazine?" asked Beaser.

"Only within the bounds of good taste," said Gaines.

Kefauver held up a comic book. "Here is your May 22 issue," he said. "This seems to be a man with a bloody ax holding a woman's head up which has been severed from her body. Do you think that is in good taste?"

"Yes, sir, I do," Gaines responded, "for the cover of a

horror comic. A cover in bad taste, for example, might be defined as holding the head a little higher so that the neck could be seen dripping blood and moving the body over a little farther so that the neck of the body could be seen to be bloody."

"You have blood coming out of her mouth," said Kefauver.

"A little," Gaines acknowledged.

"Here is blood on the ax," Kefauver said. "I think most adults are shocked by that."

Now the chairman said, "Here is another one I want to show him."

"This is the July one [cover]," Kefauver explained. "It seems to be a man with a woman in a boat and he is choking her to death here with a crowbar. Is that in good taste?"

"I think so," said Gaines.

Hannoch held up a comic book page. "Do you know anything about this sheet called, 'Are you a Red dupe?'"

"Yes, sir," said Gaines. "I wrote it."

"How has it been distributed?"

"It has not been distributed. It is going to be the inside front cover ad on five of my comic magazines which are forthcoming."

"And is it going to be an advertisement?"

"Not an advertisement. It is an editorial."

"Do other magazines have copies of this to be used for the same purpose?"

"No, sir."

"You haven't made this available to the magazines as yet?"

"No, sir."

"You believe the things that you say in this ad that you wrote?"

"Yes, sir."

"That anybody who is anxious to destroy comics are Communists?"

"I don't believe it says that!"

"The groups most anxious to destroy comics are the Communists?"

"True," said Gaines, "but not anybody, just the group most anxious."

Hannoch asked, "What is this organization that you maintain called the Fan Addict Club for 25¢ a member?"

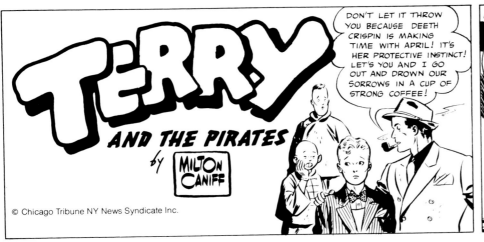

DON'T LET IT THROW YOU BECAUSE DEETH CRISPIN IS MAKING TIME WITH APRIL! IT'S HER PROTECTIVE INSTINCT! LET'S YOU AND I GO OUT AND DROWN OUR SORROWS IN A CUP OF STRONG COFFEE!

MEANWHILE

YOU'VE WORKED FOR ME BUT A SHORT TIME— YET YOU'VE HAD THE COURAGE TO POINT OUT WHAT NO ONE HAS DARED MENTION.... THAT I FRIGHTEN PEOPLE AWAY BY BEING SO SELF-RELIANT!

THE MIRROR DOES NOT LIE, MISS SHERMAN... YOU ARE SOFTLY FEMININE WHEN YOU ALLOW YOURSELF TO BE!

© Chicago Tribune NY News Syndicate Inc.

"Simply a comic fan club!"

"You advertise that children should join the club?"

"Yes."

"What do they do? Do they pay dues?"

"No."

"What do they send 25¢ in for?"

"They get an arm patch, an antique bronze pin, a 7" by 11" certificate and a pocket card, the cost of which to me is 26¢ without mailing."

"After you get a list of all these kids and their families and addresses, what do you do with the list?"

"I get out what we call Fan and Addict Club bulletins. The last bulletin was principally made up of names and addresses of members who had back issues they wanted to trade with other members."

"Did anybody buy that list from you and use it?"

"No sir," said Gaines, "I have never sold it."

There were no further questions of Mr. Gaines.

Walt Kelly was called up to the stand to testify. He was asked by the chairman whether he had some associates who would also like to testify and Kelly said he did.

"Would you like them to come up and sit with you?"

"I would enjoy the company," said Kelly.

The chairman was cordial. The committee was dealing with syndicated newspaper comic strip artists now. "Fine," said the chairman. "We would enjoy having them up here."

Milt Caniff and Joseph Musial joined Walt Kelly. The chairman swore all three in together.

In response to the first interviewer, Mr. Hannoch, Kelly gave his full name, address, and occupation, "artist, drawer of *Pogo*..."

"Have you a title, Mr. Kelly, in the association?"

"I am the president of the National Cartoonists Society. I forgot about that. I just took office last night."

Caniff said, "Milton Caniff, New York City, N.Y. I draw *Steve Canyon* for the *Chicago Sun Times* Syndicate, and King Features Syndicate."

Their third associate spoke up: "Joseph Musial. I am

educational director for the King Features Syndicate. I am director for King Features Syndicate and educational director for the Cartoonist Society. I live in Manhasset, Long Island, New York."

"Thank you very much gentlemen, you may be seated," said the chairman.

The whole atmosphere of the investigation suddenly seemed much more respectful.

"You have a set method that you want to proceed in?" asked Beaser.

"We thought," offered Kelly, "we would do a little commercial work here and show you some of the ways we proceed in our business." An easel holding a large pad of blank white paper was set up before the committee and Kelly stood before them, holding a large crayon.

Comic book artists and publishers were shaking in their shoes, and now a couple of syndicated comic strip artists were offering to entertain the inquisitors.

"However," Kelly continued, "before we get into that, I just want to take a moment to acquaint you in some degree at least with my own experience, and I think it might be of use or value if the other gentlemen would give

you somewhat of their background."

"I am sure it would be very helpful," the chairman agreed.

"I have been in the newspaper business and animated cartoons and cartooning generally since about 13 years of age," said Kelly. "I regret to say that constitutes about 28 years now.

"I got into the comic book business at one time back in 1940 or 1941 and had some experience with its early days as before the 1947 debacle of so many crime magazines, and so on.

"I decided," Kelly resumed, "I would help clean up the comic book business at one time by introducing new features, such as folklore stories and things having to do with little boys and little animals in red and blue pants and that sort of thing.

"So when my comic book folded, the one I started doing that with, I realized there was more to it than met the eye.

"Perhaps this was the wrong medium for my particular efforts. Since then I have been in the strip business, the comic strip business, which is distinguished from comic books.

"We have found in our business that our techniques are very effective for bringing about certain moral lessons and giving information and making education more widespread.

"Despite the testimony given before, I would say right offhand that cartoonists are not forced by editors or publishers to draw any certain way.

"I somewhat question the good doctor's statement [Kelly was talking about Dr. Wertham] when he said in response to your question, sir, that perhaps the originators of this material might be under scrutiny, should be, as to their psychiatric situation.

"We in the cartoon business sort of cherish the idea that we are all sort of screwball. We resent the implication that any man putting out that kind of stuff is not a screwball. That is another thing we fight for."

"I would like to say to you, Mr. Kelly, that I think your statement is admirable," said Hennings. "I am a frustrated cartoonist myself. I wanted to be one when I was a boy, and I got off the track. I have noticed the chairman of our committee doing a good deal of sketching during some of the hearings. He is really a very fine artist."

The chairman asked Caniff if he felt the same as Kelly on the issue.

"It is a fact, of course," said Caniff, "as you all well know, that the newspaper strip is not only censored by each editor who buys it, which is his right, but by the syndicate's own editors — who are many, and highly critical. And then this censorship includes the readers themselves, who are in a position to take the editor to task for printing your material. And they are quick to respond."

Musial had an editorial cartoon with him, which he offered to the chairman. The chairman invited him to place the cartoon on the board. As Musial said, in offering the cartoon, it was better than another speech.

If a picture is worth a thousand words, you can just imagine how much the guy who draws the pictures has to say about his art. Walt Kelly offered to help illuminate the investigation using his own strip as an example. While drawing his characters, Kelly said, "and you can see what thought goes into what we do and how we do it."

The famous comic strip characters of Walt Kelly started to come alive on paper.

"In the first place," began Kelly, "in every one of our strips we have a central character around whom we base most of our plotting and action.

"In my case, it happens to be a character who is supposed to look like a possum. In effect, he is a possum by trade. But he doesn't really work at it because actually he happens to be related to most of the people that read comic strips.

"Now, he looks a little bit like a monster. This little character actually looks a little bit like a monster.

"With this innocent, sweet character are a number of rather disreputable characters. The reason I bring up most of these is that each one represents a certain facet of one man's personality, unfortunately mine.

"Here is an alligator who at one time worked as a political expert for Pogo. Pogo ran for the Presidency of the United States, and, of course, didn't make it. Now, he, we thought, would make an excellent political type because he has a sort of thick alligator skin and some say a head to match, and so on. He is the sort of character that stands around street corners and smokes cigars.

"Along with that character are several other unfortunate people who go into the swamp. One is a dog who is very proud of being a dog. Of course, those of you who have been dogs in your time understand his position in that."

Senator Kefauver said, "You are not talking about a doghouse, now?"

"No," continued Kelly, "I am staying away from that. This particular dog is the kind of dog who feels that he knows all the answers and has a great deal of respect for his own judgement. And we all know people like that.

"One other character who is probably pertinent to the kind of work I try to do is a little character known as the porcupine. Now, this character is a very grumpy sort of character. He looks like most of us do when we get up in the morning. He has generally a sort of sour-faced kind of philosophy. It is a long time after lunch and I am drawing these from the side, so they may have a sort of lean to them.

"He is very sour about everything, but he says, 'You never should take life very seriously because it ain't permanent.'

"Those are the sources of things that go into comic strips.

"When I talk before journalism people I try to tell them these are various facets of one man's personality, mine, yours; that everyone has in him the ability to be all of the cruel, unkind, unpleasant, wonderful and pitiful people that exist in the world.

"That is my message to young journalism students, because they are in search of truth. They sometimes fight it and sometimes are able to report on it.

"For myself, I have never received any intimidation nor have I been dropped by an editor or publisher for anything I wanted to say.

"All I have ever been dropped for is because I was lousy.

"This character here, for example, is known as the deacon. He is one of those busybodies who assumes that everything he has to say is of such importance that I have to letter his script in gothic type, which is sometimes readable and sometimes not. I assure you when you can't read it, it is not because I am hiding anything; it is because I can't letter very well.

"That man is willing to prescribe for everyone and whatever he believes in, very firmly, having borrowed it from someone else. He is out to do you good whether it kills you or not. That is not his concern.

"Then every cartoonist being somewhat dishonest — cartoonists are very much like other people — we sometimes introduce into our strips things which we hope will be cute and will get the ladies to write in and say "Ah." This is a little puppy dog who shows up every once in a while, and the ladies do write in and think he is very cute.

"I won't continue with this," Kelly finally said, "because we will run out of paper. Milt won't have any room."

It was a tried and true and practiced "chalk talk," this theatrical use of comic character art and story to create an analogy between the sub-committee's investigation and the not totally unwholesome business of comic books.

"Who are the men drawing these cartoons?" (meaning comic books) Kefauver asked, as the investigation drew to a close. "Are they members of your society?"

"If they are," said Kelly, "and doing it under assumed names; and in a very bad style — they are not very good drawings actually — when a man is admitted to our society we don't just assume he can draw."

"None of your members do things of this kind?"

"I haven't examined all their work," said Kelly, "and I can't truthfully swear they don't, but I will be surprised and we will take action if they do."

"What would you do if you found they did?" asked Kefauver.

"They would violate our code."

"What would you do about it?" Kefauver insisted.

"I don't know," answered Kelly. "Maybe invite them outside."

The Comics Code— Purity for Puberty

The outcome of the Senate investigation failed to implicate comic books as a cause of juvenile delinquency, but it did lead to the Comics Code.

When comic books were at their all-time low, reeling from the public relations battering to which they had been subjected, the publishers got together to form a new

self-censorship association. The Code it produced was enforced by a former New York City magistrate, Charles F. Murphy, working out of an office at 41 East 42nd Street and with a budget of $100,000 for the first year. The rules of ethics were so pure they would have done a nunnery proud. Paid censors with impeccable credentials were recruited from the ranks of school teachers and librarians.

It was required that the original finished art boards of each issue be submitted to the association for approval.

ABOVE: *Perhaps the most notorious EC story—at least with those on the U.S. Senate Subcommittee investigating comic books—was "The Orphan" (*Haunt of Fear #20). *Here is the final offending page. ©2003 William M. Gaines, Agent.*

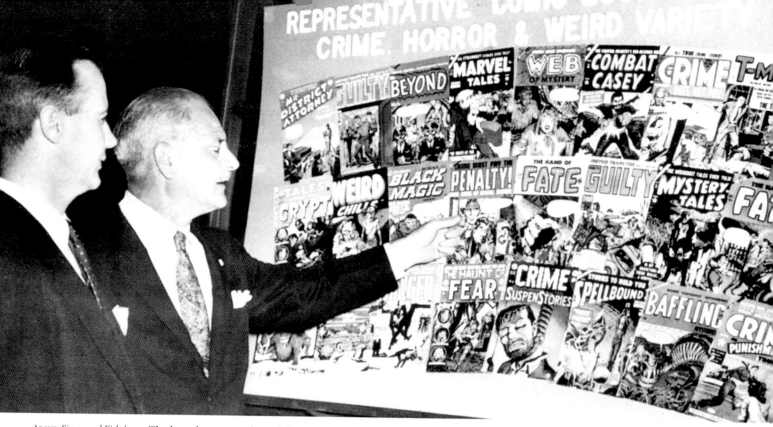

REPRESENTATIVE COMIC BOOKS
CRIME, HORROR & WEIRD VARIET...

The boards were read carefully by the staff and returned to the publishing office with a letter stating what corrections in story and art were to be made or what was to be deleted. The censors would then go over the entire book again — and again — until it was approved. Murphy and his staff of reviewers studied drawings and stories before a comic book would see production. Before 1954 was over, reviewers had gone over more than 400 comic book issues scheduled for publication by early 1955. More than 100 stories were rejected and more than 5000 drawings were directed to be redrawn to conform to the Code. Each page that met the standards was rubber stamped "Approved by the Comics Code Authority." When the comic books were published, a seal of approval on each cover indicated the publication's membership in the association. The press dubbed Murphy the "comic book czar."

The campaign to clean up the comics led to changes; among them, how female characters could be depicted. Their anatomy was now covered more fully with what was call the "Dior" treatment, in imitation of the Parisian clothing designer Christian Dior's designs. Other comic book restrictions included eliminating all scenes of blood and gore, profanity, references to physical deformities, ways to commit crime, and "illicit" love. The restrictions were similar to those established by the earlier 1948 Association of Comic Book Publishers, yet more stern. The Code also restricted what products comic books could advertise.

All this regulation was time-consuming and costly. Two major publishers refused to be panicked into joining the association. Dell and Western Publishing insisted that their Disney comics were wholesome, innocent and above all others in quality. The distributors seemed to agree and their acceptance on newsstands met little if any resistance.

The Comics Code Authority denied their seal of approval on all crime and horror books. Even in the adventure or fantasy comics, if a scene depicted violence or a crime being committed, that scene was struck from the contents. The Code Authority feared that a young reader might learn how to commit that crime from the comic book scene.

Bill Gaines and his EC Comics gave up the battle with the Code's rules and dropped the EC line of horror comics. I was at the office of the Comics Code one day waiting for approval on some censored corrections when the EC editors came in with the boards of their one remaining viable comic book. It was fairly new, and was titled *Mad* comics. The editors met with the Code staff in a private office where there was intense disagreement on censorship demands. The *Mad* people, led by editor Harvey Kurtzman, walked out in a huff, shaking their heads in disbelief. "Those people don't have a sense of humor," Kurtzman lamented.

Gaines countered by changing the format from a ten-cent comic to a 25¢ 8" by 11" magazine. Only the covers were in color. The insides, in black and white, constituted a considerable savings over the expensive four-color process and consequently bigger profits. Since it was no longer a comic book, there was no need for the Comics Code seal of approval.

Thanks to the Comics Code, *Mad* became an American success story, one of the great satirical magazines of our time.

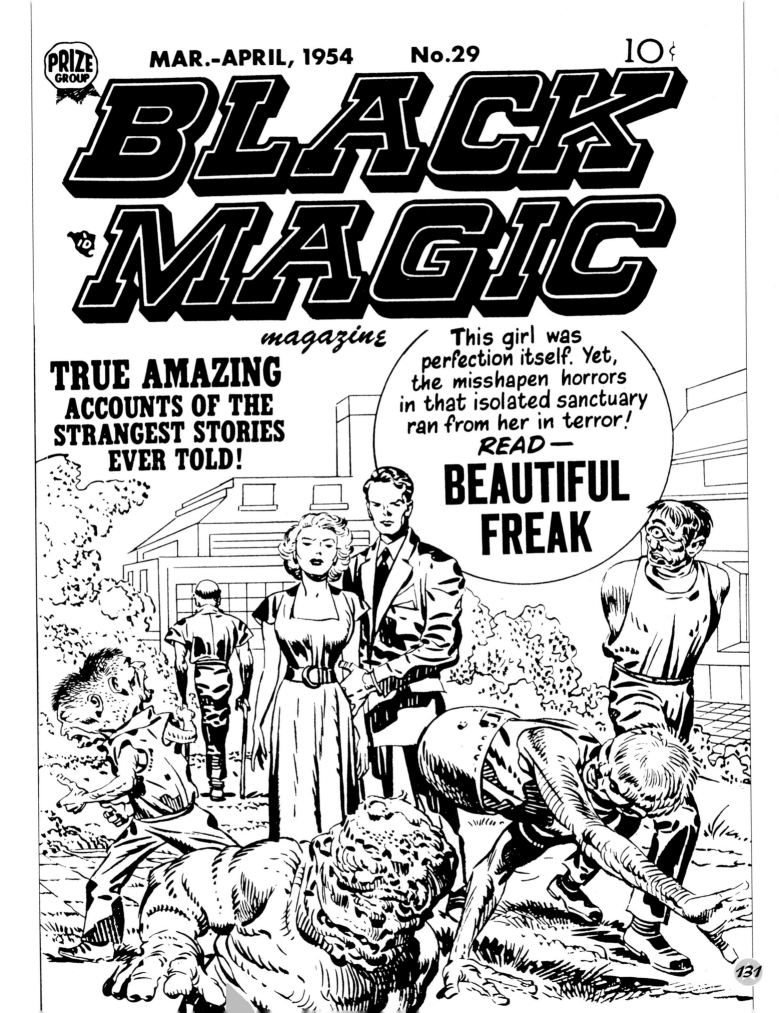

Mother nature must have split her sides, laughing, when she thought up this one! In a city of twisted, crawling deformities, this one stood out---

The Greatest Horror of Them All!

The AMAZING STORY OF A BEAUTIFUL FREAK!

"THE TRICK WAS TO KEEP LOOKING AT THEIR FACES. MOST OF THEM WERE NORMAL THERE, AND ONE COULD WITH COURAGE AND WILL POWER, MAKE A GRADUAL ADJUSTMENT TO THE REVOLTING THINGS WHICH NATURE HAD DONE TO THE REST OF THEIR BODIES! WE PLAYED CARDS, TOM, FRITZ, SING AND I... BUT, OF THE FOURSOME, ONLY I COULD WALK AMONG ORDINARY MEN WITHOUT MAKING THEM PHYSICALLY ILL!!

FRITZ PASSES, TOM.. I'VE GOT A PAIR OF KINGS. CAN YOU TOP ME?

SURE CAN, JOHNNY. I'M HOLDING A PAIR OF JACKS AND NINES--

JS-41

"WELL, NOW THERE WAS NOTHING DISTURBING ABOUT TOM-- NOT IF HE FACED YOU AND HID HIS MONSTROUS BROTHER WITH WHOM HE CAME INTO THIS WORLD-- THE HAIRY, TWISTED, HIDEOUS BROTHER WHO GREW OUT OF TOM'S BACK SHARING HIS BLOOD AND TISSUE -- AND BEARING HALF OF HIS ETERNAL CROSS.

TOM -- I SEE ELENA... SHE'S COMING THIS WAY--

HE IS RIGHT.. I SEE HER, TOO--

"POOR FRITZ WAS A MAN TO THE END OF HIS RIB CAGE. THE OTHER HALF OF HIM WAS JUST A HOUSING FILLED WITH A COMPLEX NETWORK OF TUBES AND CHEMICALS THAT KEPT HIM ALIVE. AT THE APPROACH OF ELENA, FRITZ LOPED OFF ON HIS POWERFUL ARMS!

EXCUSE ME, HERR PARKER... I MUST GO NOW!

"SING LEFT THE TABLE RATHER RELUCTANTLY. HE ENJOYED PLAYING CARDS.. HOWEVER, LIKE THE REST OF THOSE WHO LIVED AT "SANCTUARY" HE HAD GOOD REASON TO SHY FROM THE GAZE OF NORMAL PEOPLE -- ESPECIALLY THE RARE KIND LIKE ELENA, WHO WAS PERFECT IN FORM AND BEAUTY.

ELENA! I'M GLAD YOU SHOWED UP WHEN YOU DID--

THAT'S *ENOUGH*, ELENA! I WON'T TOLERATE ANY MORE OF SUCH TALK! THERE'S FILING TO BE DONE IN THE ADMINISTRATION OFFICE! NOW GO! I'LL SPEAK TO YOU ABOUT THIS LATER!

I DON'T CARE, I TELL YOU! I DON'T CARE!

GREAT CAESAR, DOC! THAT WAS A NASTY WAY TO TREAT ELENA! I DON'T SEE WHY OUR MAKING LOVE SHOULD BE ANY OF *YOUR* CONCERN!

EVERYTHING THAT HAPPENS HERE IN "*SANCTUARY*" IS MY AFFAIR! THE WELFARE AND HAPPINESS OF EVERY BEING HERE IS MY RESPONSIBILITY! I WAS *HOPING* TO LEAVE THAT DUTY TO *YOU*, ONE DAY, JOHNNY!

BUT, I NEVER SHALL, JOHNNY! I SEE THAT NOW! *YOU AREN'T BIG ENOUGH FOR THE JOB!* YOU DIDN'T COME TO "SANCTUARY" TO DEDICATE YOURSELF TO THIS WORK AS I DID...

NO, YOU DECEIVED ME, JOHNNY! YOU CAME HERE BECAUSE OF *ELENA!* I SHOULD HAVE REALIZED THAT WHEN SHE AND I MET YOU IN NEW YORK!

SO, YOU'RE JEALOUS! YOU WANT ELENA FOR YOURSELF, DON'T YOU?

JOHNNY, JOHNNY, HOW I PITY YOU! ELENA IS NOT FOR ME OR YOU... *OR ANY MAN!* DO YOU KNOW WHY I TOOK HER TO NEW YORK? WE HAD AN APPOINTMENT AT THE DENTON FOAM RUBBER COMPANY...

CAN IT, DOC! I'M NOT INTERESTED! BUT LET ME TELL YOU SOMETHING..

I'M GOING TO TAKE ELENA OUT OF THIS FREAK MENAGERIE! TONIGHT! AND IF YOU TRY TO STOP US... I'LL *KILL* YOU, DOC!

YOU FOOL! YOU BLIND, YOUNG IDIOT! CAN'T YOU SEE WHAT I'VE BEEN TRYING TO TELL YOU... ELENA...SHE'S...

AT THAT MOMENT MY ARMS WERE ALMOST YANKED OUT OF THEIR SOCKETS! AND, I FOUND MYSELF HELD FAST IN THE GRIP OF ONE OF DOC LOWRY'S MONSTROSITIES!

HURT THE DOCTOR AND I'LL BREAK YOU INTO LITTLE PIECES!

LET HIM GO, FELIX! JOHNNY'S LEAVING! THERE'LL BE NO MORE TROUBLE IN "*SANCTUARY*!"

CONTINUED ON 3RD PAGE FOLLOWING

3

I WAS UNABLE TO MOVE FOR HOURS AFTER THOSE THICK, FLESHY FINGERS RELEASED ME. IN MY ROOM, I SPRAWLED ON THE BED, SWEATING AND CURSING DOC LOWRY AND HIS FREAKS AND ANY OTHER OBSTACLE BETWEEN MYSELF AND ELENA.

I'M NOT GOING WITHOUT ELENA! CAN'T LEAVE HER HERE, AMONG THESE HORRORS! THERE'S NO TIME LEFT. GOT TO MAKE MY MOVE — NOW!

"I DIDN'T BOTHER PACKING. ALL I TOOK WAS MY HAT, A FIELD JACKET AND A LOADED PISTOL! WITH LUCK, I WOULD TAKE OFF WITH ELENA IN THE HELICOPTER WHICH BROUGHT US OVER THE MOUNTAINS AND WILD FOREST THAT PROTECTED "SANCTUARY" FROM THE WORLD OF NORMAL MEN. IF I MET OPPOSITION, I WAS READY TO SHOOT MY WAY TO FREEDOM!

WELL, HERE GOES! THIS CORRIDOR'S CLEAR. ELENA'S ROOM IS TWO FLOORS ABOVE! I'LL HAVE TO BE QUICK AND SILENT—

"NOTHING SEEMED TO BE STIRRING. *EVEN LOWRY'S FREAKS HAD TO SLEEP!* BUT I DIDN'T RELAX MY TRIGGER FINGER AS I STEALTHILY MOUNTED THE STAIRS TO ELENA'S ROOM—

"I BREATHED EASIER WHEN I FOUND ELENA'S DOOR UNLOCKED. WITH A QUICK MOVEMENT I EASED MYSELF INTO HER ROOM AND SOFTLY CLOSED IT BEHIND ME—

"THE ROOM WAS DIMLY LIT. AND I STEPPED CAUTIOUSLY FORWARD SO AS NOT TO STARTLE HER AND CAUSE AN OUTCRY. SOFTLY, I CALLED HER NAME, BUT GOT NO ANSWER.

ELENA— ELENA—

"FOR SOME UNEXPLAINABLE REASON AN ICY CHILL SWEPT ALONG MY SPINE AS I MADE MY WAY THROUGH THE GLOOM. IN A FAR CORNER WAS A COUCH — AND WAS THAT ELENA ASLEEP UPON IT? I DREW CLOSER TO MAKE CERTAIN—

"SOMEHOW MY BRAIN COULDN'T SEEM TO ABSORB THE MEANING OF THE THING THAT WAS DRAPED CARELESSLY ACROSS THE COUCH!

4

"IT WAS MADE OF FOAM RUBBER AND PLASTIC... A SORT OF COLLAPSED, DE-FLATED, FLESH-COLORED THING WITH *ELENA'S* HAIR, FACE, ARMS AND LEGS! THE EYES WERE MERELY HOLES, LIKE THE OPENINGS IN A MASK..."

"THEN I REMEMBERED WHAT DOC LOWRY WAS TRYING TO SAY BEFORE I CUT HIM OFF... SOME-THING ABOUT HIS TRIP TO NEW YORK WITH ELENA! AN APPOINTMENT AT THE DENTON FOAM RUBBER COMPANY... *AND INSIDE ME, I SHRIEKED WITH THE IMPOSSIBILITY OF WHAT I WAS THINKING!*"

IT... SLITS OPEN IN THE BACK... SO SOMETHING CAN PUT THIS ON AND WEAR IT... IT'S A SUIT... *A SUIT THAT LOOKS LIKE ELENA!*

"IT CAME TO ME... THE ANSWER... CRAWLING LIKE AN UGLY SPIDER OUT OF ITS LAIR... ELENA... *SHE WAS ONE OF THEM!* ONE OF LOWRY'S FREAKS! SUDDENLY, THE AIR WAS SPLIT BY A *BLOOD-FREEZING SCREAM!*"

"THE VERY SIGHT OF THE THING THAT CAME OUT OF ELENA'S BEDROOM AND SCREAMED IN HER VOICE SENT ME STAGGERING BACK WITH FEAR AND NAUSEA... AND GROPING FOR MY PISTOL!"

JOHNNY! DON'T RUN FROM ME, JOHNNY... I... I *LOVE* YOU, JOHNNY! I LOVE YOU!

"THAT HORRIBLE, PLEADING MONSTROSITY DRAGGING ITSELF TOWARD ME DROVE ME TO MADDENED FRENZY! *I BEGAN BLASTING INTO ITS FACE THE MOMENT THE GUN WAS IN MY HAND!*"

"AND EVEN AS I WATCHED THAT HIDEOUS FACE DISINTEGRATE INTO A RED RUIN, I HEARD MYSELF *CRYING* ABOVE THE ROAR OF THE GUN..."

"I CRIED FOR ELENA... WHOSE BEAUTY SO AWED THE FREAKS... BUT THAT WASN'T TRUE, WAS IT... THEY RAN BECAUSE THEY *FEARED* HER... SHUNNED HER.. BECAUSE NOT EVEN *THEY* COULD STAND MY ELENA... *THE GREATEST HORROR OF THEM ALL...*"

⑤

THE END

NEXT ISSUE ON SALE DURING THE FOURTH WEEK IN SEPT.

Mainline: S&K's Own Company

Comic book publishers were dropping out of the business in wholesale numbers. The printers grew frantic. It was a necessity of their business that the presses keep running. When the presses were silent, printing companies still had to pay overhead, so they were more than willing to back a new comic organization if it showed promise. Since Simon and Kirby had one of the strongest creative records in the business, a printing salesman urged us to start a new line financed by very liberal printing credit.

In the spirit, Jack Kirby and I established our own corporation, Mainline Publications, Inc. We rented an office from the Harveys at 1860 Broadway — the same office where we had done the 3-D comics. (That office had remained vacant ever since those days.) We started with four new titles — *Bullseye* (Western scout), *Foxhole* (war adventures written and drawn by veterans), *In Love* (each issue a complete romance novelette), and *Police Trap*, ("true" stories told from the policeman's viewpoint).

The distributor we chose was Leader News, the company that distributed Bill Gaines' EC Comics.

As was the custom, the distributor advanced the publisher twenty-five percent of the total income on a one hundred percent sale. This advance was paid when the books were shipped from the printer to local whole-salers around the country. We assigned that money to the printer, who would then pay the engraver. This too was common practice. Since a comic book would usually sell a minimum of thirty percent, everybody was happy. Until the profits rolled in, Mainline would be required to invest in only the editorial material consisting of the art, lettering and scripts.

While we were publishing our own books we continued to turn out the Crestwood line. When finances got tight we looked for ways to economize. I took the original art of an old love feature and wrote a whole new story around the existing art, and then embellished it with a new title. I thought that was very clever. I was proud of myself. We had saved the major cost — that of new artwork.

After the issue of *Young Love* was printed, someone in the organization recognized the artwork and pointed out the subterfuge to the publishers at Crestwood Publications.

The publishers took up the matter with their attorney. The attorney informed Crestwood that there was nothing in the contract that specified what kind of book we were obliged to turn in — as long as we turned in a book on schedule. This didn't satisfy the publishers, who naturally turned more hostile. They continued to hold off paying us while we grew increasingly desperate. Our defense was to take the offensive.

(Continued on page 147)

BELOW: *Simon and Kirby's second patriotic hero and his sidekick, Speedboy, double-team a Commie rat but good in this unused cover art, originally intended for* Fighting American #4. *©2003 Joe Simon and the Estate of Jack Kirby.*

COME ON IN...
IT'S YOUR POLICE STATION

It's a friendly, happy place... and the guys are a good bunch... easy to talk to— anxious to help you! That's their job..... That's why you should get to know them!

HERE IS THE FIRST OF A SERIES "POLICE TRAP" HAS PREPARED, TO HELP YOU KNOW YOUR POLICE OFFICER!

SAVE THESE *Authentic* ILLUSTRATIONS... HANG THEM IN YOUR ROOM OR CLUBHOUSE.

cut on dotted line

- -

WE DIDN'T *INVITE* YOU HERE, GURNEY! YOU WERE PICKED UP RUNNING NUMBERS! NOW, QUIT YOUR BELLY-ACHING AND LET ME SIGN YOU IN!

I GOTTA *RIGHT* TO SOUND OFF IF I LIKE! I GOTTA RIGHT TO TELL *MY* SIDE OF IT!

AND YOU ALWAYS *DO*... EVERY TIME WE HAUL YOU IN WITH THE EVIDENCE! WHEN YOU GET TO THE *JUDGE*, YOU CLAM UP AND PLAY "GOODY". *WE* ALWAYS GET THE *GRIPES!*

THE DESK SERGEANT

LIKE ST. PETER AT THE GOLDEN GATE, HE REVIEWS THE GOOD AND THE EVIL, AND CLASSIFIES THEM ACCORDING TO THE CHARGES... THE DESK SERGEANT SIGNS IN OR "BOOKS" THE PRISONERS AND RECORDS THE CRIME.. HE DIRECTS COMPLAINTS AND COMPLAINANTS TO THEIR PROPER CHANNELS... THE DESK SERGEANT IS THERE TO HELP AND ADVISE YOU... IF YOU'RE IN TROUBLE, TALK IT OVER WITH HIM...

THIS PAGE: *Various covers and a pin-up page featuring Simon and Kirby artwork. In the early days of the Comics Code, Mainline Publications attempted the first "crime comics" with the seal of approval. Police Trap related crime stories from the police perspective. Although the people at the Code Authority were uncomfortable with the crime aspect, they were somewhat placated by gimmicks such as the pin-up reproduced at upper left. ©2003 Joe Simon and the Estate of Jack Kirby.*

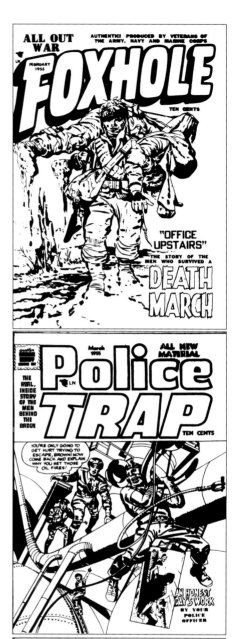

The Legend

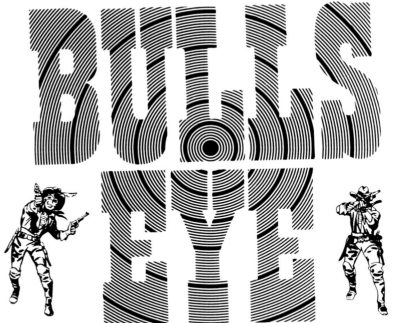

BULLS EYE

Western Scout

The one who is to become Bullseye is born in the midst of death, his first baby cry lost in the terrifying war-whoops of savage redskins led by their renegade chief, Yellow Snake.

The defenders of the frontier town of Dead Center face a massacre as they fall back behind their burning stockades. As the warriors close in, the baby's father saves his last two bullets for the mother and himself.

The baby's grandfather, a legendary sharp-shooting old scout called Deadeye Dick, clutches the baby to his chest and brings his horse to full gallop, charging out of the stockade and straight through the circle of surprised warriors, into the plains. He loses the war party sent to pursue him and the two fugitives spend days wandering, hiding and hunting to stay alive.

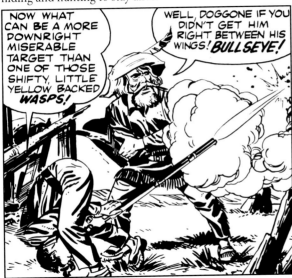

NOW WHAT CAN BE A MORE DOWNRIGHT MISERABLE TARGET THAN ONE OF THOSE SHIFTY, LITTLE YELLOW BACKED WASPS!

WELL, DOGGONE IF YOU DIDN'T GET HIM RIGHT BETWEEN HIS WINGS! *BULLSEYE!*

When Deadeye decides it is safe, he returns to the settlement to find it a smoldering graveyard. The only sign of life is an ancient Indian named Long Drink, a retired army scout who has chosen the ghost town to spend his last days in peace.

The old men settle in the ravaged settlement building and in the years to follow raise the boy to shoot, ride and scout. His speed of hand and foot is uncanny — his eyes are sharp as a bowie knife, and so he is called Bullseye.

One night, while the boy, Bullseye, sleeps, Deadeye sets out to settle the score with Yellow Snake. He challenges the renegade chief, but in an act of treachery is gunned down by one of Yellow Snake's warriors. Bullseye seeks his revenge. As he and Yellow Snake face each other, they fire simultaneously. The bullet from the boy's rifle enters the barrel of Yellow Snake's pistol, blowing it apart and making a gory mess of the chief's face. Filled with pain and rage, Yellow Snake raises his tomahawk to kill the boy, but his braves stop him, declaring that the Great Spirit has given his sign.

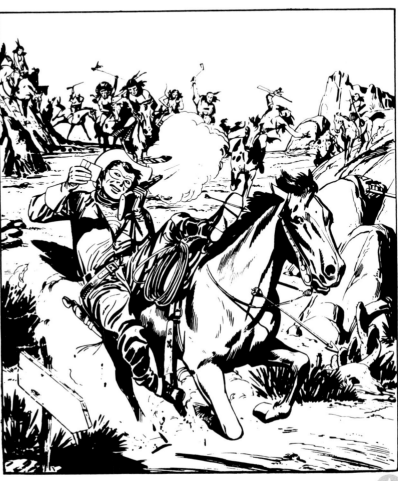

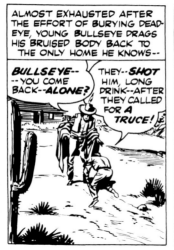

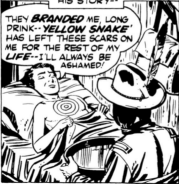

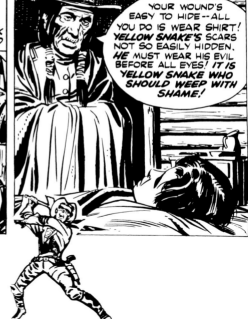

Instead, the Indians light a fire and with a red-hot iron, brand a target on the boy's chest. "This symbol," Yellow Snake vows, "shall you wear forever on your chest so I may know you when you are old enough for me to drive a spear through its center!"

Once again, Bullseye goes into hiding, struggling to survive and regain his strength. One day he wanders into the town of Longhorn Junction where he comes upon a band of hoodlums shooting up the wagon of a little peddler. Bullseye comes to the peddler's defense, dispatching the gun-slingers with lightning precision. He is branded an outlaw by the Sheriff, but escapes in the peddler's wagon.

Now hunted by the white man and an open target for the Indians, Bullseye, the youth, disguises himself and his magnificent horse, Buckshot, in bedraggled rags and embarks on a life of wandering; a man with two identities — one, Panhandle Pete, purveyor of pots and pans — the other, which will make him a legend of the West.

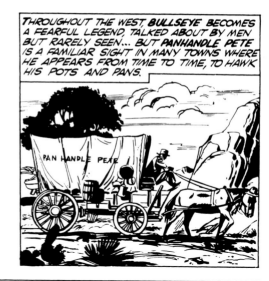

Bullseye
Action Portfolio

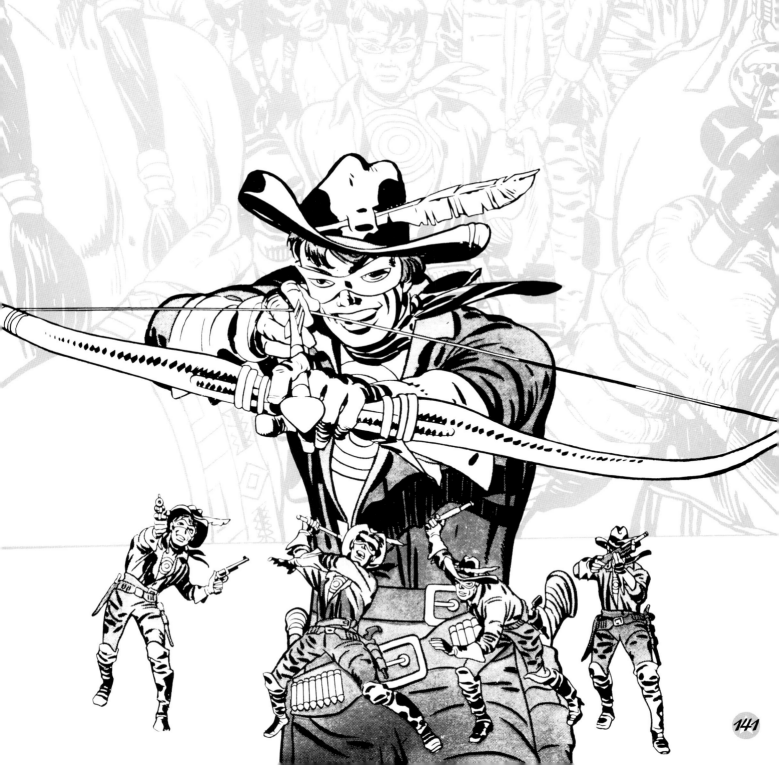

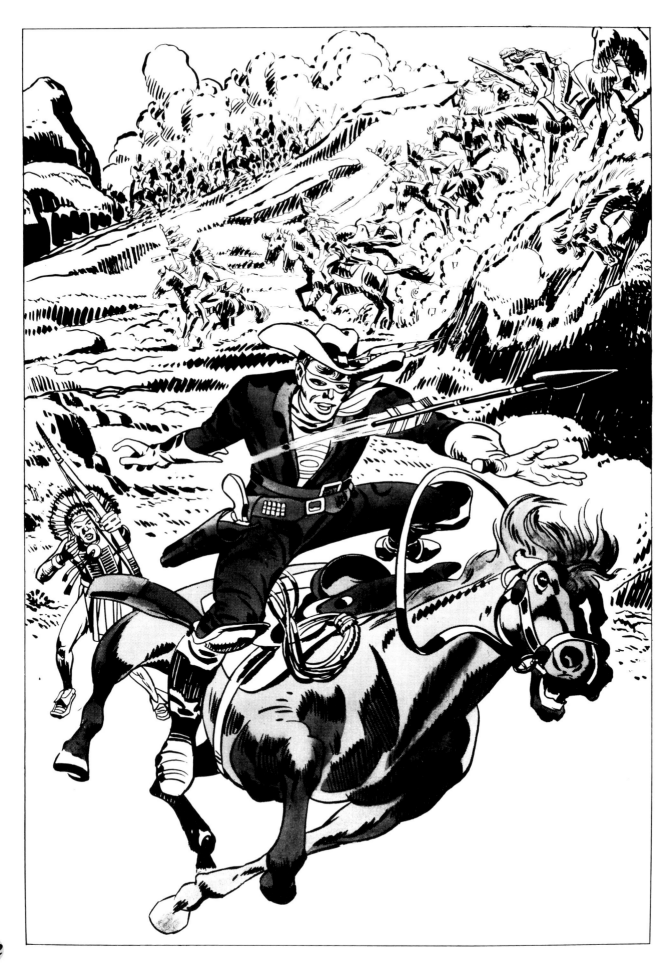

The Accountant: Fish in a Barrel

Our accountant hadn't checked Crestwood's financial books for years, although it was called for in our contract. It was a long and costly procedure, but we made a deal — Bernard Gwirtzman, the accountant and Morris Eisenstein, the lawyer of his choice, would retain one-third of whatever monies they could recover. The attorney and accountant were specialists in the business; they knew all about publishing practices — including "extra" incomes. They were confident, and we hoped fervently that they would find the publisher's fingers in our cookie jar.

In November 1954, Eisenstein arranged to have Gwirtzman and his staff of accountants move into the Crestwood offices to peruse the books and records. A member of Crestwood's accounting firm was in attendance. It took two weeks to complete the audit. When it was over, we met with Gwirtzman.

"How does it look?" I asked.

"Fish in a barrel," he answered smugly. "It's like shooting fish in a barrel."

Several days after the audit, a meeting was convened in the offices of the Crestwood attorney. In addition to said attorney, those present were: the publishers, Teddy Epstein and Mike Bleier, along with their general manager, Reese, at one side of the conference table; on our side, accountant Gwirtzman, attorney Eisenstein, Jack Kirby and myself.

Mr. Eisenstein stood up and read aloud his letter of complaint:

"On behalf of my clients, Joseph Simon and Jack Kirby, co-partners doing business as Simon and Kirby, we demand monies due and owing to them from Crestwood Publications Co., Inc., Feature Publications, Inc., Headline Publications, Inc., and any other affiliate with whom or through whom dealings may have been had by my clients.

"My clients have been preparing and submitting to the aforementioned corporation, and/or affiliates, art work and editorial material for what is commonly known as comic magazines, some of the titles of which are: *Fighting American, Young Brides, Black Magic, Young Love* and *Young Romance.*

"It is their contention that they have not been paid all the advances and all the royalties and other monies due and owing to them under their agreements with the corporations and or their affiliates. Although they have received advances and royalties from the corporations

BELOW: Panels by Mort Meskin, which parallel the difficult last days of Simon and Kirby's Mainline Publications. ©2003 the respective copyright holder.

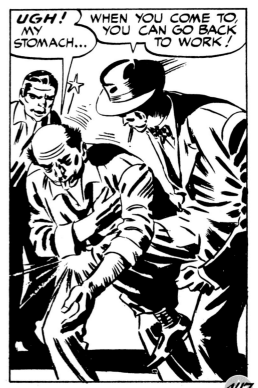

and/or their affiliates, we believe there is still considerable sums of money due and owing to them which have not been paid."

Fiery little Teddy Epstein leaped to his feet in an apoplectic rage.

"We paid every cent coming to them. We never held back one dollar of royalties!"

Gwirtzman, cool and studied, held up a sheaf of ruled papers.

"Overseas sales, sales of unsold copies, sale of used plates and other incidentals. My clients never received a smidgen of their share of these incomes they were entitled to."

Mike and Teddy broke out in laughter. They were obviously relieved that nothing major had been uncovered.

"Garbage," Mike yelled derisively. "You guys don't know this business."

"How much do you think we get for that garbage," Teddy added. "Fifty bucks here, fifty bucks there — you're talking peanuts!"

Gwirtzman continued callously. "Over the term of seven years, our clients' portion of that income comes to" — he turned over some papers dramatically — "$130,000 and 34¢."

Teddy and Mike turned ashen.

Gwirtzman laid the papers on the table. "Here are the figures, gentlemen."

The other side of the table took the papers and retired to another office while Kirby and I sat numb in disbelief.

Less than a half-hour later they returned.

"My clients don't have this kind of money," the attorney answered. "If you proceed with a court action, they'll have no alternative but to close up shop. You know how bad the business is."

"How much are you willing to offer," Gwirtzman inquired.

"Three thousand dollars."

After some serious bargaining that very day, we settled for $10,000, plus the back payments Crestwood had been holding out on us.

We went back to work, turning out the books and

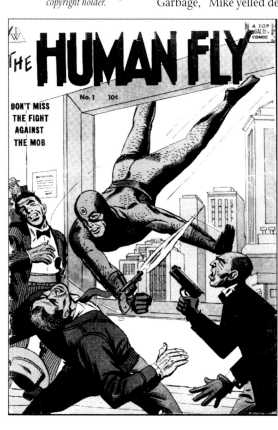

doing business with the company as if the accounting had never happened.

Our Mainline comics, meanwhile, had been showing fairly good sales with clean, wholesome material, but payments from Leader News Company, our distributor, were slowing down alarmingly. The sudden demise of EC Comics had put Leader News in a financial crisis and they soon folded their tents, leaving us holding an empty sack. Mainline Publications became insolvent, an innocent casualty in the final victory by "The People" against the vile forces of Crime and Horror Comics.

Odd Lot Publications

It became a struggle to survive for the dozen-plus publishers lucky enough to be hanging on. Every dollar of income from whatever source could prolong their business existence, or, better yet in some cases, provide a few dollars for a fast exit out of the business.

Traditional sources of extra income included the sale of reproduction rights of publications to Europe or South America, which would be translated to the language of each particular country; the sale of the zinc engraving plates to be melted down and used again for new plates or other manufacturing purposes — even the bundles of returns (unsold copies) most of which were never even opened or put on sale. These were intended to be used for paper recycling purposes only, but we all knew that they would fall into the hands of outlaw entrepreneurs and sold illicitly.

And then there was Israel Waldman. Waldman was the industry's "odd lot" publisher. More importantly, he was the last hurrah for the comic book entrepreneur who had decided to close shop. His publishing enterprise was simple and innovative. Basically, he reprinted previously published comic books, adding new covers which were not dated. Since there were no dates on his comic book covers or insides, they became merchandise, like hardcover books, salable at any time.

Waldman did not distribute through newsstands but sold in job lots to discount stores throughout the nation. Several titles were packaged together in plastic see-through bags. The individual merchant could charge whatever he chose to.

Waldman worked on a small profit basis, but his operation was not a "gamble" like the regular publisher who would have to absorb the cost of the entire printing, even if they all came back in "returns."

The retail buyers of Waldman's plastic packages were, for the most part, bargain-hunting parents. When they brought their bargains home, however, many discovered that the kids were not entirely thrilled with the choices. The kids enjoyed browsing through the comic displays at their local mom-and-pop candy store to discover and claim the latest "hot trend." Still, Waldman's products had their little share of the market.

When Mainline closed its doors for the last time, I set up a meeting with Mr. Waldman at his 20 East 46th Street office in the heart of New York's diamond district.

The block was bustling with Hasidic Jews in black suits, black hats or *yarmulkes*, many with long curled *payis* (sideburns) and tasseled shawls, called *tzitzis*, wrapped around their waists and trailing below their long European suit jackets. There were small groups doing business on the street and sidewalk. Jewelry stores lined the street, signs proclaiming, "We buy and sell diamonds" (or gold). Lovers shopped the store windows for engagement rings. One tiny shop advertised kosher pizza, a first in America.

Waldman's office building was plain and stark like the other buildings on the block. On the street in front was a large, covered truck colorfully painted in light blue-and-white with the star of David on all sides. Pale Hasidic men were hustling passersby to "come in and say a prayer." The vehicle was a mobile synagogue.

I made a quick turn into Waldman's building, then climbed the black iron steps to the third floor. There was no sign on the door. Only the number told me I had the right office. Inside I found myself in a small, caged cubicle facing another door, this one huge, iron, intimidating. There was a bell which I rang. A tinny voice from an unseen sound system responded. The voice requested that I state my name and business. I did. A very loud buzzer startled me. I could see the door snap from its lock. The voice directed me to enter. This was the way business was conducted in the diamond industry.

Mr. Waldman introduced himself. He leaned over a well-scratched wooden desk with peeling varnish holding neat stacks of yellowing artwork that must have been recently retrieved from warehouses. More stacks of dusty artwork and engravers' proofs lined the floors. Some titles I recognized. Most were not notable. There were love comics, superhero comics, even Will Eisner's wonderful crime-fighting costumed character, the Spirit.

ABOVE: *Try as they might, Simon and Kirby used house ads such as this one (which touts a title,* Night Fighter, *which was never published) to stir up reader interest in their line-up. But by the mid-1950s, sales of comics were plummeting. ©2003 Joe Simon and the Estate of Jack Kirby.*

Mr. Waldman sat down and gestured toward the other chair in the room. He smiled cordially, for the first and last time. A slim man in his early forties, he was tie-less, his shirt sleeves rolled up below the elbows, his hands smudged with the dust of the old artwork. On the desk in front of him, a business-size checkbook was prominently displayed, an obvious invitation for a quick bargain.

Mr. Waldman was all business. He took the comic books out of the envelope I shoved at him: *Bullseye, Foxhole, In Love, Police Trap.* He rifled through a few pages of each, then set them down next to the checkbook. I was disappointed that he hadn't read a story or two.

"This material is really superior," I told him.

"Where can I pick up the mats?" he asked. He was referring to matrix, the fiber molds for the zinc plates from which the final letterpress printing is made. Each mat contained four pages set up in an order that, when printed as a unit, would fall into the proper numerical sequence. There was one set of mats for black ink, one set each for red, blue and yellow.

I wrote my address on a pad on his desk. He wrote a check. It was for fifteen hundred dollars, as agreed upon by phone prior to our meeting.

"We need to keep the copyrights," I said.

"So keep them." He shrugged. "What do I need with copyrights?"

Generally, when negotiating this sort of a deal, there would be legal papers, contracts, releases, and other legal details to take care of, but Waldman didn't have the time or inclination to mess around with such trifles. After all, he was dealing with losers — the undercapitalized, undersold, debt-ridden shipwrecks of free enterprise yearning to breathe free. Fifteen hundred bucks was the price of liberty.

I accepted his check, shook his hand, and headed for the secured door. Waldman pushed the buzzer button, releasing me to descend the black iron steps and enter upon the grey street below.

The mobile synagogue seemed deserted. Instantly, a pale young man in a black suit with black hat, long curled sideburns and sashed waistband trailing below his long suit jacket appeared from a nearby doorway. He tapped me on the arm.

"*B'ist a Yid?*" he whispered.

"Huh?"

"You're Jewish?" Now he wasn't sure. It was standard procedure. They were called god hustlers (with a lower case "g" for protection against apocalypse).

"Oh! Yes, I understand."

He offered a *Siddur* (prayer book), gesturing toward the truck. "You'll say a prayer? It's a *mitzvah*. A blessing."

"Some other time," I apologized, and hurried off toward Fifth Avenue.

I had a check for fifteen hundred bucks. My prayers had already been answered.

A Killer Among Us

t was 1957. My friend Al Harvey said he was glad to have me join his company, Harvey Publications. I soon went to work turning out a new line of adventure comics.

The industry was once again engaging in a frenzy of new titles set off by some wild tip or distributor's perception that the time was ripe for more adventure titles.

My assignment was to turn out six new titles on a regular bi-monthly basis, starting out without one solitary artist or writer. The only solution was to steal and cajole talent from other publishers.

But immediately new publishers were hearing the song of the sirens and the bidding for talent was raised. The race was on and under these dire circumstances, I did my best to finish first.

It was like the hectic days at Fox Publications, and worse, because this time we had to come up with all new titles and concepts. My friends, among the best in the business, came through for me. The artists were Jack Kirby, George Tuska, Bill Draut, Bob Powell, Al Williamson, Angelo Torres, John Severin, Carl Burgos, and Wally Wood, a convert from *Mad* magazine.

The titles we came up with were *Alarming Tales, Race for the Moon, Black Cat Mystic, Warfront,* and *Man In Black.*

Script writers included brothers Dick and Dave Wood and my old protégé, Ed Herron, three buddies who were thorough professionals, amazingly prolific, and moonlighting from their regular assignments at DC Comics. Herron's health was deteriorating. He was in and out of Veterans' Hospitals, but his mind was as fertile as ever. Eddie died while in the middle of a script. Since Ed had been paid in advance for the script, Dave Wood took it upon himself to finish it so that I wouldn't get into trouble with the comptroller.

Incredibly, we were meeting schedules, turning out good, quality products — until the day Leon Harvey requested a meeting of the artists. Wally Wood showed up first. Leon, who was billed as executive editor, placed some of Wally's art pages on his very large desk in his very large office, placed a sheet of tracing paper over each board, and picked up a red crayon. That's when I knew we were in trouble.

BELOW: *New York City newspaper headlines announcing the descent of a comic book artist into the pits of Hell.*

DAILY NEWS, WEDNESDAY, AUG

Artist Slays Divorcee After 11-Day Tryst in A Gramercy Pk. Hotel

By William Federici and Nathan Kanter

A lovers' 11-day tryst in a genteel Gramercy Park hotel was by murder yesterday.

Slain—battered to death with an electric iron—was Mrs. Vio lips, 45, a divorcee, of 7 E. 85th St.

Her blood-spattered body, clad in a negligee, was found shortly after 4:30 P. M. on n bed in the two-room suite in the Hotel Irving, 26 Gramercy Park Ave........ and which she had checked with her lower on 'Aug. 1? Mrs. Robert Brent, Arlington, Mass."

Booked on the E. 22d St. sta- the slaying was Wood, 43, an artist, of 170 Hartsdale, N. Y.

Suspect Picked Up

Police found him in rina Residence Hotel, 202 ... St., into which he had ... Roger Turner. He had j off a bloodstained dark police said.

First to learn of was Paul Finegold, 26 Third St., Brooklyn, Shortly after 4 P. picked up Wood at

friendly with Mr the last 10 year met her when th E. 57th St....eac spouses."

Wood said he had been argu days, and that out anew abou terday, after a "I killed her quarrel," polic

Arraig

After quest District Att the dark-hai and lodged for arraign Cou

Artist Gets Term In Manslaughter

Robert Wood, forty-one of 170 East Hartsdale Poad, Hartsdale, N. Y., former car- toonist

Cartoonist's Last Horror Strip

By SIDNEY KLINE

Bleary-eyed, unshaven, dirty and shaken—looking like an illustration of a trapped ...inal-in-the "Crime Doesn't Pay" magazine he once edited—horror-strip cartoonist ...rt Wood, 41, was held without bail yesterday for hearing Sept. 19 on a homicide charge.

Proceedings were brief before Magistrate Frederick L. Strong in Felony Court.

Wood, unkempt in filthy cloth- ing, his face smeared with dirt after a fall in police headquar- ters, was assisted before the bench by Detective William Schreck. It was Schreck who signed the complaint charging Wood with bludgeoning his di- ...to death with

"What is the situation here?' Strong demanded of Assistant District Attorney Charles McDon- ough and of defense counsel James G. McGoldrick, who had been retained by Wood's brother, David, a TV writer.

McDonough said Wood and Mrs. Phillips had been living as man and wife, that a fight had ended in homicide. He requested adjourn- ment of proceedings until Sept. 19. The court granted the request.

..... E. Hartsdale Ave.

DAILY NEWS AUG 28 1958

SUNDAY NEWS, SEPTEMBER 14, 1958

Gramercy Park Gets the Horrors

Editor of mag called 'Crime Does Not Pay' murders ad woman in a hotel tryst

By KERMIT JAEDIKER

A BROADWAY-STYLE murder, sexy, loud-mouthed and liquor- ed-up, hit quaint, Victorian-prim Gramercy Park smack in the bus- tle the other day. While children disported restrainedly under the eyes of governesses and elegant old ladies enjoyed their constitutionals behind the spiked iron gates of New York City's only private park, high above the park, in a hotel suite, a free lance cartoonist climaxed 11 days of

WOMAN FOUND SLAIN

Cartoonist Seized as Suspect in Hotel Bludgeoning

A woman was found yes- terday afternoon apparently bludgeoned

As Wally looked on in utter disbelief, Leon, with a swish and a flourish of his crayon, proceeded to give drawing lessons to one of the most accomplished artists in the history of comics.

Odd as it might sound, I understood what Leon was trying to convey — that a figure in the air or in space should be surrounded by blank space, not overlapping any background object. He wanted heavier outlines on foreground drawings receding to thinner lines for backgrounds. Action scenes were to come forward toward the reader and be transitional from one panel to the next. His ideas were basically sound animation devices. Unfortunately, his attempts at drawing were so pathetic, he only succeeded in confusing and offending the artist.

In the midst of Leon's swishing and swirling of his now-blunt crayon, Wally picked up his boards, discarded the tracing papers neatly in the wastebasket and walked off without a word, never to enter the Harvey portals again.

Leon was devastated. The next day he implored me to get Wally back in the fold. "He's one of the greatest artists we ever had here," Leon said.

Wally hung up the phone on us and Leon gave up his drawing classes.

In the summer of 1958, Bob Wood walked unannounced into the Harvey office. From his unkempt appearance, it was evident that he had hit hard times and was drinking heavily again. The one-time high rolling creative force behind *CRIME Does Not Pay*, the "true crime" publication that in its heyday had boasted a monthly circulation of one million copies before becoming one of the casualties of the 1954 Senate Subcommittee Investigation into juvenile crime and comic books, found himself hawking sleazy gag cartoons to third-rate men's magazines as his chief means of support. Although Bob, when sober, was a passable comic book artist, I regrettably could offer him no work, and I wondered what would become of him as he staggered dejectedly out the office door.

Several weeks later I found out. The full-page headline shouted from the *Daily News* on August 27:

Artist Slays Divorcee After 11-Day Tryst in A Gramercy Pk. Hotel

The newspaper account detailed how a cab driver had picked up Wood in the highly fashionable area of New York's Gramercy Park, near the Irving Hotel. Gramercy Park was known as a bastion of primness where the rich and well to do lived among the Victorian architecture and private gardens of a world shielded off from the rest of the city by tall iron fences.

The disheveled Wood rambled nervously in the back of the cab, at one point telling the driver, "I'm in terrible trouble. I'm going to get a couple of hours sleep and jump in the river."

"What happened? Did you kill somebody?" the driver asked, jokingly.

"Yes, I killed a woman who was giving me a bad time in Room 91 at the Irving Hotel. Why don't you call someone at a newspaper and make yourself a few dollars?"

There are all kinds of characters in New York City and most cabbies get to meet their share. But Wood's words, cut with urgent anxiety, seemed real, and after the cabbie dropped Wood off in Greenwich Village at the Regina Residence Hotel he drove the cab around the city streets until he found a police officer. The cabbie recounted Wood's story to the officer who in turn reported the cabbie's story to his superior at the East 22nd Street Station.

Police soon entered the Regina hotel where they questioned the manager. The manager told the police that the guy they were looking for had signed in under the name Roger Turner. The guy was shaking so much, said the manager, that he had to hold his hand to steady the pen on the registration card. The officers went upstairs. Wood was found on the bed, stripped to his shorts; the bloodstained suit crumpled on the floor. Wood's clothes were so bloodied, police borrowed a pair of pants from the hotel manager to take Wood in for questioning.

At the same time as Wood was being taken into custody, another team of police had arrived at the Irving Hotel where they used a passkey to enter room 91. Inside, they discovered empty whiskey bottles and the woman's battered body clad in a blood-splattered negligee.

It was as Bob had told the cabbie and, still in a drunken stupor, he confessed the whole harrowing ordeal to the police. At first, reports were unclear as to why Wood killed her. Wood supposedly told police that he and the woman had quarreled about marriage — she wanted to marry him, but he was against it because he had been married and divorced three times. The five-foot two-inch Bob Wood didn't want to take another chance but she

repeatedly insisted — and he snapped. But these were the rumors.

At Police Headquarters, staggering to the stage for the lineup, Wood mumbled, "I lost my head." Clutching the microphone to steady himself on his feet, he slurred, "She was giving me a bad time." In Felony Court, detectives escorted a still rubber-legged Wood to the bench.

"What is the situation here?" asked the Magistrate.

"They had been living together as man and wife," replied the Assistant District Attorney.

Wood interjected, "That's about it."

Bob Wood pleaded guilty to first degree manslaughter. He was held without bail for hearing.

Early accounts reported that Wood had told the cabbie he had killed the woman with a hammer. Police first thought Wood bludgeoned her with an empty whisky bottle. The court established that in the heat of a lovers quarrel, during an 11-day drinking binge, Bob Wood had suddenly lost all touch with reality, pummeling his lover to death with an electric iron.

The headlines sent shock waves through a comic book industry still struggling to regain its feet. The newspapers played the story for all its worth, splashing the gruesome headlines across their pages. The accounts were graphically illustrated with photos of Bob in a drunken stupor, the woman victim carried out of the hotel on a stretcher under a police blanket. He looked, as one reporter in the Daily News wrote, "like an illustration of a trapped criminal in the *Crime Doesn't* (sic) *Pay* magazine he once edited."

The newspapers had a field day playing on the sensationalism of the incident. Ironically, those of us in the comic book business understood. It was another third-panel explosion but this time in respectable newspapers, not comic books. It sold copies.

Bob Wood was sentenced to four to five years in Sing Sing Prison on a charge of manslaughter in the first degree. The judge explained his decision by telling Wood, "It appears to me that you and the deceased were sick persons mentally because of your drinking, and the probation report indicates to me that this episode was an explosion due to alcoholism and intoxication."

Also at the time of sentencing, the judge offered Wood the following bit of advice: "I hope the time you will be away will give you a chance to get hold of yourself."

Unfortunately, it didn't.

Bob spent three years in prison during which time none of us heard from him, even though we were in constant touch with his two brothers, Dick and Dave, both busy scriptwriters in the industry and part of our free lance contributors at Harvey Publications.

Early in 1961, Dave Wood walked in with Bob and asked me to give him some work. Bob had recently been released from the slammer. He looked awful — thin and shabby and he was very contrite. This time I gave him some one-page cartoon assignments which were used to fill out comic books that ran short for various reasons. His work was shaky, out of date, but we could put up with this to help restore some of his dignity.

Bob found it impossible to find enough work to resurrect his career, however, and soon dropped from sight About a year later, I asked Dave if he ever heard from Bob.

"Bob is dead," Dave said matter-of-factly.

I stared at him in disbelief.

Dave explained that Bob's last job was as a short order cook in a New Jersey diner. One night, some of his former prison acquaintances had picked him up at the diner, taken him for a ride in their car and allegedly, after a dispute over unpaid loans, dumped his body on the New Jersey Turnpike.

The press must have missed the comic book connection, because this time Bob Wood and *CRIME Does Not Pay* didn't make the headlines.

A short time after the death of Bob Wood, the new crop of adventure comic books followed suit.

SUNDAY NEWS, SEPTEMBER 14, 1958 3

Gramercy Park Gets the Horrors

Editor of mag called 'Crime Does Not Pay' murders ad woman in a hotel tryst

By KERMIT JAEDIKER

A BROADWAY-STYLE murder, sexy, loud-mouthed and liquored-up, hit quaint, Victorian-prim Gramercy Park smack in the bustle the other day. While children disported restrainedly under the eyes of governesses and elegant old ladies enjoyed their constitutionals behind the spiked iron gates of New York City's only private park, high above the park, in a hotel suite, a free lance cartoonist climaxed 11 days of loving, sousing and arguing by bashing his divorcee sweetheart to death with an electric iron.

It was probably the most frightening incident in the district since Mrs. Stuyvesant Fish appeared in the neighborhood's first electric automobile and ran down the same man twice, first in forward then in reverse.

But it was not the aspect of terror attending the murder that appalled Gramercy Park. It was the vulgarity of it all.

Victorian Bastion

The little 127-year-old park at 20th and 21st Sts., between Third and Fourth Aves., is one of the city's last bastions of Victorian architecture and Victorian thinking. Its old-fashioned buildings with their filigreed iron balconies and prissy-neat front gardens hold for the visitor an unexpected charm enhanced by the skyscrapers rearing in the backdrop. It is a haven, primarily, for well-heeled people who cling to days past. Outsiders may stroll the sidewalks bordering the park, of course, but the park itself is open only to residents each of whom has a key to the gates. Since even wealthy children get a yen for ice cream on sticks, the Good Humor salesman is tolerated, but even he cannot penetrate the gates;

Killing took place in top floor room. Window's at left.

by Paul Finegold, 26, of 2375 E. Third St., Brooklyn.

"Take me down to Greenwich Village," Wood said. "Charles St." He'd driven two blocks when Wood told me to the Regina Hotel on 1 Take
"Okay."

"I'm in trouble," said Wood. "Awful trouble. I'm going to get a couple of

Chapter 26

Burstein, the Unknown Writer

Among the well meaning but often-misinformed researchers chronicling the history of comic books, the name Martin Burstein is often noted. In Steranko's *History of Comics* it was reported that Martin Burstein was a pseudonym for Jack Kirby. This misinformation was picked up, quoted and repeated until it became gospel. When Martin — or Marty as his friends called him — read these articles he contacted his attorney. The attorney told him "When you sleep with dogs you wake up with fleas." Whatever that meant is unclear, although you might pursue the idea that he had less than little respect for comic books.

In 1937, when I was a young artist at the *Syracuse Journal American,* Marty, who came from New York City, had recently graduated from the Syracuse University School of Forestry. He said that he chose the Forestry program because the tuition was free. The government picked up the tab. With this background — like, how to saw a tree branch and fight forest fires — Marty talked himself into a job as police reporter for the *Journal American.* That's how good a salesman he was.

Marty also spread the rumor that he was a photographer. To establish his claim to this expertise, he acquired a professional 5" by 7" Speed Graphic, the same camera used by the news photographers. He told me that when he applied for the job he toted the camera with him, along with a large rectangular leather-covered wooden camera-case strapped over his shoulder. The camera-case was stuffed with film holders, flash guns, and other items that gave him the appearance of a photographer.

The prospect of getting free camera work on a cub reporter's low salary surely must have influenced the editor to hire Marty. Now all Marty had to do was learn to use the camera. He needed also to learn how to be a police reporter.

Marty, five-feet ten-inches tall, teetering between husky and chubby with thick brown curly hair, suggested that we share a furnished basement apartment he had located just off "the hill," as the campus is known. Across the street was the campus bar where students were still celebrating the repeal of prohibition.

We were no older than the undergraduates who lived around us. This created an ego problem. After all, we were professionals, men of the world. We had to show that we were superior. Jamason — with an "a" — seemed to be the answer.

Jamason was a skinny seventeen-year-old delivery boy for the neighborhood grocery store. One day, when he was delivering some bags of groceries to our apartment in his little wooden two-wheel cart, he walked over to the gas range and sneered at the supper that we were cooking. Actually, it was more of a laugh than a sneer. He told us that he was a super chef who had worked for a while as a short order cook, his specialty being soul food. We didn't know what that was but Jamason made it sound tasty as hell.

Marty thought we should hire Jamason. Jamason was delighted. Marty told him that he should tell everyone — especially the coeds — that he was the butler. Marty also insisted Jamason dress like a butler. Jamason didn't know exactly what a butler was, and so he showed up the first day in a bold green and white striped shirt, red pants and sneakers. Marty gave him a clip-on bow tie.

Jamason worked cheap. For ten dollars a week he promised to "work his ass off." He loved to cook. His

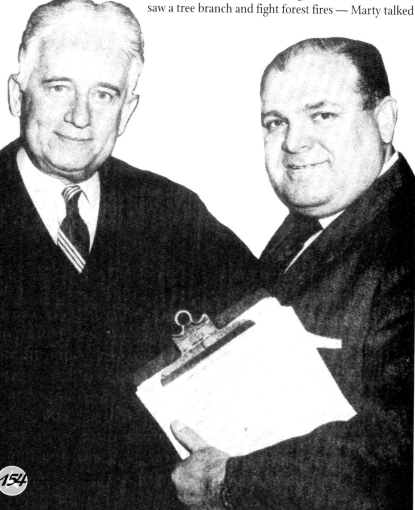

BELOW: *United States Senator Kenneth B. Keating (1900-75; New York—R) with Marty, the unknown writer (holding mandatory clipboard).*

confrontation became a standoff.

Old Teddy had an annoying manner of coaxing me to contribute free art work for his newspaper. A pen-and-ink sketch of a local merchant who happened to be an advertiser, or an alderman or police chief whose favors he curried, were prime candidates for vanity articles illustrated by such drawings. When I suggested that I be paid for the work, Teddy explained that the paper was a losing enterprise which he kept publishing only to keep the employees off the dole. It was our duty, in the name of humanity, he confided, "to see that these poor souls are able to feed their families." In all my years I had never met a publisher who admitted to making a profit, and Teddy was no exception.

When my patience reached its limit, he bribed me with an offer that sounded very promising. A friend had asked him to recommend an artist for a well-paying free-lance job. Teddy wrote down an address and said he had arranged an appointment to meet with the client.

"They want some illustrated booklets and other stuff," he said. "Even a television campaign. You'll go there tomorrow after lunch."

"Great," I was decidedly pleased. "What kind of samples should I show them?"

He smiled. "Joe, you don't have to show them anything."

"You mean they've heard of me?"

"'They heard of you from me." He was still smiling. "But if you want to bring samples, bring samples."

The following morning, I stuffed the aging, stained manila envelope with my best selection of commercial art, then hustled to the address Teddy had given me. It was a neat one-story building in a decent neighborhood a half dozen blocks from Teddy's place. I entered an orderly, uncluttered waiting room where a pleasant middle-aged woman said she was expecting me. She looked me up and down and her eyes fell upon the large manila envelope.

"What's that?" she inquired.

I told her it contained samples of my art work.

She appeared somewhat perplexed. "It could use a cleaning," she said. "The gentlemen are expecting you."

She opened the door to an office where a thin man sat at a tidy desk which held only a high black telephone and some drinking glasses. The man wore black sunglasses. Two other men sat around the desk. Each wore black sunglasses. Each had a cane leaning against his chair.

"Mr. Simon brought his samples with him," the woman teased.

The man behind the desk nodded. "Well, let's look them over." Without breaking a smile he continued, "This is the Guild for the Blind. Didn't Mr. Epstein tell you?"

He explained in detail what kind of work they needed. I was told what to draw and how to draw it by three blind men. They made more sense than a lot of clients I had dealt with. Then the lady ushered me out with my samples.

The assignment was to write and draw an instructional booklet on how individuals should react to and assist sightless persons. For example, when assisting a sightless person across the street one should allow that person to engage an extended forearm and other rules of deportment and courtesies that the average person never even thinks about.

The job turned out to be an interesting one that presented no problems.

For several months television stations broadcast the drawings with voice overs in public service advertisements. It was the first time I saw my work on TV. That alone was a small thrill.

BELOW: *Pair of panels from* Adventures of the Fly *by Joe Simon and Jack Kirby. ©2003 Joe Simon.*

Sick: A Healthy Departure

Mad magazine had grown into the newest "trend" and other comic book publishers soon hopped on the gravy train. Over the years there must have been thirty attempted imitations — *Crazy, Nuts, Insane, Frantic, Flip, Looney* — and on and on. It seemed that every publisher bought a Thesaurus to come up with a cloned title for his *Mad* exploitation. None of them remotely matched the quality of the original. Only one, *Cracked*, barely survived.

Teddy Epstein, too, was drooling over the impressive sales figures of *Mad*. He offered to put up the money and make me a partner if I would turn out another *Mad* copy.

"How much money?" I asked.

"Well, we couldn't expect to spend the amount *Mad* spends," he said hedging. "They're very successful!"

"You mean we have to do another cheap trick," I answered.

"You got it. Let's shake on it."

"Let's sign on it," I corrected him. I wrote out a brief letter of agreement listing specific costs and incomes. Teddy and his son Paul looked it over.

"It says here you get half of profits," Teddy said.

"That's what we agreed."

THE PSYCHO NEWS
FROM HERE TO
INSANITY
No. 11
10¢
APPROVED BY THE COMICS CODE AUTHORITY
A CHARLTON PUBLICATION
HEY! THERE'S NOBODY IN THERE!
I'M OVER HERE, MAX--- YOU TOLD ME TO FIND SOME NICE UNDER-WATER SCENERY!
Read
20,000 Lugs UNDER THE Sea
FILMED IN GLORIOUS CHLORINE

ABOVE: *The great success of* Mad *comics spurred innumerable comic book publishers to produce their own satirical knock-offs, including Charlton's* From Here to Insanity #11, *which featured work by longtime Joe Simon partner, Jack Kirby. ©2003 the respective copyright holder.*

"Make that net profits," Teddy insisted. "You've already listed all the costs — art and editorial expenses, printing, shipping, cost of distribution — no salaries — no rent —"

I was learning. I had grown up and thought I knew the basics of what should go into a publishing contract.

I changed profits to net profits. Teddy shrugged and signed the letter. Both of us anticipated that it was a lesson in futility since the new magazine, *Sick*, had little chance of doing better than the other failed attempts at a humor magazine.

I found a humor writer named Dee Caruso who had been writing comedy routines and one-liners for some of the leading theatrical comic personalities. Dee got some of his collaborators together and they wrote the entire book as if it were a routine for a stand-up comedian such as Don Adams or Joey Bishop, both of whom had bought Dee's material. Transforming these "wordy" routines to eye-catching graphics was a problem but our artists got into the spirit and did well. I did the cover — an Italian organ-grinder with the stereotyped long thin moustache, huge earrings, a red sash around his waist, holding a tin cup begging for pennies while dancing to the tune of the organ. The organ was being ground by an angry-looking monkey who had the man tethered to it by a chain and steel dog collar around his neck.

The title, in broken, dizzying lettering was *Sick* — preceded by "A Grim Collection of Revolting Humor."

A small photo inset of Jack Paar (who preceded Johnny Carson) was captioned "*Sick* TV Award Winner" with his actual quotes: "I'm weak and I'm sick!" Cover story headlines included "Hitler Is Still Alive!" with small type announcing that the magazine was "Printed In Inglesh" and "This magazine was selected for reading by our enemies overseas."

Under the headline "The Birth of *Sick*," the following copy set the tone for the contents:
REBELLION against Responsibility...
DEFIANCE of social conventions...
OUTLET for instinctive prejudices...
RELEASE of Repressions...

These are some of the principal causes for the birth of the Sick Joke. The Sick Joke was born on Madison Avenue, in smart East Side clubs, in Greenwich Village coffee shops, and in schoolyards all over the country.

"Did you hear that Jones of Barton-Dirksten-Smythe died."
"What did he have?"
"Cancer"
"No, I mean what accounts?"

"Aside from that, Mrs. Lincoln, what did you think of the play?"

The fathers of the "Sick" Joke, although they might deny parenthood, were Charles Addams, *New Yorker* cartoonist, and Tony Lehrer, Harvard math instructor. The chief modern exponents were Jules Feiffer, author of

Sick, Sick, Sick, and Lenny Bruce, night club comedian and author of "Hello, Pope John, this is Oral Roberts. We want to do some publicity on you in Detroit, can you send us some 8" by 10" glossies?"

One Brother: "I just pushed mother off the cliff."
Other Brother: "Please, don't make me laugh. My lips are chapped."

Police: "Your little girl was run over by a steam roller."
Mother: "Well, I'm in the tub. Just slip her under the door."

Boy: "Mrs. Jones, can Billy come out and play ball with us?"
Mrs. Jones: "Why no, you know Billy has no arms or legs."
Boy: "That's okay — we just want to use him for second base."

"Ma, can I go swimming?"
"No, you'll get your hooks wet."

"Mommy, I'm tired of going around in circles."
"Shut up or I'll nail your other foot to the floor."

What is the future of sick jokes? They will only survive if they are funnier than they are sick, or as long as the pressures of society that stimulate them are continued. If these pressures should be relaxed, we might be overrun with an epidemic of "Health" jokes — and wouldn't that be sickening….

Unlike the other attempts to clone *Mad* magazine, *Sick* tried to go its own way. It was for a slightly older audience, more irreverent; depending less on graphics and more on prose — less comic-bookish — and very sick.

Teddy arranged distribution with the Hearst Distribution Company. Ironic, I thought, since Hearst was my first employer.

The sales of the first issue were spectacular. We were very happy with our product and with the Hearst distribution. Teddy stayed with Hearst for three very profitable issues and then switched to PDC (Publishers

Distributing Corporation). PDC offered a much bigger advance payment.

The sales under the new distribution dropped. Even so, *Sick* maintained a profit for over a decade until we sold the title, but that's another story.

Our greatest fan was the legendary Lenny Bruce. When I did a feature on him he ordered 100 copies to send to his friends and clients. Lenny called or wrote to me from coast to coast through the years. Even then I thought he was brilliant but his horrendous notoriety, I must admit, embarrassed me.

On the basis of his scripts in *Sick*, Dee Caruso sold himself to a hit TV show called *That Was the Week That Was.* He later signed with NBC to do many hit comedy series in Hollywood. He was script editor for *The Monkees* and wrote films for Jerry Lewis and others.

During the rioting in Watts, after the assassination of Martin Luther King, Jr., he wrote to me: "I was in a store here the day after the rioting. Everything was looted. The only things remaining in the whole joint were eight copies of *Sick*."

Sick received its fair share of criticism. The National Council of Churches condemned us regularly. Their publications kept coming up with new names for us. "Perverts" hurt the most.

The New York Board of Rabbis wanted to close us down. Their fuss was all over a movie still of Tarzan holding a gorilla fondly eye to eye. Tarzan's speech balloon said, "Funny, you don't look Jewish."

In turn, *Sick* was defended in lengthy editorials on the pages of some of the slimiest publications I've ever seen, both newsstand periodicals and underground rags. They sent us copies of their editorials.

It was embarrassing and we wished they'd leave us alone and support some other pet cause.

We made a lot of apologies

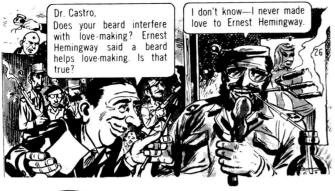

Dr. Castro, Does your beard interfere with love-making? Ernest Hemingway said a beard helps love-making. Is that true?

I don't know—I never made love to Ernest Hemingway.

26

STILL NUMBER TWO
Why try harder?

ABOVE: *For over ten years, the editors of* Sick *magazine tried to goad* Mad *into a friendly feud. But Bill Gaines was too wise to bite the bait. This "Open Letter" is from an early issue, when* Sick *was still trying harder! ©2003 Joe Simon*

AN OPEN LETTER

DEAR READERS:

Of late, many of your letters have been attacking MAD for copying ideas in SICK or attacking SICK for being a carbon copy of MAD. We did not want a feud between the two magazines. Quite frankly, of the two leading humor publications in the field, we prefer MAD. MAD is more accurate than SICK, more poignant.

The thing that puzzles us is that we know all the guys up at MAD and they're stupider than we are. We mean, we're better looking, better educated (none of MAD's staff ever finished trade school), we're better dressers and we're nicer guys. We remember when MAD was published from the heart of the city's publication hub—the garment center down on Lafayette Street. We've watched it grow from an inane, formula-ridden, backward, pompous comic book into the magazine it is today.

Now they use better paper. SICK buys the paper that MAD trims off. We squeeze it back into pulp and stretch it to get three magazines out of one. Someone once said that the stuff that's left over is sold to CRACKED.

But getting back to high class magazines, we read MAD at all our editorial meetings when we're trying to come up with clever new ideas. Our writers hardly would touch a pen to paper without first asking themselves, "How would MAD do it?" Sure, we copy MAD, but who should we copy — McCalls? Field & Stream? The minutes of a Mafia meeting? Sure, MAD has better artists — they're better because they can draw. Our artists can only trace. Someone has to hold Leo Morey's hand when he traces.

Now, that we've made our stand, please don't send us any more letters asking why we aren't original, why we don't stop publishing, why we don't try a man's deodorant. We've had it up to our armpits with man's deodorants. We hope this will put a stop to all those nasty letters, particularly those from Bill Gaines and Al Feldstein.

—The Editors

during the time that we did *Sick*. Hey, we didn't expect to receive any Boy Scout medals.

As it happened, *Sick*, through the years became less sick and more like *Mad*. Maybe we were getting older and less daring. Or just tired.

Later we introduced a character named Huckleberry Fink, who looked too much like *Mad*'s Alfred E. Newman. We also adapted Avis Rent-A-Car's slogan "We're Number Two — We Try Harder."

Our version was "Still Number Two — Why Try Harder?"

Sick magazine was my family's chief source of support for eight years during which time it became evident that Teddy was suffering financial losses from his line of companion publications which included *Man's Life,* a sleazy men's adventure magazine, some equally sleazy love "confession" and detective magazines and other titles that came and went.

When we were approached by Steven Krantz, a successful film producer, to do a television series on *Sick*, I was understandably very excited at the prospects of the royalties and publicity that would result. Krantz explained that his production company would shoot our material, animate it and edit it for a syndicated TV series. He delivered a contract which I turned over to Teddy and Paul Epstein. They sat on the contract for a full year despite pleas from Krantz and myself to consummate it.

I was furious at their indecision until I learned what was going on in the company.

The printer, Danner Press, of Canton, Ohio, was owed large sums of money from Teddy's failing magazines. They were willing to forgive the debts in exchange for the title to *Sick*.

Teddy's response was to change printers, but his

financial troubles continued until they were overwhelming and he could no longer continue publication.

Teddy drove out to my house in Woodbury, Long Island and explained to me and Harriet, my wife, that *Sick* magazine was losing money and he was forced to sell the title. He had found a buyer, Pyramid Books, who wanted me to continue packaging the magazine on a per-issue fee. I would, of course, no longer participate in the profits.

"I should get half of the sale price," I suggested. "We're supposed to be partners."

"Sorry, Joe. It doesn't work that way. The copyrights are registered to my company, Crestwood."

Needless to say, after Teddy left, our spirits were heavy. The first thing I did was to call the new printer in Germantown, Pennsylvania. He said he couldn't understand what Teddy was talking about.

"*Sick* is doing quite nicely," he said. "It's the other Crestwood magazines that are dogs. We've closed Teddy down until he pays the printing bill on those losers."

I told Harriet what the printer had said.

"Does that make us feel better?" she asked.

All work on *Sick* was stopped as I joined the ranks of the unemployed. My five young children couldn't understand why daddy wasn't in his studio at the drawing board. I mowed the lawn a lot that week as we tried to maintain a brave facade, but I knew that I couldn't wait for the Pyramid sale to go through before finding other work — and there was a good chance that Teddy was only softening the blow when he told me Pyramid wanted me to continue packaging *Sick*.

Harriet reminded me of the contract Teddy had signed when we began publication.

"What about it," I asked. "What good is it now?"

"Just look at it," she insisted. "I'd like to see what it says."

It was eight years since Teddy and I had signed the agreement. I didn't even remember what I had done with it. But after hours of searching, it finally turned up in an old file cabinet in the attic.

I brought the file folder down to the kitchen where Harriet and I looked at the letter. We read it again. We

OPPOSITE PAGE: Lenny Bruce, the notorious "sick" stand-up comedian, ordered 100 copies of each issue of Sick *magazine containing items about him. They were mailed to agents and nightclubs. ©2003 Joe Simon.*

The LENNY BRUCE Story

LENNY BRUCE was born on Long Island some 40-odd years ago. When he was five his parents were divorced and his father, Myron Schneider, got custody of the child. Times were bad and the elder Schneider barely eked out a living working in his brother's shoe store in Freeport, Long Island. And so Lenny had to be constantly farmed out to relatives.

Even as a child Lenny was a mischief-maker. Relatives refused to keep him in their homes for long and he was shuttled back and forth constantly. Thus, World War II was a blessing for him. He enlisted in the Navy, though underage, and served nearly three years on the cruiser Brooklyn. Lenny participated in the landings at Anzio and Salerno, and finally escaped from tedious stateside service by posing as a homosexual.

After the war, he drifted around aimlessly until he was introduced to the world of small-time show biz by his mother, Sally Kitchenberg—known today as Sally Marr—a local nightclub MC and comedienne. For the first time in his life he felt he "belonged."

Lenny's first big break came in 1949 when he won recognition on the Arthur Godfrey Talent Scouts Show by doing standard impersonations with a German accent. After that he began touring the smaller clubs all over the country.

In Baltimore he met and married a stripper named Hot Honey Harlowe. When they were divorced, he received custody of their one daughter, Kitty. Together they played the club circuit, until he branched out on his own and began attracting attention in the "hipper" clubs of Frisco and the Village with his "avant-garde" material.

When he died on August 3, 1966, in a hilltop house on the Sunset Strip of California, Lenny Bruce was already a legend. His obscenity trials were front-page news and his style and brand of comedy were being imitated all over the country. Today he is even bigger as now we all see the "truth" of this man. Lenny Bruce will live on as long as there's a social consciousness about, and a sense of humor to go with it...

"Sitting ringside are two boys in show business who got their start ... in the windy city—the wonderful Loeb and Leopold."

"If Nathan Leopold had any sense of humor, he would have grabbed another kid when he got out."

On mine cave-in: "Get away from there, kid, quit kicking dirt in the hole!"

"If you like foreign cars, we gotcha little Fuzzvutten here—this is a German car that was used a little bit during the war taking people back and forth to the furnace."

When April Showers, they come your way,
They leave Strontium in the milk you'll drink in May...

And when it's raining,
And birds leave their nests,
It isn't raining rain, you know —
It's raining fallout from those tests...

both smiled. She kissed me and we started laughing.

"How did you know," she asked. "Who told you to do this?"

"I don't even remember it," I said. "It's just luck, I guess."

"No, Joe. Not luck. You're smart! I'm proud of you."

I wasted no time bringing a copy of the agreement to Teddy's office.

"You can't sell the *Sick* title," I said.

He was annoyed. "Who says I can't? Why can't I? Did you hear that, Paul? He says I can't sell my own magazine!"

I shoved the copy of our agreement before him.

"Because I own it," I stated defiantly.

"What's this?" he said.

Teddy read the letter and blanched. He shoved it to Paul. Paul paled. It was addressed to Teddy Epstein and Crestwood Publications and it began this way:

"You have expressed an interest in publishing my title, *Sick* magazine..."

There were no whereas and whereof lawyer-type phrases but it was definitely clear who the title belonged to. Even though some of the sentences ended in a preposition.

No one ever said Teddy was stupid. He knew he had a big problem on his hands and his lawyer later confirmed it. Benjamin Winston, his attorney, was legal counsel to many companies in the publishing industry.

"This is what comes of signing a legal document without consulting a lawyer," he told Teddy.

"I forgot all about this goddamn letter," Teddy fumed. "What can I do?"

Winston advised him to see if he could come to some kind of settlement with me.

"We're talking big money here," he advised Teddy "— and nobody wants to buy a lawsuit."

Harriet answered the phone when Teddy called. His voice was honey-coated. Harriet cut him off cold. "We don't want to sell, Teddy," she said matter of factly — and hung up.

Teddy called back the next day. Harriet again answered the phone.

"What do you want, for Chris' sake?" he implored. "Seventy-five percent," she said. Teddy hung up the phone.

This routine continued for days. Finally, we came to an agreement. I would accept fifty percent of the sale price in a lump sum up front. Teddy would get his half in a payoff that would take a year. The buyer, Matt Hutton, owner of Pyramid Books, insisted on a partial payoff, which is customary in such transactions.

The sale went through without further delay. I went along with the deal, continuing to turn out *Sick* magazine for the new publisher.

Old Teddy sent a lovely bouquet of flowers to Harriet with a warm note of affection.

Sick magazine moved up to Pyramid Books' suite in the prestigious Newsweek building on Madison Avenue.

Talk about a happy ending to a sick story!

I packaged *Sick* magazine for Pyramid for two years. Matthew Hutton, owner of the company, did not interfere with the editing process and sales were profitable; but I was getting a little tired of it and so in the third year at Pyramid I stepped aside from the editing chores but continued to do the covers, and a little art work.

Pyramid was acquired by Harcourt Brace Jovanovich,

So when you see clouds
Up on the hill,
They may someday leave crowds
Just lying still...
So keep looking for the bluebird,
If you can't find him — you know something's wrong,
When those radio-active showers come along...

a large publisher of textbooks and other such tasteful tomes. You guessed it; the new owners didn't think *Sick* belonged in their line. The title was sold to Charlton Publications for $100,000. Only the title, no rights to anything else such as previously published features, which could have given Charlton reprint material for paperback books or annuals or any other reprint project that could have made additional profits for the publisher.

Last Port of Call

Charlton was a company I had done business with when Jack Kirby and I were publishing as Mainline Publications. They operated in Derby, Connecticut as a unique, self-contained, all-purpose publishing service owned by John Santangelo and Ed Levey. In one spacious complex of brick buildings, Charlton conducted their own editorial, printing, and distribution service. In their development period, the only trade they had failed to master was the simplified color engraving technique used in comics, a highly specialized skill mastered by only a handful of companies and dominated by Post Photoengraving, which serviced the majority of the comic book publishers. Santangelo offered Post a deal they couldn't refuse. He threatened to pull his sizeable business out from under them, or as an alternative they could set up a shop in his building on a partnership basis. With trepidation, Post agreed, reasoning that half a loaf was better than none. Charlton's Santangelo made sure that his men were well represented in the new engraving crew and saw to it that they learned all the skills.

There came a time when Santangelo no longer needed his partner, at which time he took over the engraving business, severing the ties with Post Photoengraving.

Charlton's rates for artists and writers were the lowest in the industry, yet the company attracted talent by giving the artists practically a free hand and all the work they could handle, assuring them of a regular income. The creative work as well as the printing was substandard, resulting in smaller print runs and lower sales than their competitors, but Charlton still managed to maintain a profit level because of their independent operation — if the publishing end broke even or lost a bit of money, the printing, distribution and engraving affiliates chalked up profits, enough to put them over the top.

Charlton was the last port of call for a publishing enterprise on the verge of going under. Santangelo and company were usually willing to continue publication of failing magazines or comic books, taking over the printing, engraving and distribution at their own plant. And eventually taking over, period.

When Leader News, our Mainline Publications distributor had failed, Jack Kirby and I turned to Charlton as a last opportunity to continue publishing our fine of comic books. We made frequent trips to their plant in Connecticut where the highlight of the day was a tasty Italian lunch at the executive table of the employees'

spacious cafeteria. When the noon whistle blew, the printing crew, mostly Italian immigrants who spoke little or no English, gulped down a hasty sandwich and then retired to an adjacent construction site where they picked up their masonry tools and continued putting up new buildings, a project that seemed endless. After the lunch hour, the men returned to the printing shop to resume their regular work.

Kirby and I made a small living at Charlton for a couple of years and then went the way of other patrons. Out.

Later, Charlton hit pay dirt distributing a new magazine — *Hustler*. Profits from the porn magazine were spectacular, but this time they lost the game. When the well-heeled publisher, Larry Flynt, became dissatisfied with their circulation, he left Charlton to buy out Publishers Distributing Corporation (PDC) and take over his own distribution.

The fact that Larry Flynt was the target of a "hit" that paralyzed him for life was coincidental and had nothing to do with the preceding events.

Working at Home

Putting together comic books and *Sick* magazine in my home in Woodbury on the north shore of Long Island, an hour and a half from the old comic-book haunts of Manhattan, presented no large obstacles. Artists and writers abounded in the area, welcoming the opportunity to do business near home, thus avoiding the bother of commuting to the city.

The neighborhood kids who congregated in my yard grew familiar with the "glamorous" artists who were seen coming and going with their packages of magical drawings. The kids fantasized of going to art school one day so they could cash in on the wonderful business of comic books and some day themselves work at home in blue

ABOVE: *Working at home in Woodbury, Long Island, Joe Simon said he was at the center of two poles. George Tuska in Hicksville was the South Pole. Bob Powell was located on the ritzy North Shore. These two talented Polish-Americans worked with the author on countless comic features for years. Powell, an Air Force combat veteran of World War Two knew aircraft like Bo knows football — from personal experience. Above is a panel by Powell. ©2003 the respective copyright holder.*

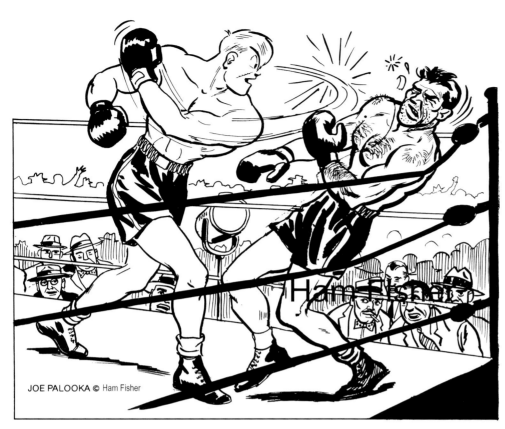

JOE PALOOKA © Ham Fisher

jeans and stockinged feet.

Jack Davis, Jack Kirby, Wally Wood, Jack Oleck and Al Williamson were among the comic book luminaries who regularly made an appearance.

Bob Powell, because of his grand-living style, was one of the kids' favorites. Bob had emigrated from Buffalo, New York, in time to join Eisner and Iger's Universal Phoenix agency where he produced the original *Sheena of the Jungle* when he was in his early twenties. He later went out on his own to start his own little shop which did so well that within five years he bought a luxurious home among the rich people in Oyster Bay Cove, Long Island, not far from my place. Powell was one of the few artists to write his own scripts. He employed young, promising artists to contribute to and imitate his style or just do backgrounds for his work while editors marveled at the vast amount of work he produced. A pilot in the Air Force during World War Two, Bob excelled at drawing aircraft, honing minute details worthy of the finest illustrations. He drew on his war experiences to write and draw stories about aircraft.

In a business frequented by eccentrics, Bob Powell was a model of discipline. His work day began without fail at 6 A.M. and ended promptly every weekday afternoon at 4 P.M. He refused to work on weekends or holidays.

Most of us who worked at home faced the problem of maddening interruptions from family, friends, visitors, salesman, phone calls, shopping trips, driving the kids around and more, forcing us by necessity to become night workers. Usually we had to catch up for a lost week on weekends and holidays. But none of this weakness for Bob. He sealed himself and his workers in his studio, refusing to come out until the fat lady sang at four, not for pope or publisher. He communicated through a loud speaker from studio to front door without interrupting his work.

When Bob delivered the finished pages to my studio it was in a colorful restored antique sports car after his workday ended (and before mine began). Then he was off to an evening's relaxation with drinking buddies, an old-money group of Long Island's distinguished blue bloods from the estates of Old Westbury.

In summer, when Bob was cruising on Long Island Sound in his splendid 30-foot "yacht," his son, John, home from college, his head shaved clean in the collegiate fashion of the day, dropped the art off in Bob's slick sports car. Our little Bedlington Terrier, Sheba, usually hostile toward visitors, kept a respectful distance from the Powells, probably awed by their splendor.

When the comic book business went sour, Bob adjusted by establishing a "display" business, designing

HORACE DRIPPLE DOTTY DRIPPLE TAFFY DRIPPLE PEPPER

Good Luck
BUFORD TUNE

THIS PAGE: *1940s. Autographed over-sized cards of Harvey comic book stars were sent to letter writers and subscribers. Joe Palooka ©2003 the Estate of Ham Fisher. Horace Dripple ©2003 King Features Syndicate. Terry and the Pirates ©2003 Tribune Media Services, Inc.*

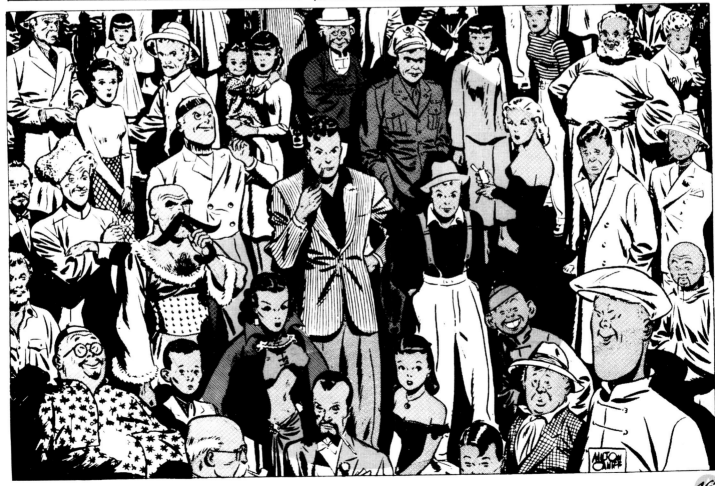

ABOVE: *Al Capp's* Li'l Abner *(1957) was an international star and a critic of both left- and right-wing politics. ©2003 United Feature Syndicate.*

ABOVE: *Smug self-portrait of Al Capp from* Comics and Their Creators *by Martin Sheridan (1942). ©2003 the Estate of Alfred Capp.*

and building complicated dimensional displays for conventions, exhibits and business presentations. His work was colorfully inspired and professional, but there was not enough business to sustain his grand manner. He picked up bits and pieces of architectural renderings and other freelance jobs but it didn't add up to a living.

In the last years of his life (Bob died at age 53), he found financial and artistic fulfillment painting full-color porno strips for cheesy girly magazines. Without intending sarcasm or irony, I will tell you that his art work on *Pussy* were the most beautiful renderings of his career.

George Tuska, another of my neighbors from the nearby town of Hicksville, in the center of Long Island, was notorious among his neighbors, not because he drew the syndicated comic strip *Buck Rogers,* but because of his odd annual celebration of the arts. Every spring, George assembled in his back yard more than a dozen of his oil paintings. The neighbors knew what to expect. Tuska was a big, athletic man who transmitted a mistaken impression that he was a surly brute when in reality he was hard-of-hearing and so, to an extent, uncommunicative.

When George took his paintings outdoors the neighbors invited friends over to join them in peeking from behind their window blinds to observe George in his rites of spring. Every year, he liberated his artistic soul by setting fire to the paintings that offended him. George, who was really a gentle, sweet person, drove the fifteen or twenty minutes to my house at least once a week to pick up scripts or deliver art work. Sheba also misjudged George's nature. She always seemed to know when to expect him, waiting to launch a snarling attack on the big man's ankles when he

departed from his car in my driveway. The scenario was the same every time George showed up, with George leaping from his car to race the fanged menace to my door while swatting at her with the art boards. Too many pages were delivered bent and battered while all I could do was to accept them with embarrassed apologies.

Joe Palooka & Li'l Abner: A Feud to the Death

Since 1897 when *The Yellow Kid,* a comic strip in Hearst's *New York American* was reprinted in a cardboard-covered newsstand edition, newspaper comic strips have been published in varying forms; first in black-and-white, then in the traditional four-color comic books. Most of these syndicate retreads were plagued by boring layouts consisting of too many small panels per page and complicated by a lack of the editing necessary to eliminate the repetition caused by the "continuation" format of the dailies. In their original version, the last panel of one day's storyline would be almost duplicated in the following day's strip so that the reader would be reminded of where he left off (much like the movie serials).

Al Harvey had an idea that he could take this same dull material, edit it to eliminate the repetition and rearrange the panels into larger, irregularly shaped page layouts and individual stories with big original splash pages and titles. New action art would be created for the covers; usually drawn by a "ghost" artist imitating the style of the original.

Al Avison and I became the head ghosts.

Harvey arranged for reprint rights with comic strip artists from King Features and other syndicates, offering them fifty percent of the profits where they had been receiving as little as five percent from other publishers.

Over the years, Harvey Publications published Milt Caniff's *Terry and the Pirates,* Chester Gould's *Dick Tracy,* Chic Young's *Blondie and Dagwood.* Harvey also published *The Phantom, Kerry Drake, Scarlet O'Neil, The Katzenjammer Kids, Jiggs & Maggie,* and others.

A few of the artists who created their strips maintained full financial control over them. Two of the more prominent were Ham Fisher (*Joe Palooka*) and Al Capp, the flamboyant creator of *Li'l Abner.* These two became

close friends — not to each other, but to Al Harvey, whose company paid them handsome royalties. Actually, Capp and Fisher disliked each other with an intensity that lasted to their dying days.

Capp had started his comic strip career working as an apprentice and then assistant to Fisher. The two men were as different as could be — Capp, a brilliant, extroverted intellectual; Fisher a quiet plodder whose strength was in his traditional storytelling on the drawing board. Their personalities clashed constantly, and when Capp quit *Joe Palooka* to start his own strip, the battle was on. Each tried to outdo the other, both extremely successful with their characters becoming world-wide institutions, spawning major films, toys, merchandising, and even Broadway musicals. But it was Al Capp, because of his quick wit and biting sarcasm, who became the favorite of radio and television talk shows, always ready with a quip or quote for the press — in constant demand as a public speaker.

Born Alfred Caplin, Capp grew up in New Haven, Connecticut, the elder son in a poor, hard-working family. When he was nine years old, on a hot, sweltering day, he climbed atop a moving ice truck to cool himself off. He reached for a sliver of ice to quench his thirst, slipped on the ice, lost his balance and fell to the trolley tracks. A trolley car ran over the struggling boy, resulting in the loss of a leg.

Al Capp's younger brother, Elliott Caplin, also a foremost writer for comic strips as well as an editor and playwright, told of the tragedy which all but tore the family apart. According to Elliott, young Al became moody and morose as his whole world began to disintegrate. For years he sat home reading and drawing pictures — and brooding. But he never discussed the loss of his leg. As time passed, he mastered his pain through humor. Eventually, the family was able to afford a down payment on an artificial limb, which he soon outgrew.

When Al Capp became successful he was fitted with a new improved wooden leg but he never learned to walk on it with any degree of balance.

Capp's *Li'l Abner* strip was one of the first to mix politics with comics. His attacks on the redbaiting U.S. Senator Joe McCarthy were devastating. He ridiculed both left-wing and right-wing politics, attacking deception and ignorance as he found it.

His celebrity was such that President Truman held a ceremony to award him the Medal of Honor. As Capp walked across the stage to receive his medal, a screw came loose from his artificial leg and he tumbled to the floor. The audience screamed in horror. Someone yelled, "Get a doctor." Capp replied, "No, get a good mechanic."

Al Capp loved to party. One night when he was on a speaking tour in London, his celebrating friends all but wrecked his hotel suite. Capp collapsed into the Presidential bed, pulled the covers over him, and slept into the next afternoon.

When he awoke, he phoned for room service. The waiter, a tall, erect stuffy type came into the room to take his order. Capp poked his head up from beneath the covers. He ordered bacon and eggs, pancakes, coffee, toast and butter.

The waiter wrote the order on his pad. He turned to the far side of the bed. A leg, clad in stocking and shoe, protruded from beneath the covers. It was Capp's wooden leg. The waiter said "And what will the other gentleman have?"

Capp said "He'll have the same."

Despite Al Harvey's attempts to heal the rift between Ham Fisher and Al Capp, they remained enemies to the end. Moe Leff, an artist who had drawn the *Palooka* strip for many years, left Fisher to work for Al Capp, an act which further enraged Fisher. Fisher was confronted with family problems and dying of cancer. It was reported that he took his own life.

I did many covers for Ham Fisher's comic books and consulted with him many times. Even today, when I leave my studio, I look up at the windows of his former studio in the Parc Vendome Apartments directly across the street from my place in New York City and I remember.

BELOW: *Joe Palooka's creator, Ham Fisher, contributes this caricature of himself to Martin Sheridan's book,* Comics and Their Creators *(1942). ©2003 the Estate of Ham Fisher.*

INSTEAD OF A SELF PORTRAIT I HAD PALOOKA DRAW ME! HAM FISHER

Sick Simon Satire

For more than a decade, Stan Lee's byline appeared on almost every book or comic put out by Marvel. Some people thought his name was "Stan Lee Presents." He was described as "creator of Captain America" in feature stories in the *New York Times, Newsday,* and many other publications, including a full-color page in *Time* magazine.

It was believed in the industry that the *Sick* magazine piece printed here was part of a vendetta to get even. In reality, Stan was shown the script in advance. His comment: "Very funny."

The big news in publishing circles is the return to popularity of comic books. The adventure comic books, that is—not the comic comics. Trouble is, have you looked at them lately? They're really funny! Every character is just pure fantasy—either a hero or a villain with no in-betweens. And each one is dressed in some ridiculous costume that makes them look like they're walking around in their long underwear. You won't find a human being anywhere in these books. And if you ever meet the guys who turn it out you'd run into the same trouble. To investigate this comic situation SICK recently visited one of the more active editorial offices that turn out . . .

The New Age of Comics

by Joe Simon Art by Angelo Torres

You call yourself an *artist*, Dripko? You should be drawing *relief checks!* The Giant Cockroach in last month's Super Misery Comics came out looking like Fearless Dick Daring in this month's Incredibly Nauseous Comics!

You know darn well Giant Cockroach is the *good guy* and Fearless is the villain!

I got mixed up, Sam. I thought the Abominable Dragonman was the hero.

How many times I gotta tell you? Dragonman is the one with the electronic tonsils who kills people with his hot smelly breath!

That's right. He used to be the Crawling Aardvaark but you changed his image because readers couldn't identify with him.

Good thinking, Shirley, you're the only one who remembers!

I'll make the changes, Sam. I draw so many different characters I get confused sometimes.

Alright, do the whole book over and have it on my desk in an hour— we've got twenty other books to get out today!

And don't forget to sign my name to it!

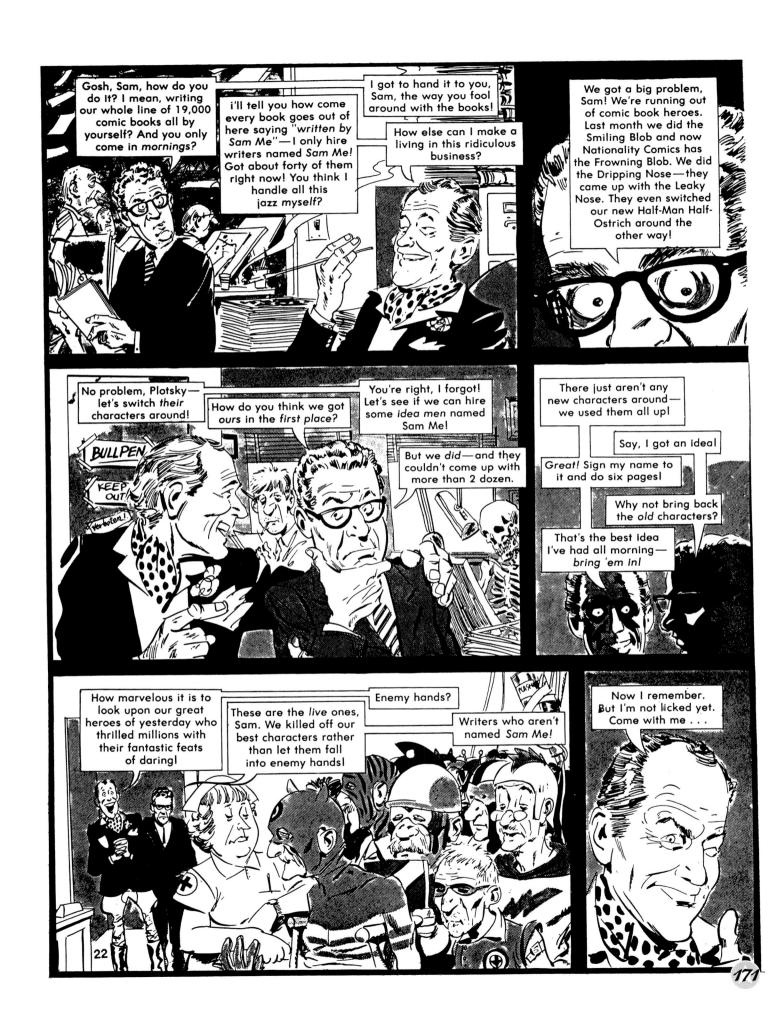

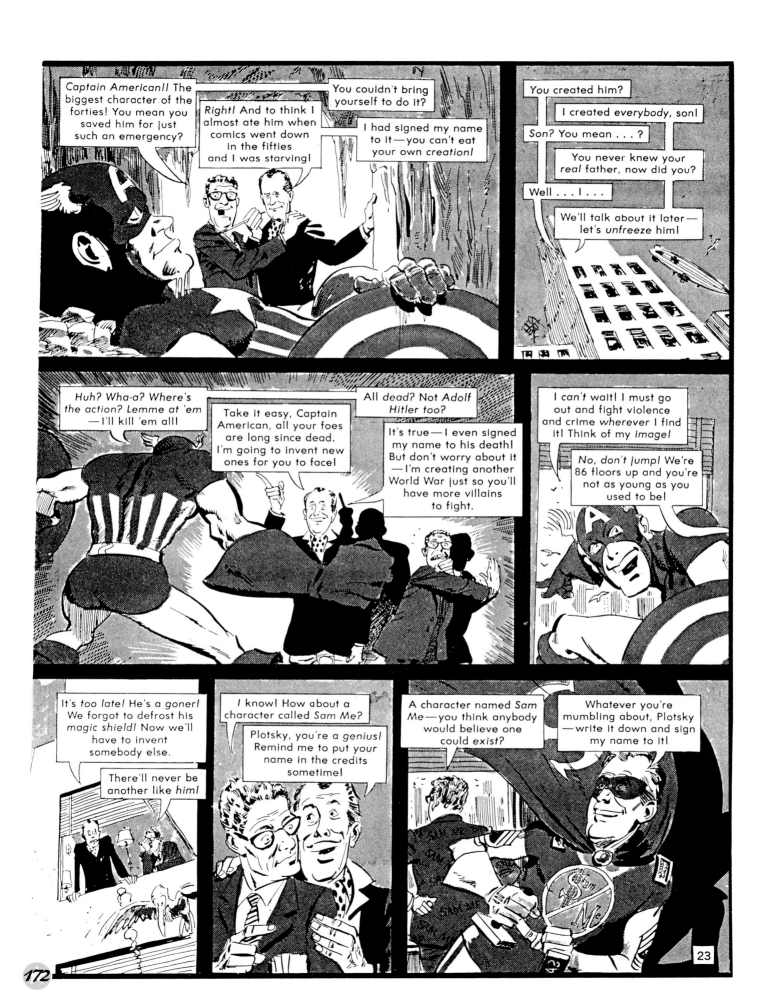

The Birth of Spider-Man

n 1953, a year before the devastating Senate investigation into comics, I was visited by C.C. Beck, the artist who was credited with being a major force behind the success of *Captain Marvel.* Beck told me that he owned the Ukulele Bar & Grill in Miami, Florida, and while tending bar, often thought about doing another superhero. He offered to "take a crack" at the business again, if I would come up with an idea for a new character and a script.

Jack Oleck, my brother-in-law, who had been the number one scriptwriter for Simon and Kirby since the early days of *Young Romance,* had time on his hands. Oleck always had time, even if he turned out a script seven days a week. As always, he was anxious to join in a new venture.

Beck's whimsical style of drawing had always intrigued me. His art required a simple, child-like story to make it most effective.

I worked up a few ideas to discuss with Oleck. So many titles had come and gone by that time that it seemed futile to come up with a concept even remotely unique. After a lot of doodling, I settled on one that looked a little better than the others. I roughed up a logo, *SPIDERMAN,* then did the finished lettering. By the time it was finished, the logo was seventeen inches long and just about fit on the illustration board.

When Oleck came over to my studio, he gazed at the logo with an expression I interpreted as awe.

"You like it?" I asked. "You really like it?"

"Jeez, why so big?"

"Because when it's reduced, it won't show all the flaws."

Oleck pulled out a cigarette and lit a match in one motion. "We could burn it and toast some marshmallows," he observed.

That was his way of saying he approved.

We held a script conference in the backyard. Subconsciously, I think the storyline went the way of *Captain Marvel.* There is a troublesome boy named Tommy Troy, living in an orphanage, who is expelled into the custody of a weird elderly couple. In their attic, he is fascinated by a spider weaving a web. In the web, Tommy finds a glowing ring with a hinged lid on top. When the boy opens the lid, a genie appears and announces that he will grant Tommy one wish. Tommy wishes to be a superhero.

After a pot of coffee went dry, Oleck went home to type up the script. Two days later, he came back with the finished script and we met with Beck. I kept flipping

BELOW: *Joe Simon launched* Adventures of the Fly *and* The Double Life of Private Strong *(featuring a revival of the Shield) for Archie Comics in 1959.* ©2003 Joe Simon.

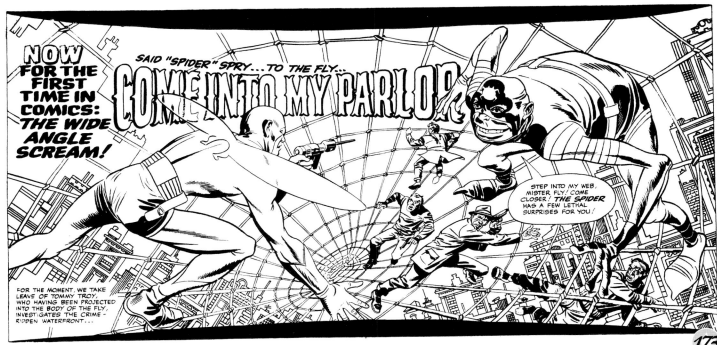

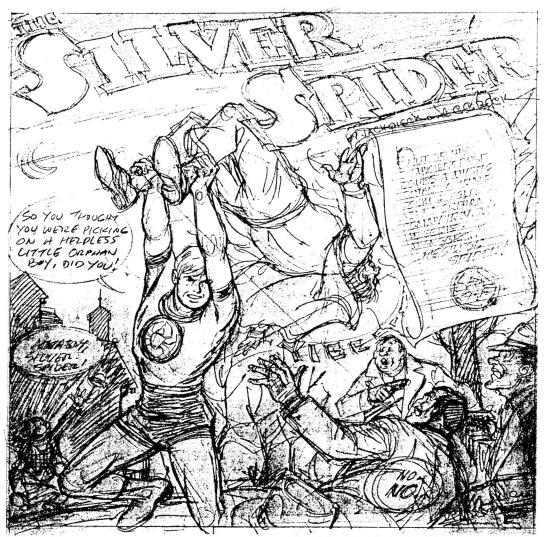

"Strictly old-hat. Almost a take-off on Green Hornet." He went on to note that, "it should have something new to offer, not a conglomeration of characters' situations."

On February 23, Sid wrote a second memo entitled, "Conclusions on Character" (Silver Spider). [*See opposite page for facsimile.*]

Early in 1959, while I was working on the first issue of *Sick* magazine, John Goldwater, chief honcho of Archie Comics, called me at the Crestwood office. This was the same Goldwater who threatened the lawsuit which caused us to change the shape of Captain America's shield. John asked me to create and package a couple of superhero comic books. "Superheroes are about to come back," he predicted. Immediately, I thought of the Silver Spider. I told Goldwater I'd go home and invent a superhero.

The next morning, I rode the Long Island Railroad to Pennsylvania Station, then taxied to the Harvey office, at 1860 Broadway. Leon Harvey's desk was squeaky clean. So was his office. He walked around that neat office looking for my package. There was no point to it because it was six years since I had left the Silver Spider pages with him. "It must be in the storeroom," he finally conceded. "Someone must have brought it down to the storeroom."

This was standard procedure. Everything at Harvey's eventually wound up in the storeroom. If you dropped a Kleenex in Leon's office, you could bet you'd find it in the storeroom. To know the Harvey storeroom, you had to picture a city dump. It lay in the sub-basement, beneath the basement of their office building, a vast wasteland of artistic clutter including bundles of unsold comics, original art in large, dusty manila cardboard containers, with individual art boards scattered about the shelves and floor, probably separated forever from the features they were once part of. It took two workers the better part of a week to find the Silver Spider package. Leon beamed at his efficiency.

"Superheroes are dead," he proclaimed. "Of course, that's today. Tomorrow everything may change." He thought about it for a moment. "Of course, I'm only talking out loud."

Did he mean *thinking* out loud? Leon's sage

through the pages and returning to the title.

"What's bothering you?" Oleck wanted to know.

"It's the title," I answered. "Spiderman, Batman, Wonder Man, Sandman, there are too many damned 'Man' titles around. It's another knock-off, a cliché." For a less used and abused knock-off, I changed the title to "Silver Spider," as a "tribute" to one of the earlier features I had done — the Silver Streak. We all agreed it was the right move, and Beck took the script with him to pencil it up.

Beck's drawings, when he brought them in, were much sketchier than Kirby's. The Silver Spider looked like Captain Marvel. I called in Howard Ferguson, our letterer nonpareil, to letter some of the pages so the presentation would appear to be more finished.

I took the Silver Spider pages to my old friends at Harvey Comics. Leon Harvey, a notorious procrastinator, looked them over slowly, with polite interest. Leon nodded — a lot; then asked that I leave the presentation with him for a day or two. On February 8, 1954, Harvey gave the Spider to Sid Jacobson, a young editor, to evaluate. Sid sent an "EDITORIAL MEMORANDUM" to Leon. In commenting on "the name," Sid wrote:

E D I T O R I A L M E M O R A N D U M

February 23, 1954

TO: LEON HARVEY
FROM: SID JACOBSON
RE: SILVER SPIDER

Conclusions on character:

Physical Appearance--The Silver Spider should be thought
of as a human spider. All conclusions on his xhxxxxxxx
xnxxxxxxxxxxxxxxxxxxxxxxxxxxxxxxxxxxx appearance and
powers should stem from the attributes of the spider.
My first thoughtx of the appearance of a human spider
is a tall, thin, wiry person with long legs and arms.
He should have a long, thin, bony face, being more
sinister than handsome. The face of the Submariner
comes to mind.

Costume: Because a spider is for the most part a one-
colored insect, I believe the human spider should
wear a costume of one color (in this case, silver)
that completely covers his body. Here, I can visualize
the Batman's costume, minus the cape. There should
also be a semblance of feelers on the hood, these
perhaps being antennae for receiving messages from
Genie or some other source.

Powers: The powers of the human spider should pretty
much correspond to the powers of the spider. He
therefore wouldn't have the powers of flight, but
could accomplish great acrobatical tricks an almost-
flight by the use of silken ropes that would enable
him to swing a la Tarzan or az a la Batman. The silken
threads that the spider would use might come from
a special liquid, from some part of his costume,
that could become silken threads in much the same
way as the spider insect. These threads would also be
used in the xxixx making of a web which could be used
as a net. The human spider might also have a "poison"
to be used as a paralyzing agent.

Nemeses--His main nemesis should be a natural enemy
of a spider--either The Fly or Mr. D.D.T. He should
wear a costume, like the Joker or the Penguin. The
xxxxix nemesis should be introduced in the first book
and appear in each subsequent one. Other nemeses
should appear, each one having a specialized personality.
Here the Dick Tracy villains naturally come to mind.

Story types: The stories should run the gamut from
robbery, murder to international intrigue. They
should be loaded with gimmicks and xxxxx amazing
inventions and plots hatched by the enemies. They
should give room for the human spider to show his powers.

THE NEXT DAY...

I TELL YOU, NOBODY CAME ONTO THAT DOCK ALL NIGHT... I HAD MY EYE ON THE ENTRANCE EVERY MINUTE!

A FORTUNE IN JEWELS IS MISSING AND THE GUARD SAW NOTHING! IT'S RIDICULOUS!

ABOVE: *The superhero really was a"Fly on the wall" in this panel by Simon and Kirby.* ©2003 Joe Simon
BELOW: *Joe and Jack gave patriotic hero the Shield a touch of Captain America-style action in a pair of* Double Life of Private Strong *issues.* ©2003 Joe Simon.

HOW COULD A MAN THROW LIGHTNING BOLTS GENERATED BY HIS OWN BODY?

quotations often resulted in malapropisms. I clutched the package, and was on my way. The next day, at the Archie office, I made a verbal pitch to John Goldwater. "A super-hero who climbs straight up and down a building using a fine thread that he holsters in his costume like a fishing tackle. We'll call him the Fly."

I hadn't brought the Silver Spider pages with me. It wouldn't go down well if Goldwater ever learned that he was getting a character that had been rejected by another publisher. Anyway, Goldwater liked the idea.

The second book I proposed to Goldwater, was *The Double Life of Private Strong*. He was an army private, who did superhero chores in his spare time in a colorful red, white and blue costume, which was more or less, a salute to Archie's old Shield character. Private Strong was... sort of like Captain America. John hadn't forgiven Captain America for wiping out the Shield sales-wise. I hated the Shield concept. John Goldwater loved it. Before I left, I had an agreement to produce the two comic books, on a regular schedule.

We negotiated a liberal fee, and I went to work, gathering together some of the best artists in the business... Jack Davis, the wonder artist... my neighbor George Tuska, who was drawing the newspaper strip, *Buck Rogers,* Al Williamson, Carl Burgos, of *Human Torch* fame who did penciled layouts for the other artists... among others. Each artist was given a script and costume design.

Jack Kirby, understandably worried about the declining state of comic books, had attempted several comic strips for newspaper feature syndicates; but was unable to effect a sale. In January 1958, Jack Schiff, an editor at DC Comics, was approached by Harry Elmark, general manager of the George Matthew Adams Service, a newspaper feature and cartoon syndicate with a request that DC produce a science fiction comic strip for the Matthews Service. Jack Liebowitz wasn't interested, but he did encourage Schiff to do it on his own. Schiff contact-ed free lance writer Dave Wood and together they came up with a concept named *Sky Masters of the Space Force.* Wood brought in Jack Kirby to do the pencils. The venture was supposed to be a three way partnership, but Schiff soon withdrew and arranged to be paid 4% of the proceeds as payment for setting up the deal.

Dick Wood, Dave's brother, joined in the writing chores. Wally Wood was the last of several inkers. Kirby said he thought the world was full of Woods.

Sky Masters was a handsome strip that did well for almost two years, then gradually lost newspaper subscribers to the point where it was no longer profitable. Kirby complained that the Wood brothers were responsible for the decline of the strip because they kept disappearing and refused to give him their phone numbers. "They told me to leave messages at their mother's house."

Jack Schiff claimed that Kirby had refused to pay him his share of the 4% they had agreed on. Although the Wood brothers had kept up their payments to Schiff, they too were named in a legal action brought by Schiff and conducted in the Supreme Court on December 3, 1959, in White Plains, N.Y. Jack Liebowitz appeared as a witness for Jack Schiff. Jack Kirby was the defiant defendant. Jack Oleck and I attended the proceedings that day. The court-room was full of Jacks. The decision was in favor of the Jack named Schiff.

Because of the hard feelings caused by the *Sky*

Masters incident, Kirby couldn't or wouldn't return to DC Comics. He was working at Marvel when I met him on Columbus Circle, at the entrance to Central Park. In a brown derby hat, twirling a cane-handled umbrella, he looked quite dapper, like an English horseman off to the foxes.

"Is that the dress code for syndicated artists?" I asked.

"I'll never do another newspaper strip again," he vowed. "What do you think of the derby?"

"Watch out for the pigeons," I warned.

Marvel, in that period, was in a very shaky position. Jack related how Martin Goodman had been at the point of shutting down his comic book department.

"They were actually moving the furniture out," he said. "Only myself and Stan Lee were there. I threw myself on the desk, and refused to let them remove it."

"Jack, you're not serious."

"We begged Goodman to give us more time," Jack continued. "I guaranteed him I'd come up with new winners."

This was to be the beginning of Marvel's remarkable resurgence, with Jack and Stan leading the way in the development of the new Marvel line of superheroes.

I informed Kirby about the M.L.J. project, and he was greatly enthused — especially when I told him we would split the payments. A few days later at my studio, I handed him the Silver Spider pages. "C.C. Beck is out of the business," I said. "We're doing this over. Same script, only we're

calling him the Fly instead of Silver Spider."

Kirby looked it over. "A spider man that walks straight up and down a building? If he's a fly, why doesn't he fly?"

"So we'll give him wings," I said. "Small wings. Attached to his costume. The collar of his costume can be shaped like wings."

Kirby thought about it. "So he doesn't walk up and down buildings?"

It was getting too complicated. "Hey, let him walk up buildings and let him fly if he wants to. It's a free country. Take it home and pencil it over in your immortal style." Jack also took the Spiderman logo with him.

That's how heroes are made.

Next morning, at 2 A.M., Kirby called from the basement studio in his home, which he called the Dungeon. "There are spider webs all over this script," he complained.

I thought about it for a moment. "We'll make the villain a spider. Call him Spider Spry. Spry-Fly... get it? Will that take care of your problem?"

It did... in a way... except for a few minor details, like why would a fly fall from great heights because he was unbalanced by a bright light? And why does he climb up and down buildings when he should be flying like an

I-I'M NOT CRYING! ONLY **BABIES** CRY! AND YOU ALWAYS TELL US TO - TO BE BRAVE. BUT, TOMMY, I - I'M SO **HUNGRY**!

WE'RE ALL HUNGRY - AND TONIGHT MISTER CREACHER BEAT BILLY BECAUSE HE DIDN'T SCRUB FLOORS FAST ENOUGH. ISN'T THERE SOMETHING WE CAN DO, TOMMY?

MISTER CREACHER IS IN CHARGE OF THIS ORPHANAGE - AND YOU KNOW HOW MEAN HE IS. I DON'T THINK HE'D LISTEN TO US...

...BUT AT LEAST WE CAN TRY. I'M GOING TO HIS OFFICE TO TALK TO HIM.

HIS OFFICE! TOMMY, YOU **CAN'T**! WE'RE ALL SUPPOSED TO BE ASLEEP. HE'LL PUNISH YOU FOR BREAKING THE RULES.

BUT SOMETIMES, RULES MUST BE BROKEN! TOMMY GOES DOWN A DARK AND GLOOMY CORRIDOR, WHERE SHADOWS SEEM TO REACH WITH CLUTCHING FINGERS...

HE REACHES A LIGHTED DOOR, RAISES HIS HAND TO KNOCK, AND FREEZES!

BUT I - I'VE BEEN PAYING YOU! McCOY, I **CAN'T** STEAL ANY MORE OUT OF THE ORPHANAGE FUNDS. THE KIDS ARE HALF STARVED NOW...

WHO CARES? LET 'EM STARVE! I RUN A GAMBLING HOUSE, NOT A CHARITY BAZAAR!

THAT WALLOP WAS JUST A SAMPLE! NOW GET THIS, CREACHER! YOU'VE LOST A PILE OF DOUGH IN MY PLACE... AND I WANT **CASH**, NOT I.O.U's!

BLASTER... **LOOK!**

M-MAYBE THIS BENCH WILL SLOW THEM DOWN...

AFTER HIM! THAT BRAT MUST HAVE HEARD EVERYTHING WE SAID!

IN THE DORMITORY OF THE WESTWOOD ORPHANAGE FOR BOYS, A TINY FIGURE STIRS UNDER TATTERED BEDCLOTHES, A SOB HANGS ON THE CHILL NIGHT AIR... AND YOUNG TOMMY TROY IS INSTANTLY ALERT...

BILLY, WHAT IS IT? WHAT'S WRONG? WHY ARE YOU CRYING?

I-I'M NOT CRYING! ONLY BABIES CRY! BUT, TOMMY, I-I'M SO HUNGRY!

WE'RE ALL HUNGRY... TONIGHT, MISTER CREACHER BEAT BILLY BECAUSE HE DIDN'T WORK FAST ENOUGH SCRUBBING THE FLOORS! TOMMY... WHAT CAN WE DO?

MISTER CREACHER IS IN CHARGE OF THE ORPHANAGE... AND YOU KNOW HOW HE IS! HE WOULDN'T LISTEN!

THE RAGGED, HALF-STARVED, HALF-FROZEN LITTLE GROUP CROWDS AROUND TOMMY...AND SUDDENLY HE MAKES A DECISION!

BUT AT LEAST WE CAN TRY! WHERE ARE MY CLOTHES? I'M GOING TO HIS OFFICE TO TALK TO HIM!

HIS OFFICE! TOMMY, YOU CAN'T! WE'RE SUPPOSED TO BE ASLEEP! H-HE'LL PUNISH YOU FOR BREAKING THE RULES!

BUT SOMETIMES RULES MUST BE BROKEN! IN A FEW MOMENTS, TOMMY IS ON HIS WAY!

THE CORRIDOR IS DARK AND THE SHADOWS SEEM TO REACH WITH CLUTCHING FINGERS, BUT TOMMY GOES ON! HE REACHES A DOOR, RAISES HIS HAND TO KNOCK...AND FREEZES...

BUT I'VE BEEN PAYING YOU, McCOY! I CAN'T STEAL ANYMORE OUT OF THE ORPHANAGE FUNDS! THE KIDS ARE HALF-STARVED NOW.

WHO CARES? LET 'EM STARVE! I RUN A GAMBLING HOUSE, NOT A CHARITY BAZAAR!

AARON CREACHER SUP'T.

THIS IS JUST A SAMPLE, CREACHER! YOU'VE LOST A PILE OF DOUGH IN MY PLACE! I WANT CASH... NOT I.O.U.S!

BLASTER! LOOK!

179

UNDER THE EVER CONSTANT WATCH OF THE MARCH COUPLE, TOMMY WORKS LIKE A DRUDGE IN THEIR HOUSEHOLD...

HE'S LIKE AN EVIL OLD SORCERER...LIKE THE KIND YOU READ ABOUT IN BOOKS! AND HE SURE MAKES ME WORK!

THAT ROOM UPSTAIRS... THAT'S WHERE THEY SAY THAT OLD MAN MARCH PRACTICES BLACK MAGIC!

MRS. MARCH IS A STRANGE ONE TOO! NO, THEY'RE NOT LIKE OTHER PEOPLE... THEY PUTTER ABOUT IN A ROOM IN THE ATTIC WHICH THEY KEEP LOCKED...

DRAWN BY THE IRRESISTIBLE CURIOSITY OF ALL BOYS, TOMMY, ONE DAY FINDS THE ROOM IN THE ATTIC UNLOCKED...

TOMMY MOVES FURTIVELY ABOUT THE SHADOWY ROOM, TAKING IN THE EVIDENCE OF EXPERIMENTS IN FORBIDDEN FIELDS! BUT THE ATTIC IS HUGE, HOT, PILED WITH THE LITTER OF A CENTURY... AND TOMMY IS TIRED... SO TIRED...

I'VE GOT TO REST... SLEEPY...IF I CAN ONLY GET RID OF THESE FLIES...

HOURS PASS...WHEN TOMMY'S EYES OPEN ONCE AGAIN, THE CANDLE IS GUTTERING OUT... BUT SOMETHING GLEAMS IN THE DIM LIGHT...

A SPIDER! WHILE I WAS ASLEEP HE SPUN A WEB...TRIED TO TRAP THE FLIES...BUT THEY'VE ESCAPED..BEHIND THIS STRANGE GLOWING THING...

WHY, IT'S A RING! GOSH, IT'S KEEN! SHAPED LIKE A BEE...OR A FLY! SURE IS A BEAUTY! I'M GONNA TRY IT ON!

4.

honest fly? Neither of us bothered to change those silly problems. Who would notice them anyway?

Less than a week later, Kirby brought in the penciled pages. They were vintage Kirby drawings. In my opinion, the very best. We were brought together again.

Kirby had changed the original Silver Spider costume so that the Fly no longer looked like a combination of Captain Marvel and Captain Tootsie, another C.C. Beck creation of yore. Out went the web-pistol. The Fly now carried a buzz gun, which paralyzed his foes with stinging darts. It wasn't scientific, but who cared? It was good comics.

We also dumped the cartoon genie. In his place stood Turan, "Emmissary" from the Fly Dimension, where everyone was a human fly. Some people might say he was more "realistic" than a genie with a Santa Claus moustache.

I packaged a couple of issues of each of the two titles, and we waited for the sales reports. Since the M.L.J. group had never achieved great sales in their attempts at adventure or superhero titles, it was no great surprise that *Adventures of the Fly* and *Private Strong*, while critically acclaimed, just failed to make it over the top. While sales figures were not spectacular, they still showed enough promise to merit continued publication.

John Goldwater's son, Richard, in the few weeks since he was out of college, had "worked his way up" to editor-in-chief of M.L.J. Comics. He came to the conclusion that the art work on *Private Strong* and *The Fly* was not up to his standards. It was his opinion that Jack Kirby,

Jack Davis, Al Williamson, Bob Powell, Angelo Torres, and George Tuska — all legendary comic book artists, probably the most respected group ever to appear between one set of covers — should be replaced by artists with slicker styles. In his own words, "like the DC Artists." I suggested that Richard handle the books himself.

I stayed with *The Fly* for only four issues. *Private Strong* was killed after two — one issue too soon to finger sales reports as the culprit. Years later, I learned why John Goldwater had dropped his beloved *Shield* like a hot potato. DC Comics' lawyers had sent him a cease-and-desist order which put forth the amusing claim that the Shield's powers aped Superman's too closely. File that one under "what goes around comes around."

Richard Goldwater boldly set forth on his first venture, assigning new artists to the project who were obviously not up to the task. Between issues, Tommy Troy grew up and graduated from law school. A Fly-Girl was added to the cast. The Fly even learned to use his wings, but couldn't get sales off the ground.

The Fly was ultimately swatted into oblivion. Like a lot of flies, it took several hard swats before his little legs stopped moving. They killed him off in 1964. A year later, he was back, calling himself Fly Man, but now the artists were no longer imitating DC Comics. They were imitating Marvel, specifically Jack Kirby. That lasted until 1967. If Richard had stuck with Simon and Kirby, he could have saved himself a lot of buzzing around.

In 1983, M.L.J., then the Red Circle Group, brought him back as the Fly. This time the feature was billed as "created by Joe Simon." Ironically, the first story was entitled, "The Return of the Sinister Spider!"

Which reminds me of a story....

The Spider-Son I Never Knew

In 1982, Will Eisner's *Spirit* magazine published an interview with Jack Kirby, conducted by Eisner. "Spider-Man was not a product of Marvel," Kirby was quoted as saying. "Spider-Man was discussed between Joe and myself. It was the last thing Joe and I had discussed. We had a strip called the, or a script called the Silver Spider. The Silver Spider was going into a magazine called *Black Magic*. *Black Magic* folded with Crestwood and we were left with the script. I believe I said this could become a thing called Spider-Man, see, a superhero character. I had a lot of faith in the superhero character, that they could be brought back very, very vigorously. They weren't being done at the time. I felt they could regenerate and I said Spider-Man would be a fine character to start with. But

Joe had already moved on. So the idea was already there when I talked to Stan."

When I read this, I did a double take. It was news to me! Twenty-one years after he had first hatched from a spider's egg, here was I, suddenly accused by my old collaborator before all the world of being Spider-Man's father.

I called Jack. He confessed to an old indiscretion that, in the curious biology of comic books, made me responsible for bringing Spider-Man into the world.

"But why, Jack?" I demanded.

"I had no work — I had a family to support, rent to pay — what else could I do?"

I was flabbergasted to put it mildly. But there were a few holes in Jack's never-dependable memory. For instance, there was no *Black Magic* involved at all.

So, like the Green Hornet, I undertook an investigation to piece together the true chronology of Spider-Man's birth. I figured I was safe. The brat was already too old for child support.

Martin Goodman had literally shut down his comic book business in 1957, but after a brief period decided to give it another shot with a new company called Atlas (later known as Marvel). His new distributor was Independent News, the affiliate of DC Comics presided over by Jack Liebowitz.

Atlas launched a series of pseudo-horror comics: *Strange Tales, Tales of Suspense* and *Journey Into Mystery* featuring "big monster" stories populated with creatures like "Fin Fang Foom," "Dragoon the Flaming Invader," "Goom, the Thing from Planet X," "Googam, Son of Goom," and "Save Me From the Weed." These fables were written by Stan Lee and showcased the pace-setting art of Jack Kirby, Steve Ditko and others. They were the precursors of the Marvel resurgence of the Sixties. They appeared to be horror comics, but actually complied with the Comics Code. Since there were no real horror comics being published then, the titles did fairly well.

At the same time, DC Comics had found its own niche with revitalized superheroes, ganging them up into one group called the Justice League of America. They were an updating of an old DC group from the Forties, the Justice Society of America, and were made up of Superman, Batman, Wonder Woman, Green Lantern, the Flash, Green Arrow and Manhunter from Mars. Some of these characters had belonged to the Justice Society too, but seemed reluctant to admit to their earlier affiliation.

As the Sixties dawned, giant DC had the superhero market to itself and little Atlas had all the monsters. And so it might have continued but the usually canny Jack Leibowitz made one of the big mistakes in comic books.

While playing a round of golf with Martin Goodman, he happened to let slip that he had a hot little seller in *The Justice League of America* — or *JLA* as it was known to its fans.

Goodman, always ready to follow a trend, hastily tipped his caddy and rushed back to the Atlas office. He ordered Lee to fetch up a new superhero group book, and Lee turned to the logical artist to help him on this project, Jack Kirby. The result was the *Fantastic Four,* which starred a collection of retreaded characters from Goodman's old Timely line and other sources, led by Reed Richards (Mister Fantastic), the Invisible Girl, the Human Torch and a strayed Atlas monster called the Thing. But Goodman was reluctant to risk the popularity of the big monster books by doing something radically different. The solution was to feature, on the first cover of the *Fantastic Four,* a huge monster dwarfing the superheroes. This same technique was repeated on covers two and three. When the sales figures came in, they actually indicated a slight increase. The cover to the third issue was hastily redone to show the superheroes prominently. After that, the monsters were kept inside where they wouldn't scare potential readers.

SPIDERMAN

Goodman was cautiously encouraged. He instructed Stan Lee to bring him another monster-style hero. And so the Incredible Hulk was conceived. As they had on the *Fantastic Four,* Lee and Kirby plotted the stories, and Stan wrote the dialogue from Jack's penciled pages. Kirby

did the first five issues, and Ditko penciled the sixth. Then the title was shelved. Sales were obviously not up to expectations. No matter what you are told to the contrary by artists or writers, a publisher never puts a stop to a profitable publication. (A few years later, after the Hulk had lumbered through the pages of the *Fantastic Four* and a few other titles like an Alka-Seltzer proof nightmare, Lee and Ditko revived him in *Tales to Astonish,* and he went on to become one of the most popular characters in what they now call the Marvel Universe. Which just goes to show that you should never throw a good character away — even if he is a monster.)

Goodman could see that the monster fad was fast fading. He instructed Lee to start putting superheroes into his old monster titles. One title on the soon-to-be-canceled list was *Amazing Fantasy.* Lee called Kirby in and asked him if he had any comic characters lying around that hadn't been used.

As I learned years later, Jack brought in the SPIDER-MAN logo that I had loaned to him before we changed the name to the Silver Spider. Kirby laid out the story to Lee about the kid who finds a ring in a spider web, gets his powers from the ring and goes forth to fight crime armed with the Silver Spider's old web-spinning pistol.

Stan Lee said, "Perfect, just what I want." He then brought it to Martin Goodman, who thought it was anything but perfect. Goodman told Stan comic book readers hated spiders. No one would ever buy the thing. Lee explained that he had been an avid reader of *The Spider* pulp magazine when he was a kid, which featured the exploits of a breast-beating masked millionaire who wore a black cape and slouch hat, and solved crimes by blasting his enemies one of whom called himself the Fly — into oblivion with a pair of overheated automatics. Half convinced, Goodman reluctantly let Lee go ahead, but insisted that Spiderman be dumped into *Amazing Fantasy*'s final issue. If Spiderman bombed, it wouldn't

matter. The book was already dead. If sales rose, the character could be brought back in a new title.

Lee told Kirby to pencil-up an origin story.

Kirby went home and, using parts of an old rejected superhero named Night Fighter — on which he had partly based the costume of the Fly — revamped the old Silver Spider script, including revisions suggested by Lee. But when Kirby showed Lee the sample pages, it was Lee's turn to gripe. He had been expecting a story about a skinny young kid who is transformed into a skinny young kid with spider powers. Kirby had him turn into a muscular adult with superhero muscles. It was Captain America with cobwebs.

The similarities between Kirby's six-page offering and the not-quite-forgotten Fly were immediately recognized by staff members. As a consolation prize, Lee told Kirby to get busy on another new insect brainstorm called Ant-Man, who never went anywhere. He turned Spiderman over to Steve Ditko, who had been drawing every issue of *Amazing Fantasy,* anyway.

Ditko ignored Kirby's pages, tossed the character's magic ring, web-pistol and goggles into a handy waste-basket, and completely redesigned Spiderman's costume and equipment. In this life, he became high school student Peter Parker who gets his spider powers after being bitten by a radioactive spider. Lee liked Ditko's story, but not the cover he had done. He had Kirby redraw the cover to give it a dynamism he thought was lacking in Ditko's version. Ditko inked the cover to keep the "look" consistent with the inside pages. Lastly, the Spiderman logo was redone and a dashing hyphen added. He would forever be known as Spider-Man.

Evidently *Amazing Fantasy* #15 sold respectably, because the following year, 1963, Spider-Man returned in his own title, by-lined by Lee and aided and abetted by Ditko, who went on to draw 38 issues of *Amazing Spider-Man,* plus a couple of *Annual*s, breaking down the graphics from storylines he and Lee dreamed up together. Ditko abandoned *Spider-Man* in 1966 and, despite piteous pleas from editors and fans, has steadfastly refused to draw him to this day.

Kirby's Ant-Man didn't fare so well. Lee had looked at his recent sales figures and saw that an issue (#27) of *Tales to Astonish* featuring "The Man in the Ant Hill" was one of 1962's top sellers. He and Jack Kirby took hapless scientist Henry Pym and made him a superhero who could shrink down to the size of an ant. And that was how Ant-Man came to be. He wasn't selling, so they gave him a girlfriend called the Wasp and when that didn't work they gave him elevator shoes and called him Giant-Man. Finally, they gave up and gave him the boot from *Tales to Astonish,* replacing him with Ditko's Hulk.

But Kirby didn't go hungry. His Mighty Thor ran for years in *Journey into Mystery*, as did a revived Captain America in *Tales of Suspense*. He pleased Martin Goodman by conceiving two new superhero team books with Stan Lee, *The Avengers* and *The X-Men*.

And every once in a while, he would draw a Spider-Man story — invariably forgetting the black spider on the character's chest.

Kirby went on to produce over a hundred issues of the *Fantastic Four*, quitting the title — and Marvel — only after Jack Schiff retired from DC Comics.

The Amazing Spider-Man eventually became Marvel's top seller. When John Goldwater realized how hot he was, he revived my old Fly, renamed him Fly-Man and bequeathed him with new powers lifted from Spider-Man and the less successful Ant-Man. And you know what? He *still* didn't sell!

From the Silver Spider in 1953 to the first appearance of Spider-Man in 1962, it took almost a decade for the character to evolve. Spider-Man went on to star in Saturday morning cartoons, live-action TV shows, Dixie cups, "underoos" and a major motion picture. He became a cottage industry in red tights, outselling Superman and

Batman. To this day, every Marvel letterhead features Spider-Man's cobwebbed kisser. Stan Lee never seemed to tire of telling people that of all the characters he "created," he's proudest of "Spidey," as he called him with paternalistic affection. Jack Kirby continued to insist in interviews that he created the character and designed the costume.

Steve Ditko, for his part, was reluctant to clarify his role in the Spider-Man affair. Instead, he spent many hours writing heavy, lengthy treatises and essays about creativity, creation, creating and justice from his tiny studio over Hamburger Harry's on the west side of New York City.

Finally, I would like to make a statement — to Stan — and Jerry and Joe, Steve, Ed, Dick and Dave — to the Als and Leon, Wally, Clarence, Bill, Will, Martin and all the Jacks and even the Bobs —

All of you are the creators! You developed a unique American art form that entertained the world at a time when it was needed, at budget prices. You were young, you were brilliant. You invented and more importantly, you executed. You were THE COMIC BOOK MAKERS.

185

Chapter 29

The Copyright Capers

Copyrights are eligible for renewal after 28 years. Before the new copyright laws of 1978, there was a fuzzy area of interpretation as to who was entitled to renew, the author or the "proprietor," meaning owner or publisher. When Captain America came up for renewal in 1969, I retained the law firm of Friend & Reiskind, a small company experienced in show business, to apply for the copyright renewal. The U.S. Copyright Office granted the renewals in my name and sent me the certificates of copyright for the first ten issues.

My attorney, Edwin Reiskind, notified Marvel publisher Martin Goodman and Krantz films, which was in the process of doing a television series on Captain America.

Martin Goodman, through his corporations, retained a large, prestigious law firm specializing in copyright and trademark, to contest my claim and attempt to retrieve the copyrights.

In the pre-trial hearings, under oath, Martin Goodman conceded that "Joe Simon created Captain America."

At the same time, in U.S. District Court in New York, Theodor Seuss Geisel (Dr. Seuss) was in litigation with the owners of the defunct *Liberty* magazine over copyright ownership of the Dr. Seuss cartoons which had in the past been published and copyrighted by *Liberty*.

The court found in favor of Dr. Seuss. This decision set a precedent that was favorable to our case for ownership of the *Captain America* material.

In television land, it was Superhero Day on the *Mike Douglas* talk show. There was Adam West, star of the then-current *Batman* TV series in costume with his sidekick, Robin, trading quips with host Mike Douglas to the delight of the studio audience. Suddenly, in bounced Stan Lee, outfitted in a colorful red, white and blue stars-and-striped Captain America costume replete with floppy boots and gloves, shoving the round flagged shield at the camera. Watching this, we were engulfed in laughter.

Jack Kirby, working for Marvel Comics on a free-lance basis, was summoned to Martin Goodman's office.

"Simon said he created Captain America," he was told. "He wants the copyright and it looks like you're out."

Kirby bristled. What he didn't know was that a co-author is entitled to half ownership of any copyright awarded to the designated "author." That's the law.

It was agreed that Kirby would side with Marvel in contesting my claim. Kirby signed a document surrendering to Marvel Comics all rights to Captain America in perpetuity (that word again). In return, Marvel promised to pay Kirby the same amount they would pay Joe Simon upon settlement of the case.

Kirby would sign over all rights in perpetuity several more times before he retired.

Meanwhile *Liberty* magazine had appealed the decision in favor of Dr. Seuss and the courts had overturned the original verdict. Dr. Seuss announced plans to appeal to a higher court.

Liberty magazine and Dr. Seuss reached an out-of-court settlement. *Liberty*'s victorious appeal stood, setting a precedent that made our chances of retaining copyright ownership bleak. My attorney advised that we negotiate to settle the case. We finally agreed on a price Marvel would pay me to surrender my claims to the copyrights.

Since I was unaware of Marvel's deal with Kirby, certain terms of the eight-page settlement contract mystified me. To wit: "Simon and Friend & Reiskind agree that, except pursuant to an Order, Judgment or Decree of a Court, they will not disclose or communicate the terms of this Agreement..."

Upon risk of life imprisonment or the firing squad or whatever penalties such disclosures present, I will tell you that part of the payment was made to me, part to my attorney — a much larger share than his legal fees would constitute. My attorney, in turn, passed his payment on to me.

Almost three years later, I ran into Kirby. He told me he had not collected his money. Eventually he was paid the sum that I received as my share. The second share of the settlement, the money my lawyer turned over to me, was not included in Kirby's payment.

Marvel had saved a substantial amount of the money they had promised Kirby.

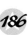
BELOW: Stan Lee and Jack Kirby revived the Sentinel of Liberty to great success in the 1960s. During that decade, Joe Simon sued Marvel for ownership of the Captain. Cover detail from Tales of Suspense *#59. Pencils by Jack, inks by Dick Ayers. ©2003 Marvel Characters, Inc.*

'60s & '70s Comics

Sporadically, Joe Simon would return to the four-color comic book world, often at the behest of friends in the business, such as when Alfred Harvey asked the author to helm a Harvey Thriller imprint in the late '60s, a short-lived attempt to inject action in the otherwise kiddie-comic infested Harvey Publications. The books did contain notable work by Wally Wood, Al Williamson, Howard Nostrand, and a talented newcomer, Jim Steranko. In 1968, Joe created *Brother Power, the Geek* for National Periodical Publications (DC). A few years later, DC publisher Carmine Infantino invited Joe on board as an editor, where the author helmed the romance titles as well as *Prez* (about a teenaged U.S. President), *Champion Sports, The Green Team* (a kids gang made up of millionaires), as well as *Sandman*.

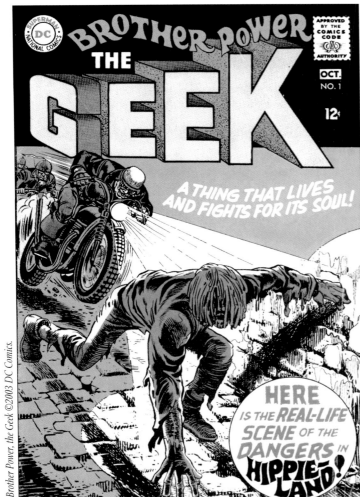

Brother Power, the Geek ©2003 DC Comics.

Spyman ©2003 Joe Simon.

Unearthly Spectaculars ©2003 Harvey Family Entertainment.

Prez ©2003 DC Comics.

Jigsaw, B-Man ©2003 Joe Simon.

Chapter 30

Still Later...

In October, 1976, I received a lengthy letter from Jerry Siegel, who was living in California. The letter, crudely typed on both sides, folded in half and stapled, summarized his case against the publishers of *Superman*. It was a classic performance in frustration, which obviously mirrored many years of brooding, accusing National Periodical Publications and former publisher Jack Liebowitz of misrepresentation and bad faith.

Later, I learned that the same letter, in the form of a news release, had gone out to several people in the industry as well as newspapers in California. The saga of Siegel and Shuster versus the publishers of *Superman* was once again surfacing, almost thirty years after their abortive lawsuit to regain ownership of the character.

The incentive, most likely, was the announcement of a major motion picture on the life of Superman, which reportedly was to net Warner Communications, the owner of National Periodical Publications, an estimated $3 million to $10 million for the rights.

A group of artists, including Jerry Robinson (president of the National Cartoonists Society) and Neal Adams (a talented free-lancer who did a substantial amount of work for National Periodical Publications) heard about the letter and were outraged at the injustice of the case.

They immediately launched a media assault against Warner, culminating in the appearance of Siegel and Shuster on *CBS News* and all three local New York TV news programs, as well as Howard Cosell's *Saturday Night Live*. Jack Liebowitz, who now sat on the board of the giant corporation, countered with interviews explaining

BELOW: A surprise run-away hit of 1974 for DC was The Sandman, *a title in which, Publisher Carmine Infantino reunited his longtime friends, the legendary team of Joe Simon and Jack Kirdy ©2003 DC Comics.*

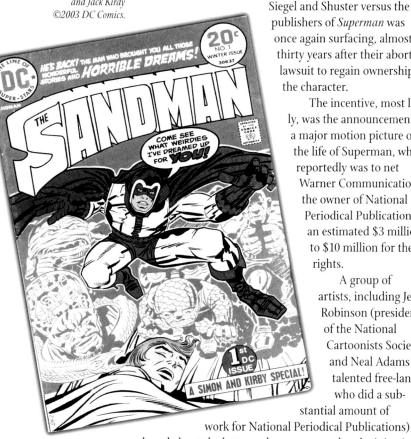

that Siegel and Shuster had, between them, been paid over a half million dollars in the period in which they worked for his company. Liebowitz's retaliation did little to cool a very bad public opinion reaction against Warner.

In retrospect, Jerry Robinson best told the Siegel and Shuster story during a symposium at the Mid-American College Art Conference at the University of Nebraska, in which I appeared with Jerry, Jules Feiffer, Will Eisner and Clarence Beck (artist for *Captain Marvel*). Jerry, who was involved as much as anyone, tells the story:

"Siegel and Shuster, in order to cash that first check for $130, were obliged to sign a rubber-stamped contract on the back of the check, turning over all rights to the publisher for perpetuity. This was fought out in a lawsuit which was a very complicated, drawn out case.

"In effect, Siegel and Shuster had created a Frankenstein monster, since their creation had made the publishers multi-millionaires, able to hire the biggest law firms and drag the case through the courts until the creators had exhausted their means and, out of desperation, were forced to surrender. They were awarded a relatively meager settlement, then immediately fired.

"Jerry and Joe were both good friends of mine. We worked together. I was doing *Batman*, they were doing *Superman*. Joe, the artist, had bad eyesight even then. Since then he's been declared legally blind and had been out of work for 25 years. The writer, Jerry Siegel, suffered such emotional trauma that he couldn't create another story. We would walk past a newsstand and see a copy of Superman and Jerry would get physically ill. Eventually he suffered a heart attack and settled for a job as a mail clerk in California."

Robinson continued: "Joe was supported by a brother who was a draftsman earning a minimal income. One winter day, Joe was sitting on a bench in the park where he was observed by a policeman to be cold, without a coat, and starving. The officer took him to a luncheonette. He bought him a bowl of soup. A group of kids walked in carrying comic books. Joe noticed that one of the comics was Superman. Joe said, 'That's my creation: Superman.' The kids looked at him and said he was crazy. The cop said he had just picked him off a bench in Central Park.

"'Oh, would you like me to draw a picture?' Joe asked. He took out a pencil and sketched a picture of Superman on a paper napkin and gave it to the kids. The policeman, perplexed, paid for Joe's soup, and then went on his way.

"Another time, Joe had a job as a messenger boy in New York, and as fate would have it, was given a package to deliver to the same building where the Superman empire was located. Wandering around the halls, he was straining his weak eyes to find the company that was to receive the package when one of the employees at DC Comics saw him. The employee ran to his boss and said, 'My God, do you know who's wandering around the halls? Joe Shuster.'

"The next morning, Joe received a call from the CEO telling him to 'come to my office right away.' Joe rushed in, thinking finally something was going to be done. Instead the exec scolded him for embarrassing the company by wandering around the halls in rags. He fished one hundred dollars out of his pocket, gave it to Joe, and said, 'At least buy an overcoat. And get a new job. We don't want you hanging around the building.'"

As Robinson summarized: "It occurs to me that if Siegel and Shuster had had any kind of contract — even a terrible contract — they would both be millionaires by now... Most of the artists who do newspaper strips get a percentage of all profits. I do a daily panel. It's syndicated nationally, and I get 50 percent of the gross receipts from the various newspapers that it appears in.

"But before you ridicule Siegel and Shuster, you've got to understand the mentality of the times and of the industry. We were all very young. I was 17 when I started. Joe and Jerry were high school kids. We were just happy to see our work published. All of us — any one of us — had no second thoughts about signing any piece of paper that would keep us working in this fabulous, glamorous cartoon business.

"What was the alternative? A job as a shipping clerk? A career in some other field that didn't interest us at all — that's if we were lucky enough to find something? It was the tail of the Great Depression, you know, and jobs were not easy to come by. So we signed the release on the back of the check... Not one check, but each and every one. Every possible authority and ownership was spelled out on those releases. Movies, toys, merchandising, foreign rights. They still haven't changed, in all these years."

So much for Jerry Robinson's thoughts on the matter of Siegel and Shuster. The story does have a happy ending, of sorts. As a public corporation, Warner Communications could ill afford the embarrassment of the unrelenting publicity assault. The matter fell into the hands of Warner Vice President Jay Emmett, a nephew of Jack Liebowitz. Emmett, who himself was earning close to $200,000 a year, eventually reached a settlement with Siegel and Shuster. It was agreed that Warners would pay each of the pair $20,000 a year for life, or to their families, for a minimum of ten years after their death. In addition, the words "Created by Jerry Siegel and Joe Shuster" would be added to the logo of *Superman*.

Reportedly, the terms of the settlement have been upgraded since that first agreement.

ABOVE: *A convention appearance by three giants of the comic book industry is captured on film. From left, Carmine Infantino, renowned artist and the publisher of DC Comics from 1970-76; Sergio Aragonés, famed* Mad *cartoonist and creator of* Groo the Warrior; *and the author, Joe Simon.*

day and he said, 'This is Martin Goodman's wife's nephew.'"

"Oh, damn," said Stan.

"You were seventeen years old."

"Sixteen-and-a-half."

"Well, Stan, you told me seventeen. You were probably trying to be older. I did hire you."

"It seems to me that Martin didn't know I was working there until he met me in the hall one day and said, 'What are you doing here?' And I've told that story for years. I hate to think it's wrong."

"It was an awfully small office for that to happen, Stan. They must have had only ten or twelve employees."

"The only ones I remember were you and Jack Kirby, Elsie Feldstein, Arthur Goodman — I don't remember anybody else."

"Right."

"Was Milton Shifman there?"

"Morris Coyne was the accountant."

"I didn't know him."

"Abe (Goodman) was doing some bookkeeping."

"Oh yes, Abe! Was Dave Goodman around?"

"Dave Goodman, sure. He had a desk there; but Dave would walk around with a camera, taking pictures of girls, telling them that they'd be in the magazines."

"I haven't seen him for years," said Stan.

"I lent him my new Buick convertible once. Jack [Kirby] and I were doing *Captain America* on 45th Street in our own office — and we sent Dave down to pick up some stuff and he left the door of my Buick open and the next car came along took the door off!"

"So now I've got to try and figure out what the hell I'm gonna say about how I got started in this business, Joe! Robbie came in one day and he said that this is Stan and he's going to work here?"

"And Martin wanted me to put you to work."

"Uh huh..."

"And you came in with your damn flute and started driving everybody crazy."

"Did I really do that?"

"Yep."

"That's funny, that is funny..."

"And that's about it..."

"Next time I'm in the city, I'll give you a call, Joe."

"Where are you these days, Stan?"

"You can reach me out here in California at the studio. Got a pencil?"

"Always."

"Got a cigar in your mouth, Joe?"

"Always."

"Nothing's changed!"

In 1989, Stan Lee, then producing television and film versions of his comic books, phoned me from California with a problem.

"I lecture all over the country," said Stan, "and during the question-and-answer period I'm always asked how I got started in the business. I tell the audience that I answered an ad. And I make a little joke out of it. I say, 'I probably got the job because I was the only guy who answered the ad.' I've been saying this for years, but apparently it isn't so. And I can't remember because I said it so long now that I believe it."

"For crying out loud, Stan, is your head going at your age?" said Joe.

"Joe, I've got to tell you something: I don't worry about it because I never had a good memory. If I had a good memory then — and I don't now — I'd probably worry about it. But even as a kid I couldn't remember. So why should I worry now?"

"You know, even with the characters I used to write I would forget their names. Like with The Hulk, I would call him Bruce Banner, I would call him Bob Banner. I'd get mail from the kids: Don't you know your own characters? they would write! So as I say, I'm hoping that I did answer the ad, but I thought I'd better check with you."

"Your uncle Robbie brought you into the office one

Index